Wisdom With Understanding is Better Than Rubies

Lurine Karon Greenberg Fine Arts Collection

Drawing and Painting
ANIMALS

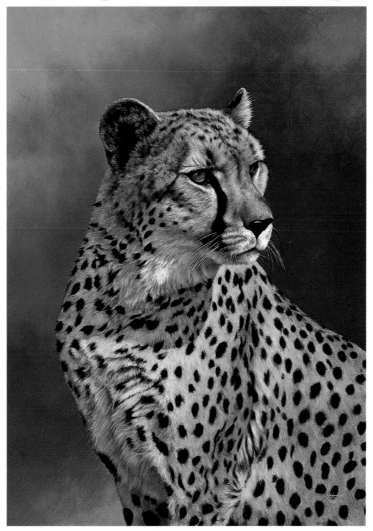

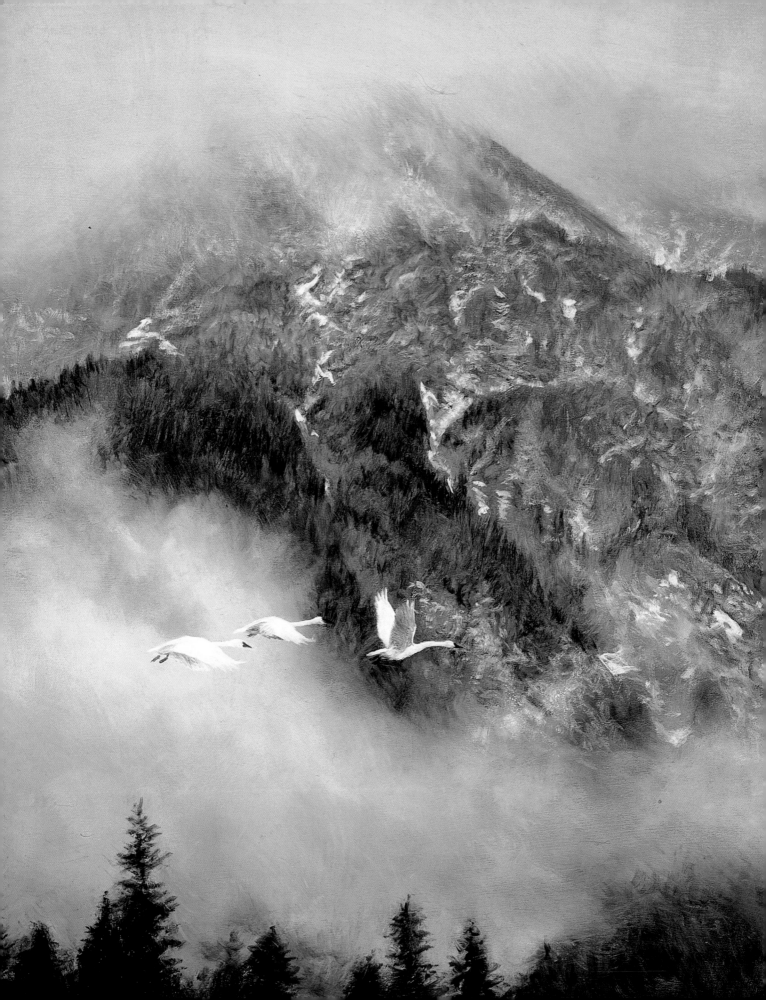

Drawing and Painting
ANIMALS

Edward Aldrich
edited by Bonnie Iris

WATSON-GUPTILL PUBLICATIONS
New York

To mom, with love

Frontispiece:
CHEETAH PORTRAIT
Oil on Masonite, 16 x 22" (41 x 56 cm), 1994.

Title page:
MOUNTAIN FLIGHT
Oil on Masonite, 16 x 30" (41 x 76 cm), 1997.

All artwork appears courtesy of the respective artist, with the exception of
Pride's Proud Family (pages 94–95), which appears courtesy of Mill Pond Press
and Dino Paravano.

Copyright © 1998 Edward Aldrich
First published in 1998 in the United States by
Watson-Guptill Publications
a division of BPI Communications, Inc.
1515 Broadway, New York, New York 10036.

Library of Congress Cataloging-in-Publication Data

Aldrich, Edward.
 Drawing and painting animals : how to capture the essence of
wildlife in your art / Edward Aldrich ; edited by Bonnie Iris
 p. cm.
 Includes bibliographical references and index.
 ISBN 0–8230–3606–5
 1. Wildlife art—Technique. I. Iris, Bonnie. II. Title.
N7660.A55 1998
758'.3--dc21 98-24730
 CIP

Printed in China

First printing, 1998

1 2 3 4 5 6 7 8 9 / 06 05 04 03 02 01 00 99 98

Editors: Candace Raney, Marian
Appellof, and Victoria Craven
Designer: Jay Anning
Graphic Production: Hector Campbell

ACKNOWLEDGMENTS

A book like this doesn't happen in a vacuum. My ability to create unremittingly is due to the support, guidance, suggestions, prodding, and inspiration of many people. I am deeply grateful to all of them, without whom this book would not have been possible.

Those people who listened to my ups and downs with an understanding ear helped more than they will ever know. My thanks and love go to my brothers Jeff and Brian, to my father, and to some extraordinary friends, Dennis Bennett and Mitch Kramer. I am especially grateful to Dennis Bennett for generously supplying all the product photographs and most of the shots of my paintings. He is as gracious as he is talented.

The final book was influenced by the questions, advice, and suggestions that came from my conversations with a number of wonderful artists. My greatest thanks go to Scott Dubois, Ben Trissel, Jacque Devaud, and Bill Alther for helping me to see with new eyes.

My undying thanks go also to Gary and Monica Milburn, Mike and Suzanne McClure, and Alex Montoya for their professionalism and their friendship. They have been so much more than my link to clients.

I have been very fortunate to have had some of the field's very best and most renowned artists working with me on this book project. A very special thanks goes to those artists who generously shared their materials and their time with me.

My sincere thanks go to my college professor, Tony Janello, for giving to me a sense of direction that continues to guide me today.

My collectors, too, deserve a very special thank you. It is through their eyes that I see the real value of what I do. Seeing the joy that my artwork brings to them gives an added dimension to my work.

My very special thanks goes to Bonnie Iris who worked diligently with me on this book. Without her ongoing guidance and expert and intelligent suggestions this project wouldn't have happened.

And lastly, and certainly most importantly, there is my mother, the one person who has been there through everything. In addition to being my mother and my dearest friend she has provided me with an infinite amount of support, understanding, and wisdom. Without her, I wouldn't be where I am today.

Contents

Preface

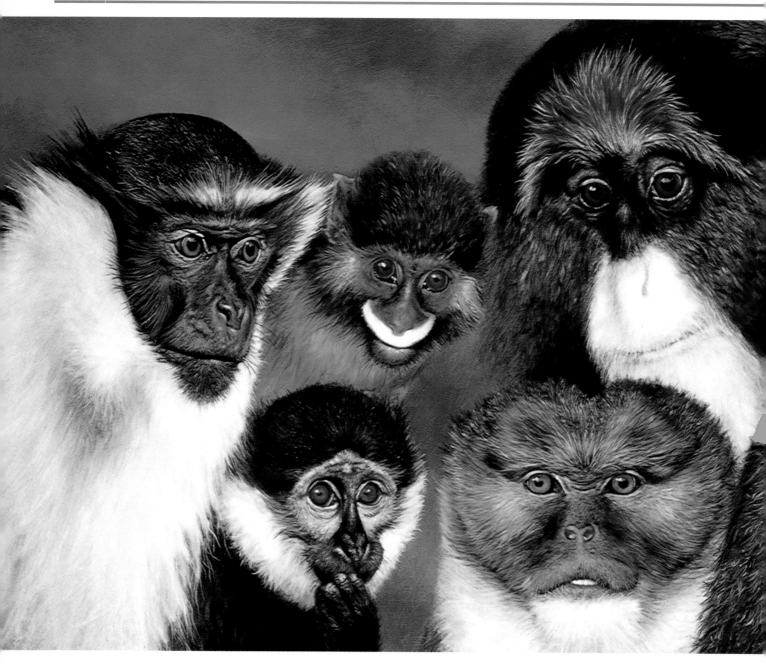

A GROUPING OF GUENONS
Oil on Masonite, 16 x 30" (41 x 76 cm), 1996.

It's hard to learn how to paint, and the road ahead is rocky. But if you're serious and committed to the ongoing exploration and development of your creative self, be prepared for moments of exhilaration and accomplishment coupled with days of frustration, boredom, anger, and jealousy. At times you'll think you are "not quite good enough," or your paintings may turn out completely different from the way you saw them in your head. You'll also make many mistakes along the way, but the fact that you're frustrated means you're struggling to learn and grow and explore.

The lesson to be learned from this is simple: Never settle for pretty pictures or paint only what sells. Your highest artistic achievement depends on holding true to your vision and artistic passion. Since not every technique is right for every artist, by including in this book many different ways of working I have made sure there is something here for everyone—beginners and professionals alike.

The material in this book combines my own techniques and ideas with those of several other talented wildlife artists—some of the greatest living artists I've ever known—and I'm honored to have their work appear here. There's also another reason for including them: Every artist in this book has an individual, personal, and passionate approach to his art, a dynamic presence.

The book is also much more than a technical how-to manual. It is filled with some of the most commonly overlooked aspects of the creative process that lie at the core of a successful painting. If I have done my job right, you'll be left not only with the knowledge of how to draw and paint animals but, more importantly, you'll be inspired to jump right into it.

So, strap yourself in and enjoy the ride. The result of your struggles can be rewarding beyond your wildest expectations. You are creating art only you can create-your touch will be different from everyone else's. And when you're able to step back from a painting you created and say "Wow, I did that," the reward is already there.

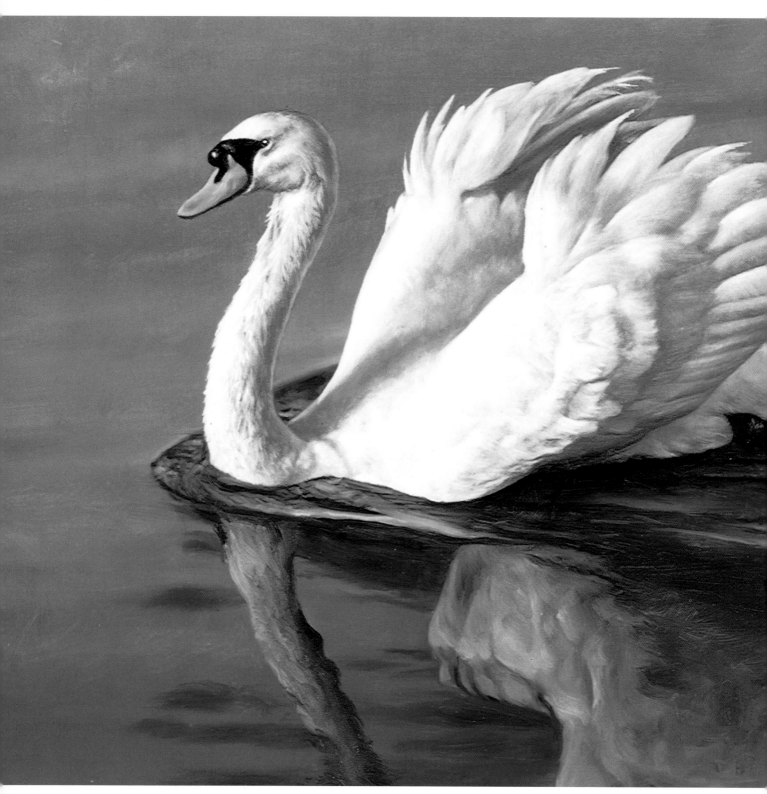

HER MAJESTY *(Mute Swan)*
Oil on Masonite, 12 x 20" (30 x 51 cm), 1996.

MATERIALS

THERE'S A VAST ARRAY of materials and tools available, each with a different effect. In this chapter we will look at just some of the many different varieties of materials that are commonly available. The ones discussed here are the materials that I personally favor. Other artists may prefer different materials for a variety of reasons. You should sample as many of them as you can until you establish your own preferences. The process of exploration and experimentation will broaden your drawing and painting experience and challenge you in unexpected ways. You will find that certain products excite you creatively and others leave you underwhelmed. After trying many tools and materials, you will eventually settle on those products that enhance or encourage your own artistic voice.

Drawing Materials

Where do you start? In the beginning, the simpler you keep it, the better off you'll be. Basically, you'll need a drawing pad, a pencil (2B is fine), a pencil sharpener, and possibly an eraser. The drawing utensils pictured here are the ones I use on a regular basis.

As you experiment with the different drawing tools available to you, you'll find yourself drawn to some more than others—to the kinds of marks they make, to the way the tools feel in your hand and on the paper. That's why it's so important to try them all.

CHARCOAL

Charcoal is excellent for laying in broad areas of tone. You can achieve great results from selectively smudging areas with your fingers or a stump (rolled paper pointed at the end, resembling a big pencil). Working on toned paper with light materials, such as Conté crayons or China markers, for example, gives still a different effect. Charcoal helps you to focus on the solidity of the animal's body so that you will build up its mass, not just draw its outline.

CONTÉ CRAYONS

Conté crayons are somewhat like charcoal but give you more control. They come in a variety of basic colors, such as brown, red-brown (called "sanguine"), black, and white.

CHINA MARKERS

China markers are composed of a waxy substance wrapped in paper, which is unwrapped as the marker is used. They come in a variety of colors; white China markers are effective on toned paper, such as brown construction paper.

Charcoal, Conté Crayons, China Markers

Both in the very foreground and in the box are Conté crayons. In the middle, from left to right: a Conté carbon pencil, round stick charcoal, square compressed charcoal, two graphite sticks, China marker.

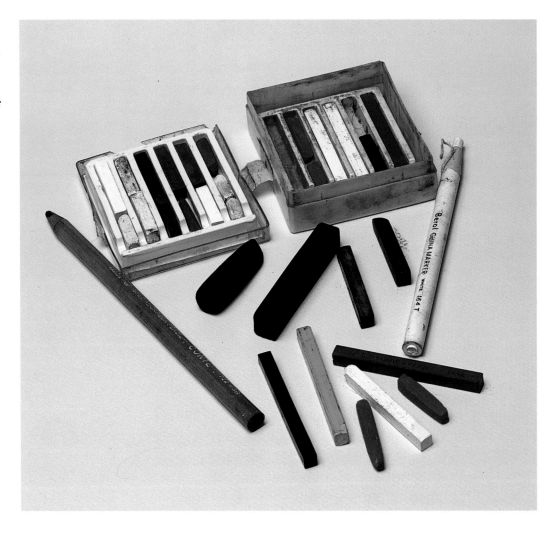

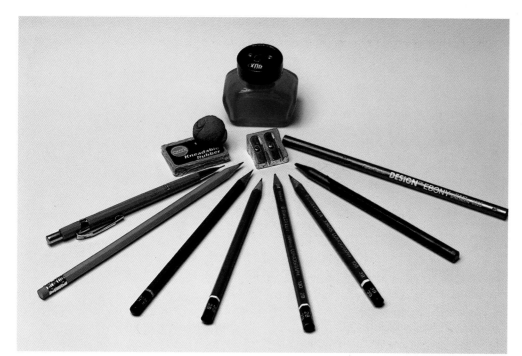

PENCILS

Pencils come in all varieties. The marks they make can give drawings very different looks and feels. From light to dark, thick to thin, the effects vary greatly. I prefer a medium-weight pencil (2B to 4B) or a solid graphite stick. Medium-weight pencils are great all-around implements for drawing (neither too hard nor too soft). Solid graphite sticks, which can be used on the tip or an edge, provide a wide range of line quality that can have great effects.

Graphite Pencils

These pencils range from 9H (hardest and thus lightest) to 9B (softest and darkest). I generally use medium-weight pencils, numbers 2H to 4B, because I like the look and feel of the marks I get with them.

Solid Graphite Pencils

Like the other pencils, graphite pencils also come in a variety of darknesses. But unlike regular pencils, solid graphite pencils have no wood around the graphite and therefore can be handled in other ways, for different effects. A stick of graphite has four flat sides instead of six sides, like a pencil. This allows you to draw with an edge of it so as to cover larger areas with one stroke. It can also be manipulated like a calligraphy pen for yet another look.

Mechanical Pencils

These also come in a variety of thicknesses and darknesses. Many people prefer them because they don't require as much sharpening as regular wooden pencils. Others prefer to feel the wood of the pencil rather than the stiff metallic casing of the mechanical pencil.

Ebony Pencils

These are very dark lead pencils, excellent for the darkest parts of your drawing.

PENCIL SHARPENER

For field work, a sharpener with an attached container for shavings is recommended. Some people do prefer to use single-edged razors or X-Acto blades to sharpen their pencils, as well.

KNEADED ERASER

Most artists use a kneaded eraser when drawing because its shape and size can be varied (by tearing off pieces and shaping it with your fingers) to fit even the tiniest spot. Like several erasers, it doesn't abrade the surface and leaves no color residue on the paper. However, especially in the beginning, using an eraser can be a bad habit. Instead, restate the line where you want it and either leave the incorrect line alone or just erase it lightly.

PENS

Pens are great because they're permanent. Since you can't erase ink, pens force you to be conscious of your line work. If you make an error in pen, simply incorporate it into your drawing.

India ink can be a very expressive medium, if applied with a brush, though it can be tricky to control. Be ready for a loose look if you use it.

PAPER

Your drawing paper can be simple loose paper clipped to a board for support, or it can be a sketch pad, or toned paper like the type used for pastel. Some artists prefer using a high-quality smooth watercolor paper for drawing.

Paper comes in different weights (thicknesses), surface feel (tooth), and sizes. Your choice of paper will depend on your personal preference and drawing style. When starting out, I find it easiest to bring a simple sketchbook. Sketchbooks are compact and are easier to handle than many pages of loose paper. Check out the variety of sketch pads and drawing pads manufactured by the different companies to see what you prefer.

Sketch Pads

There are many different types and sizes of sketch pads. Choose one you're comfortable with in terms of size, texture, and weight (thickness). Typical surfaces range from smooth (plate) to rough, from tiny pocket-sized sketchbooks to big 18 x 24" tablets, and from very thin paper to fairly heavy illustration board. A basic drawing pad (manufactured by many companies) with a slight tooth—not too rough or too smooth—can be excellent for simple sketches. If you want a smooth surface for intricate detail, try Bristol board. I like a 14 x 18" size because it's portable yet gives me enough room on the page so as not to feel confined. I generally like paper with a medium tooth or texture, but I do use Bristol board when I feel like drawing on a smooth surface.

If longevity is a consideration with your drawings, you may want to look for paper that is acid free. This "archival" paper (specifically labeled as such on the pad) is free of the acids that help to break down or yellow the paper over time. Many companies make it, including Morilla and Canson.

Toned Paper

Toned paper can be anything from basic brown kraft paper to a rainbow of colored paper. These papers (for example, Canson Mi-Teintes) are typically used for colored drawing mediums such as pastels, Conté crayons, and colored pencils, but can also be used with almost any drawing medium. The advantage of using toned papers is that you can "push" darks into them by using dark colors and "pull" lights from them with light colors, such as white chalk.

**Sketch Pads
and Sketchbook**

Various drawing pads and drawing board with clips.

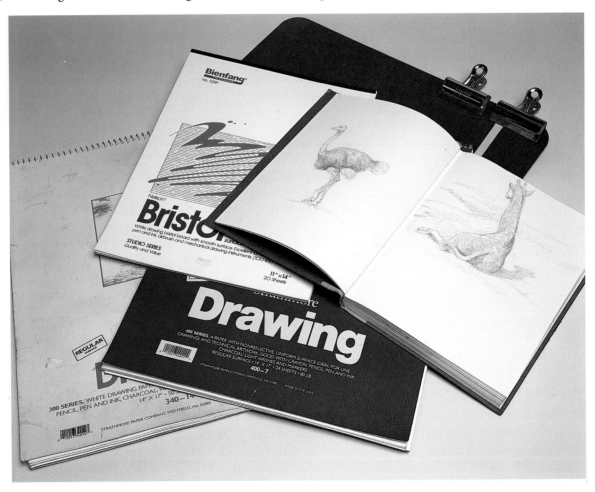

Oil Painting Materials

Oil paint is made with ground-up powdered pigment (color) combined with an oil medium (generally linseed oil) and mixed to create the consistency it finally appears in. Different pigments can change the consistency of the paint from "slippery" to "thick."

OIL PAINT

The consistency, tone (or purity of color), and quality of oil paint vary with the brand, pigment, and amount of filler. Winsor & Newton is a good all-around brand, but other companies make some wonderful, high-quality paints as well. Experiment with the different brands and colors to see what you like most in hue, richness, feel, and consistency. Some other decent brands are Utrecht, Rembrandt, and, if you really want top-shelf (and top-price) paint, Holbein or even Blockx, which is able to produce a remarkable color saturation and oil consistency.

Pastels

Pastels are dry crayons made from powdered pigment. They come in hard, medium, or soft varieties and come in various shapes from round to square sticks. Since working with pastels requires the laying down of precise colors and a minimum of blending, they come in a huge variety of colors and values. There are also very simplified basic sets for beginners, though.

Basic Colors

This is the core palette I use both in the studio and in the field. Titanium white, burnt umber, burnt sienna, raw sienna, yellow ochre, Naples yellow, cadmium yellow, cadmium red, alizarin crimson, cobalt blue, and ultramarine blue. My basic palette consists of those colors I use most frequently. Since I paint a lot of animal portraits and limited habitat scenes, these basic colors are those I use for fur, feathers, and general animal colorations. This is why there is a heavy emphasis on the earth tones: ochres, siennas, and so on. Notice that there are a couple of reds, a couple of blues, and a couple of yellows in addition to these earth tones. These other basic colors can, when combined effectively with my core colors, create almost any other color that I may need. I like to keep as simple a palette as possible. I even combine burnt umber and ultramarine blue to get my black.

Additional Colors

Cerulean blue, raw umber, sap green, permanent green, viridian, cadmium yellow pale, cadmium orange, cadmium red deep, and phthalo green, phthalo blue supplement my more basic palette when a wider range of colors is needed. For instance, the greens come into play here. These are very necessary when you are depicting plants of any sort and are critical when painting landscapes. Some of the other colors, cadmium orange, for example, are almost impossible to mix from other colors.

PAINTING MEDIUMS AND SOLVENTS

Mediums and solvents are liquid vehicles that are added to the oil paint to create more favorable consistencies. Mediums aid the flow of your paints and create a glossy finish. You may find the following mediums useful for various stages of painting. Solvents, usually turpentine or mineral spirits, thin paint down. This provides for a great underpainting vehicle.

Sun-bleached Linseed Oil

Sun-bleached linseed oil is slightly thicker than basic linseed oil, but not as thick as stand oil. Its consistency is perfect for glazing.

Liquin

This is an alkyd resin that is designed as a medium to quicken the drying time of oils. It's also great for glazing.

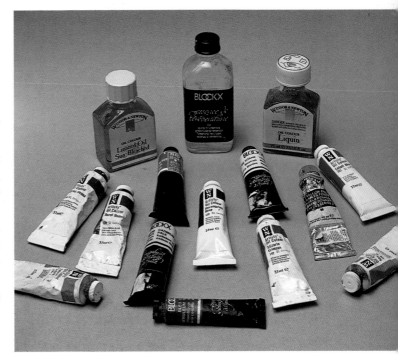

Basic Palette of Colors and Mediums

Mediums (left to right): sun-bleached linseed oil, turpentine, Liquin.

Gum Turpentine and Mineral Spirits

When painting in layers, it is good to be conscious of the "fat over lean" rule. It is best to paint a more oil-rich paint (fat) over a more diluted paint (lean). Adding a small amount of turpentine will dilute an oil color down, making it dry a lot quicker and providing a great first coat to a painting. Fat over lean is done to minimize later cracking in the oil paint. There are several brands available. Don't think because it lacks odor, it's not dangerous to your health. It may be odorless, but you still need ventilation.

VARNISHES

It's necessary to varnish your oil paintings to secure a long-lasting work of art. Varnishes can be either matte (dull finish), gloss (shiny finish), or a mixture of both. The varnish you choose will depend on the painting and the effect that you are after. I find that it's better to use matte for very dark paintings, for example, because gloss is too shiny. Historically, the classic varnish has been damar varnish and turpentine (since damar doesn't dissolve in mineral spirits). Various companies also now manufacture synthetic varnishes—for example, Liquitex makes a varnish of acrylate monomers called Soluvar that is soluble in mineral spirits.

I apply varnish in one coat with a 4"-wide foam brush, which is very effective and cleans well with turpentine and a rag. Other artists like to cover the surface with several coats of varnish to really seal it. There is also a spray damar varnish, which some artists swear by.

PAINTING SUPPORTS

The support is any structure that the paint and ground are applied to. The support you choose will considerably affect the look of your painting, especially if your paints are thin. It's easy to tell the difference between a smooth, gessoed, and sanded wood panel and a gessoed, coarse-weave, stretched canvas. The smoothness, of course, is the most obvious difference, but you'll also notice considerable variation in the amount of "give" (the extent to which the surface pushes back when a brush is applied). Wood panels have no give, but a stretched canvas does, thus providing a "feel" some artists can't do without. The surface you choose will depend on your preference and the effect that you want to achieve. Here are some typical supports and ways to handle them.

Canvas and Canvas Boards

Canvas and canvas boards are great for those artists who enjoy painting with thicker paint. The weave of the canvas "grabs" the paint so it doesn't slide all over the surface when applied over thinner paint. The weaves available vary from fine linen to coarse canvas. The one you choose will greatly affect the paint application and the overall look of your art.

Canvas can either be stretched over stretcher bars or adhered to a board, such as Masonite or a thick, sturdy foamcore called Gatorboard, with a nonacidic paste. Premade canvas boards (generally canvas mounted to thick cardboard) can also be bought rather inexpensively and these can be great for quick outdoor studies.

Unmounted canvas can be bought raw (unprimed) or primed with acrylic or oil-based priming. Both of these can be used for oil paintings. When working on these surfaces I generally prefer a fine-weave linen (portrait linen) that has been sized (with a rabbit skin glue) and primed at least two times with oil priming. This gives a good ready-to-work-on surface once it is mounted to the board. See *The Artist Handbook* by Ray Smith for complete instructions on stretching, gessoing, and mounting canvas to boards.

Pochade Box and Easels

For outdoor painting it is often necessary to bring a self-contained box that holds all your painting supplies. A small box is called a pochade box. A larger box, with legs and an easel built right into it, is a French easel and is a must for field work. I'll cover this in depth in the next chapter.

When painting at home there are a couple of different ways you can work. A large studio easel is ideal for almost any size painting. A large (36 x 48") drafting table, tilted vertically, can be a great board to hold your paintings as well. I have both and use them interchangeably.

Masonite and Wood Panels

Masonite (or hardboard) is a board that is made up of steam-expanded wood fibers that has been hot-pressed together at high pressure. It has no grain like regular boards and is very smooth, thus creating a great surface to paint on, since it will not crack or age like normal boards will. It comes in ⅛ or ¼" thicknesses. I generally use ⅛"-thick, tempered Masonite boards (¼" thick for larger work). Tempered Masonite is treated with a water-resistant chemical that is fused into the board so it won't absorb water and therefore won't expand like a sponge under damp or wet conditions.

Some artists prefer untempered Masonite because tempered Masonite may repel the water-based gesso (though I've never seen a sanded tempered panel repel gesso) or are unsure about the archival nature of the chemicals. The untempered version is okay if you're careful to protect it against moisture damage by gessoing all the sides and edges.

When gessoed and sanded, wood panels range from smooth as glass to a variety of other textures. A smooth surface is great for minute detail and glazing. If you prefer more texture, you can apply a final coat of gesso with a large coarse brush such as a house painter's brush or a sponge, being careful not to smooth out the gesso too much. This can provide wonderful textures that can give great effects. Prepared wood panels work well with both oils and acrylics.

Other kinds of wood, like birch or poplar, can be used as a painting support in either raw or plyboard form. If you choose other kinds of wood, be sure to check the pieces individually for warping, knots, or other imperfections that may show up in the painting.

Grounds and Gesso

The "ground" is a layer or layers of substance that is applied to the support to create a favorable surface to paint on. Historically, a canvas would be sealed with a rabbit skin glue and then primed with an oil-based primer. Today most commercial canvas will be primed with an acrylic white version of

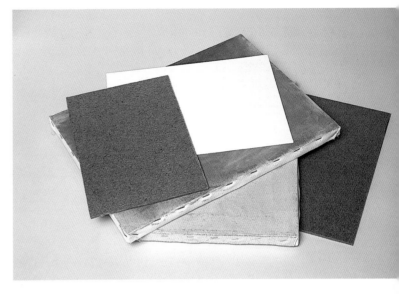

Painting Surfaces

This is a variety of painting surfaces, including Masonite, stretched canvas, and canvas board.

PREPARING MASONITE PANELS

Gesso, Foam Brush, Large Bristle Brush, Sandpaper

- Buy a few 2 x 4' or 4 x 8' sheets of ⅛" or ¼" tempered Masonite from a lumberyard. (Use the ¼" thickness if the desired size of the board is larger than 18 x 24".)

- Using a table saw, circular saw, or a hand saw, cut the board to the required size and sand the entire front of the board with a 100-grit sandpaper.

- Wipe off the dust and put the board down flat. With a 4"-wide foam brush, cover the board with a layer of acrylic gesso (you'll need one can), being sure to smooth out all thick areas. With the same brush, gesso the sides of the board. Gesso dries quickly so rinse the brush out immediately.

- Let the board sit for thirty minutes to an hour or until it's dry to the touch. Then lightly sand it with 220-grit sandpaper.

- Repeat this process—applying gesso then sanding it smooth—for at least two more coats (using two more foam brushes), though you don't have to gesso the sides on the last two coats. Make sure the final sanding gets the board to the required degree of smoothness. If you like a texture to your board, apply the last coat with a wide bristle brush and don't smooth out the texture.

- Since boards, especially thin ones, tend to buckle, it's best to lay them flat on a table or other flat surface for a couple of days until they're completely dry so that they dry flat.

Note: I recommend that you also gesso the back of the board to seal out moisture and to ensure the longevity of the painting.

gesso. Gesso is basically a glue binder that has been added to a white chalk and mixed to a creamy consistency. Most of today's gessoes are simple acrylic polymer emulsion and thus have a bit of "plasticity." On Masonite I use this acrylic gesso. On canvas and linen I enjoy an oil preprimed and glue-sized version.

BRUSHES

Brushes are distinguished by their bristle type, shape, and size. Brushes are generally made of either soft hair or bristle. Soft-hair brushes can be either synthetic (white or brown) or real hair (sable or squirrel). Brush shapes are broken down into two main categories—round and flat. When looking down the shaft of the round you'll see a circle full of bristles. A flat brush has the bristles flattened into a straight line. Within these categories are filberts (which is a flat brush with rounded edges); brights (shorter-haired flats); and various other kinds for specific purposes. Brush sizes are numbered from smallest (000) to largest (20).

With the many brushes available, it's a wonder anyone gets past the frustration of choosing the right ones. The key is simplification. You can achieve most textures with just a few well-chosen brushes. The ones I describe here let me get practically any effect I want.

Flat Synthetic Brushes

Flat synthetic brushes, made from nylon or polyester, are the primary tools in my brush arsenal. (I use Winsor & Newton University brushes in sizes from ⅛" to 1½" wide.) These are the brushes I glaze with. You can also use them like a calligraphy pen, varying the line from wide to sharp within the same stroke by turning the brush from its broad, flat side to its edge. They're also great for blocking out areas

and for sculpting flat planes on objects. I use these flat synthetic brushes 75 to 80 percent of the time.

Round Synthetic Brushes

Whether pointed or blunt, round brushes have a distinctly different (rounder) characteristic stroke from flats. By applying varying degrees of pressure on a round brush, you can get a wide range of expression in your strokes.

Fine-Pointed Sable Brushes

I only use soft, fine-pointed sables like 000 and 0000 for details—small, out-of-place hairs, long individual whiskers, or the hairs found in some animals' ears. I use these small sables about 5 percent of the time.

Flat Bristle (Hog Hair) Brushes

These brushes are the same shape as synthetic flats but use a coarser, stiffer, natural hair bristle. Flat bristle brushes are generally used for "full-bodied" paints, but I use them as well for texturing. These coarse brushes are among the best brushes for depicting fur, and get even better with age. I use a frayed, worn-out brush (see photo) 20 to 25 percent of the time, and when I'm painting fur I use them almost exclusively (page 106).

Filbert Bristle Brushes

Resembling a flat brush trimmed in an arc shape, filberts behave like a cross between a flat and a round.

Cleaning Brushes

If you want your brushes to last for more than a couple of paintings, it's important to clean them after each day of painting. Give them a basic rinse with mineral spirits, odorless turpentine, or gum turpentine. Wipe the excess thick paint onto

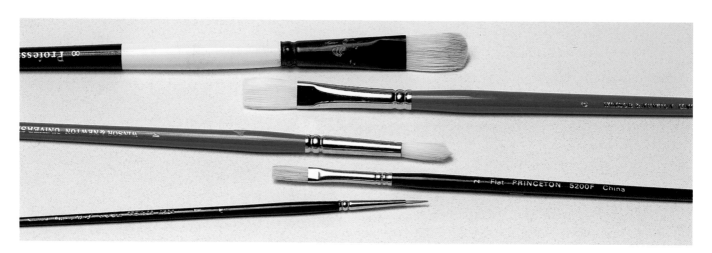

Brushes

From top to bottom: filbert bristle, flat synthetic, round synthetic, flat bristle, fine-pointed brush.

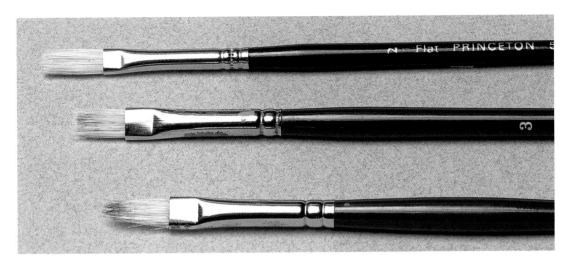

Frayed Brushes

Old bristle brushes are great for painting fur. From top to bottom: new bristle brush, partially frayed brush, very used brush.

rags or paper towels. Then thoroughly clean them with soap and water until no color bleeds from the brush when rinsed. Depending on how gentle you are with your brushes, daily cleaning can make them last months or even years longer. You should also be wiping excess paint off your brush with a rag or paper towel, while painting, in between brush strokes. Keeping the brush relatively clean will help to keep your colors pure and bright.

PALETTES

Good palettes are made of disposable paper, glass, or wood. Glass cleans up easily and works well in the studio, but can be heavy and bulky to carry and may break. Wood can be harder to keep clean, but some people swear by it and these work well when used in French easels and pochade boxes. The disposable paper palette is light and convenient, but the ones that are sealed on only two sides can be inappropriate for use outdoors, where the wind can blow the pages around. On the other hand, the disposable palette is great for museum trips, since the page can be folded back on itself to protect the paint when you're done.

You should also have palette cups—small cups that either clip onto the palette or stand on their own. These hold the mediums and solvents for easy access while painting.

When I use a glass or wood palette, I find it's better to clean or scrape the paint off while it's still wet rather than try to chip off rock-hard paint later.

PALETTE KNIFE

Palette knives come in various shapes and sizes. I use themt for mixing colors and applying paint in ways that can't be done with brushes. For example, paint can be scraped onto the painting with just the edge of the knife to create fine sharp lines (see page 87 on painting grass).

MAULSTICK

This long dowel-like stick, with felt or other cushioning material on one end, is used to stabilize your hand while you're working on a wet painting. It's very useful for detail work. The soft end is placed on the edge of the painting or on a dry area and your hand rests on its long side.

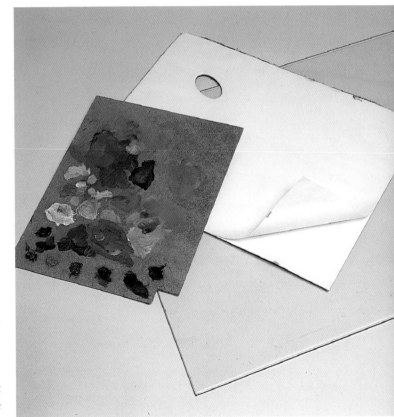

Palettes

Wood, Paper, and Glass

Watercolor Materials

Although I generally work in oil, sometimes watercolor offers me a refreshing change of pace. By its nature, it lets you do things you can't do with oil. It is especially suited for certain subjects, doing studies, and for working on location. (We will look at the on-location materials in more depth in Chapter Three.)

PAINTS

Watercolor paints come in either tube form or pan form. Paint in tubes has a consistency similar to that of oil paints. Pan watercolors are small cakes of dried paint. Water is added to these pans to liquefy the colors. I prefer tube paints to pan paints because it's easier to get deep, rich colors without having to mix water with the dry paint for a long time.

PALETTE.

I like a big plastic palette with multiple compartments to hold the different colors. I use essentially the same color palette as I do for oil painting.

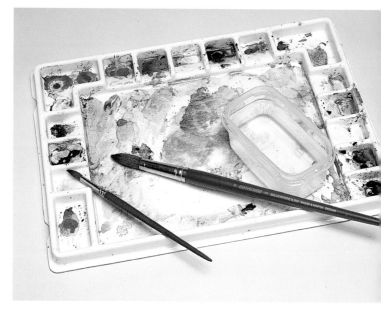

Palette

Here's the one I use. Choose what's right for you.

Watercolor Materials

Watercolor block, watercolor container with two compartments, art masking fluid, water bin, paper towel, brushes, and paints. The palette is shown above.

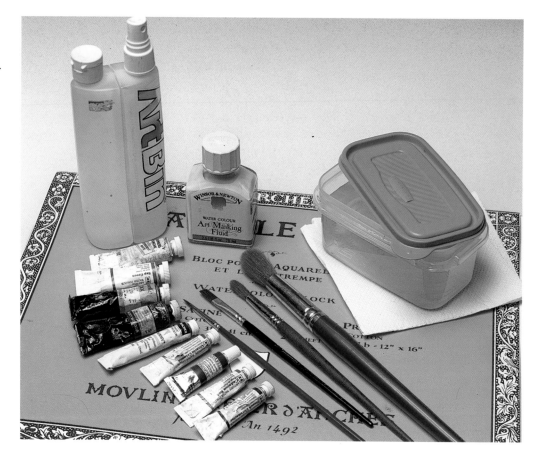

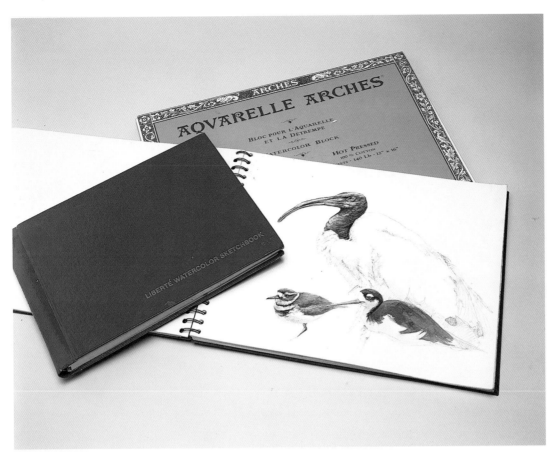

BRUSHES

I have a range of sables, synthetics, rounds, and flats—from small (000) pointed brushes for details to large (20) and even 1¼" flat brushes for large washy areas. I have no preference for types of brushes but use many kinds.

PAPER

Paper thickness is rated by weight—the thicker the paper, the heavier the weight, and the less it weighs, the less likely it is to buckle when wet. The most textured paper is called "rough"; paper with a slight tooth is called "cold press," and the smoothest paper is called "hot press." Some artists like the way rough paper holds the pigment in the valleys of the paper, others like the look of a totally flat paper. I suggest you experiment with all kinds of paper to see what can be achieved.

Support for Paper

If you paint on an individual piece of paper, you'll need to fasten it down so that it won't buckle when wet. Rigid wooden boards are excellent for this. Cut or rip the paper to a size smaller than the board, soak the paper for about half an hour until it expands, then tape it to the board with brown packing tape. (Note: You have to add water to the tape to get it to stick.) You can also staple the paper to a thick foamcore board.

Sketchbooks

Watercolor sketchbooks come in different sizes and types of paper. For field work, get something portable such as small sketchbooks made from watercolor paper, sheets of watercolor paper taped or stapled to a board, or a watercolor block (a pad of watercolor paper sealed with adhesive on all sides so the top sheet can be painted, then peeled off when through, exposing the next clean sheet). You may also want to take along a spiral-bound or hardbound book to record notes and ideas.

Water Containers and Other Necessities

Keep at least two reservoirs of water at hand while you paint, one for mixing with your colors and for cleaning brushes, and the other to replenish the first one with clean water when it gets dirty. You can use old yogurt cups or other containers, or buy cups at the art materials store.

There are a few other items that you'll need. **Masking fluid** is used for blocking out areas to be protected from broad, loose washes. **Paper towels** are good for clean up and blotting areas of the painting. I sometimes use a **sponge** for texturing.

DRAWING OR PAINTING ON LOCATION

RAWING OR PAINTING in the field can be one of the most difficult, yet rewarding, experiences you can have. The changing light, as well as adverse weather conditions, such as fluctuating temperatures, rain, and wind, can make for some uncomfortable drawing and painting situations. So why not just take a photo?

If you want to master the art of drawing, you *must* draw from three-dimensional subjects. Drawing from photographs is wonderful fun and can produce some great results, but there's no substitute for drawing from life (or even from museum mounts) for training your eye with solid forms. The fact that we have stereo vision allows us to bring a sense of solidity to our art, but it's sure hard to achieve if your reference is two-dimensional.

If you have never drawn living animals before, don't be hard on yourself when you see the result. It's not easy. And don't expect to get the same quality drawing you get from copying photos. Drawing from life can be disappointing and frustrating. Expect a lot of throwaways. Only a few "gems" will emerge from a day of doing many, many drawings, and that's okay. It's far more important to train the eye than to get immediate and finished results. Remember, you're aiming for the *character* of the animal, the qualities that make that animal different from the others, not accuracy. Accuracy comes with practice—lots of practice.

Just as drawing an animal from life instills a better sense of the animal's character, painting from the real scene generates colors and emotions you can never imagine in the studio. We've probably all come upon a breathtaking or emotionally moving scene, taken a photo or slide to capture it for future reference, only to find when our pictures are developed that the scene has lost its intrigue, sometimes to such an extent that you can't recall what was so special about that moment. That's because the wondrous qualities of a scene lie as much in the experience and emotion of the moment as in its visual beauty. That's why we have to paint it right then and there, even if it's only a quick color sketch or miniature study.

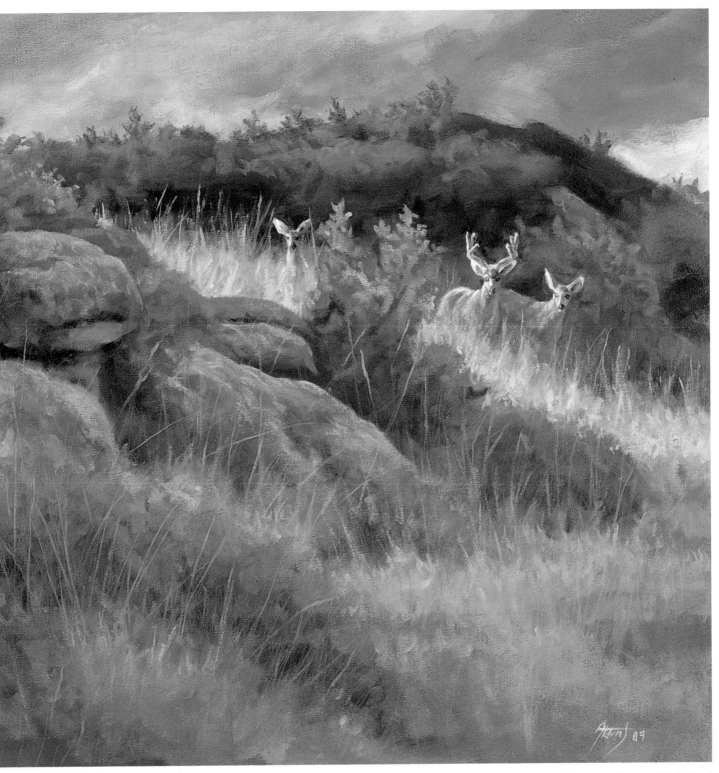

TURNING POINT *(Mule Deer)*
Oil on canvas, 24 x 32" (61 x 81 cm), 1989.

The Basic Setup

When I'm working away from my studio, I take one of two basic setups along. For a prolonged painting (a painting generally taking more than one visit to a particular site), I bring a fanny pack to hold my drawing and/or painting supplies and a foldable stool with pockets. I paint on location almost the same way I paint in my studio, except my posture is worse because I generally paint on my lap. I've gotten quite used to this arrangement and now prefer it. These paintings end up looking quite a bit like ones done in the studio—they have quite a bit of detail and refinement. But for my alla prima work (paintings finished in one session), I use a French easel or pochade box instead so I can stand back from the painting from time to time.

If you plan to work on location, you'll need a foldable drawing easel (if you like to draw on a vertical surface), a foldable stool with pockets, a fanny pack to hold your supplies, and a spotting scope or binoculars.

FRENCH EASEL

When I am working outdoors on a large alla prima painting I use a French easel (a combination paint box and easel) that opens to hold a large canvas or board and can carry as many oils, brushes, and accessories that are needed to complete a painting. French easels adjust to sitting or standing positions (as well as to uneven terrain) but I like to stand so that I can easily step back to view the work in progress. Although designed to be portable, French easels are rather bulky and heavy, so you won't want to carry one great distances. When ultimate portability is required, I use a smaller paint box.

POCHADE BOX

This smaller paint box holds a basic palette of oils and a basic range of brushes. It also has three 9 x 12" slotted spaces for wet oil paintings so they can be kept separate without smudging. The box fits in a large fanny pack or small backpack, so it's perfect for hiking trips.

FANNY PACK

Whether you need to carry a basic set of oils or watercolors, brushes, rags and the like, or just bring drawing materials, one of the easiest ways to transport these items is in a fanny pack. The only things it won't hold are your palette and the painting. But it does leave your hands free to carry your wet painting in one hand and the palette and stool in your other hand.

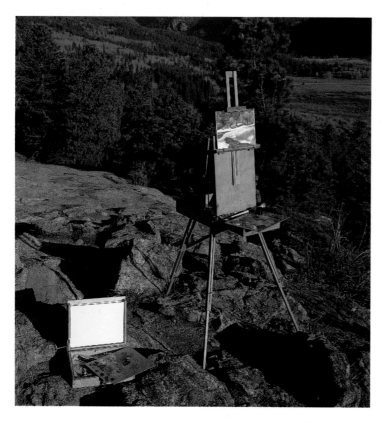

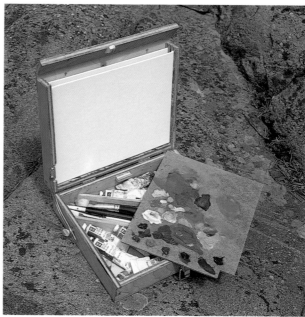

Essential Equipment for Painting on Location

French easel and pochade box (close-up).

FOLDABLE STOOL

I like to paint on my lap, so I bring a portable stool to zoos, museums, or outdoor spots where there are no rocks or downed trees to sit on. Of the many varieties available, I prefer the kind with pockets, so that drawing and other materials can be kept right in the stool.

OIL PAINTING GEAR

When I'm working in oils on location I take my standard set of colors (as discussed in Chapter One, page 15), flat and filbert bristle brushes ranging from 14" to 1½" wide (bristle or hog hair brushes hold thicker paint better than synthetic brushes), a disposable paper or wood palette, turpentine and rags or paper towels, and the prepared board I'm painting on. (For outdoor sketches, I find that a textured support, such as canvas or unsanded, gessoed board, is best for gripping the paint and creating soft edges.)

PORTABLE WATERCOLOR SETS.

For painting in watercolor on location, you can choose between two types of portable paint sets: the small set of pan colors (small cakes of dried watercolor paints) and the larger number of items required for tube watercolors. While tube watercolors are obviously bulkier, they are more instantly available to the brush. Artists who want ultimate portability and like everything—palette, pigments, water, and water cups—in one place prefer the small set of pan watercolors.

Fanny Pack and Stools

Shown here are a fanny pack and two different kinds of foldable stools with pockets (one with three legs, the other with four legs).

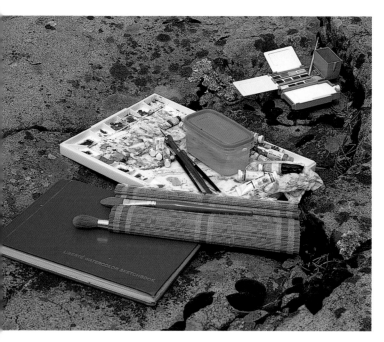

Portable Watercolor Sets

Pictured here are small and more elaborate setups.

PLEIN AIR STUDIES

We can learn a lot from plein air painters. Their best paintings have a freshness and life few studio paintings can capture. A "plein air" painting can mean anything from a quick study to more elaborate work done outdoors. Quick outdoor field studies can be very beneficial. Besides producing some wonderful images, making small one or two-hour oil studies can loosen up the normally meticulous realist painter, access the true colors of nature, and put you in touch with your feelings. The first-hand experience of painting natural surroundings is also an invaluable reference for replicating accurate painting effects in the studio. Working from nature forces you to see the landscape as a whole and omit those little details you simply can't observe at a distance.

Blocking in the basic colors and forms in the landscape also helps teach you how to create solid forms and masses. I made the field studies you see here either on my French easel or in my pochade box.

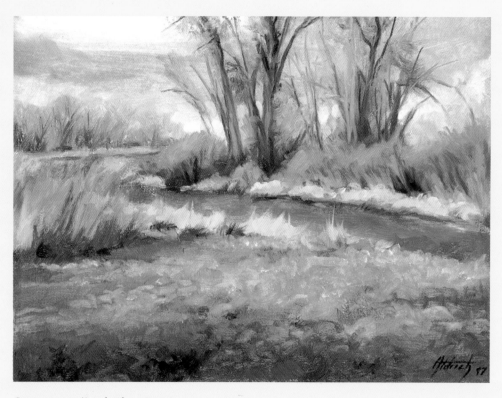

OUTDOORS *(South Platte River)*
Oil on canvas board, 9 x 12" (23 x 30.5 cm), 1997.

This painting provides the feel and impression of late afternoon lighting and color. A photo could never have captured it, because it's an artist's interpretation, which is what painting is all about. I finished it in about an hour and a half, just as the sun was starting to set. It was designed as a landscape study, not an animal painting. Paintings like this can stand on their own or act as references for future paintings.

Practical Advice

Whether you draw or paint in a museum, at the zoo, or in the field, and whether you are capturing a simple glimpse of inspiration or creating a full outdoor painting, there are some practical matters to consider.

Drawing and painting animals and their environments from life can be daunting when you are first starting out. Moving animals, the general public, and adverse weather conditions can all be causes for distraction and frustration that artists who generally work in the warm comfort of their studios are not prepared for. For those who feel they need a little direction or practical advice before they jump into this way of working, what follows are some pointers from my on-location experiences.

The most important thing for you to do is just get out there and draw and paint—as often as you can. The more you do this the better you will get.

When you're searching for a subject, look for a background scene that grabs you rather than painting the obvious, classical outdoor scene you think others want to buy. For example, I love rocks—their colors, textures, shapes, and solidity. So in the field I look for interesting rock formations and can frequently be found sitting in the midst of a beautiful landscape of mountains and lakes painting a particularly interesting (to me) glacial boulder. So if you're intrigued by the way the light comes through the trees, or by the subtle hues in snow, or by barren, lonely, open fields—great! Paint the subject that excites *you!*

Unless I'm planning to do just a quick study, before I bring my paints to the location, I visit the spot once or twice. Initially I scout out a paintable subject and make a finished drawing of it and possibly a compositional sketch. At this point I bring only my drawing materials. When the drawing is complete, I determine the size of the painting and cut the board. Then, as I handle any studio painting, I transfer the drawing to the board and tone it.

WORKING AT A ZOO OR IN A MUSEUM

Zoos and museums are usually very accommodating and welcome artists wholeheartedly. But before you walk in with a huge setup complete with easel and canvas, check with the office. On the other hand, if you're just one person drawing on a stool in front of a cage or a museum display, it rarely presents a problem. In the museum, I work on my lap rather than at an easel because I don't want the throngs of little children who frequent the museum to accidentally bump my easel, and also because I don't want to take up a lot of space in front of a diorama.

WORKING OUTDOORS

When you work outdoors, especially in the field, you'll need the right clothing, particularly a broad-brimmed hat to keep your eyes, face, and the back of your neck in shade, as well as basic hiking items, such as sturdy shoes and rain gear for unexpected storms. You should also have along drinking water, snacks, sunscreen, and mosquito repellent—commonsense items for comfort that are really no different from what you would pack to prepare for any hike or prolonged outdoor experience. For working in the wild, a spotting scope or binoculars are very useful. You should also have a map if there is any chance you could lose your way.

Avoid Direct Sunlight

When you draw, stay in the shade, or at least make sure your drawing is in shade. Direct sunlight has a tremendous glare and is pretty hard on the eyes. Sunlight can also bleach out color, making it impossible to judge your colors and values properly. As a result, compensating for this harsh sunlight, you may make your colors too dark or too bright without realizing it. Even if your work is in the shade, the sun may be in your eyes. So take along that wide brimmed hat—anything from a baseball cap to a large straw hat will work—to keep the sun out of your eyes.

Coping with Cold and Wet Conditions

In the winter, if you expect to be spending hours working in low temperatures, you may want to include special gloves for painting. I've found that a thin but warm cotton glove covered by a thicker fingerless wool glove provides warmth while still leaving dexterity in my hands. Of course, you'll also have to dress warmly enough, too. Be sure to wear heavy boots, with several layers of socks—and if there's snow on the ground or if it's recently rained and the soil is wet, make sure they're waterproof. Nothing can make you more miserable or be more distracting than wet or cold feet.

That's advice for times when the weather is dry, but the ground is wet. When it's raining, or even snowing heavily, I avoid painting outdoors altogether. The moisture can do unfavorable things on the palette and be equally as annoying on the painting itself. If I start a painting and it starts to rain, I pack up and wait until it stops. Or if I'm painting close to the road, I continue to paint in my car. Generally

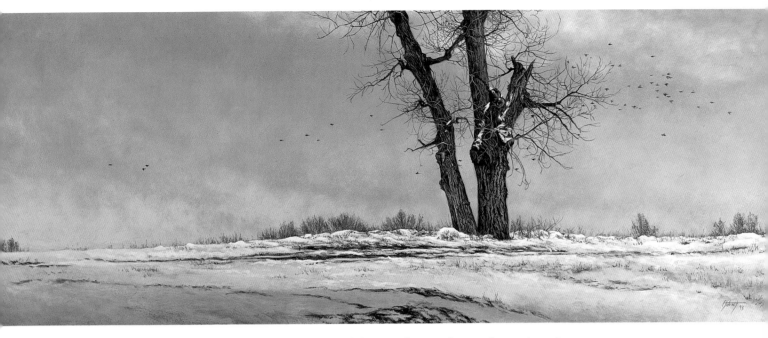

FROSTY MORNING *(Blackbirds)*
Oil on Masonite, 14 x 37" (36 x 94 cm), 1993.

I came upon this scene while on a walk not too far away from my house. I was overcome by a feeling of stillness and starkness, intensified by the many subtle tones of white, gray, blue, and brown. I just had to paint it.

speaking, if it's cold enough to snow, it's too cold to stand in one place for a couple of hours to do a painting anyway. But then again, I may not be as hardy as you.

Sketching from Your Car

Sketching in your vehicle can be a lifesaver in bad weather. If you get close enough to an animal in a car and it's bitter cold or drizzling or if you think you'll scare the animal away if you open the door and get out, you may want to draw right from the relative comfort of your car. This is a perfectly sound way of working and can allow you to get drawings that would have been impossible to get any other way.

DEALING WITH THE PUBLIC

While painting at the zoo, at the museum, on a trail, or in any public location, you must be prepared to meet the public. People love to watch an artist in action, so expect to have them stop and watch you draw, ask questions, or make comments about your work. Most comments are brief and trivial, but some people may want to engage you in fuller conversations. How do you handle this?

One way is to develop patience and a thick skin. Another way to avoid conversations while you're working is to look for an out-of-the-way spot. Still another is to keep your responses down to a smile or a nod when asked questions. This semiresponse generally dissuades people from continuing to bother an artist who is so obviously in great concentration. When you work in high-traffic areas, however, where there's more contact with people, anything can happen. Be prepared for even more observers and potential conversations, and be careful to keep your supplies near you so no one trips over them.

Some people are by nature more awkward around people than others. A gregarious artist, however, can hold a conversation and still continue to paint—again, this comes with experience. The more you paint in high-profile areas, the more you'll become accustomed to it. Then, too, it's easy to be happy and talkative when your painting is coming out well, but when you're frustrated and ashamed of your work, it can be very annoying to have people come around and gawk. A situation like this requires tact and the ability to mentally shut people out, not rudely, but just by focusing more on your work and blanking out your surroundings. After years of painting in public places, I really don't mind having people around and usually welcome their compliments. It can even be ego boosting.

Finding a Good Subject

So where do you find a good subject? The answer is "almost anywhere." Different qualities are compelling in all subjects. Some may be drawn to the power and grace of big cats in the zoo, while others may be excited by the simplicity of birds in the park or on a museum mount. One artist may want to paint horses, while yet another may prefer to capture the essence of a wild red fox near its den. The interests of wildlife artists are as diverse as the number of animal species. So go where your heart pulls you and your passion for these animals will show in your art.

You'll find animals to draw in parks, farms, in the country or mountains, on trails, in open space, sometimes eating the flowers (or unsealed garbage) in your own backyard. So keep a small sketchbook and pencil with you at all times, especially when you plan to visit a place where you're sure to find animals, such as a farm or wildlife refuge. If you don't want to leave it to chance and really want to draw an animal, there's always the museum and the zoo. There, at least, you're sure to find what you're looking for.

IN THE WILD

For many of us, sketching in the field is one of the most rewarding forms of artistic expression. On location, working with the creatures we admire so much we want to immortalize them on paper, the experience of being in the real habitat of the animals you're drawing is unparalleled. On location you get the feelings, smells, sounds, and the whole experience of being in the place the animals call home. These elements eventually find their way into your art, subconsciously or otherwise.

Even early on, I was amazed to learn how much wildlife is around us if only we'd stop and look. Once, after painting about half an hour in a spot I'd been to many times before, I noticed some movement out of the corner of my eye. A large, beautiful mule deer buck had bedded down less than forty yards from me and was just sitting there. The movement I noticed was his antlers as he scratched himself. I stopped painting and just watched him for a while. There was ample time for me to draw him—only I hadn't brought

SEAGULLS
Graphite on Strathmore sketch pad,
14 x 17" (35.5 x 43 cm).

Seagulls are generally good models because they let people come relatively close to them and remain fairly still. This is a typical page of seagulls done on a pier by the ocean. As you can see, there are starts of drawings as well as more refined sketches here.

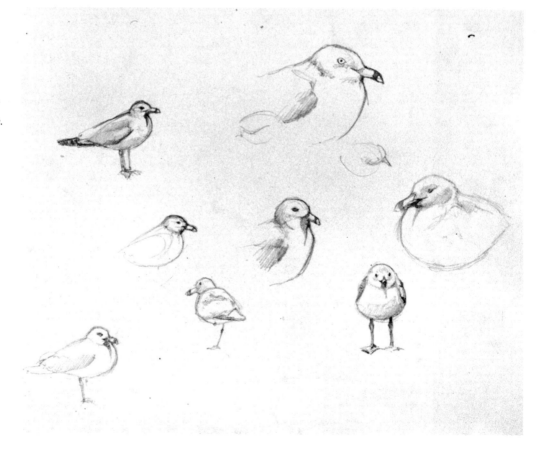

a sketchbook. Since then I've learned my lesson and now always take along a sketchbook on all my hikes and outings.

Working in the field is a trickier form of reference gathering, with many variables you won't get in other, more predictable places. So don't expect to get the same quality drawings. But if you give it a chance and become familiar with a particular habitat or with specific animals over repeated visits, you'll come away with references you couldn't get any other way. These are drawings of the *experience* of being there and no camera can reproduce that.

In the wild, the obvious choice of subject is an animal close enough to draw. But unlike the zoo or museum, the field is a very unpredictable place, and it's often impossible to get close to wildlife there, even if you find it. This raises some basic and practical issues. The answers that follow should help in your successful gathering of drawings.

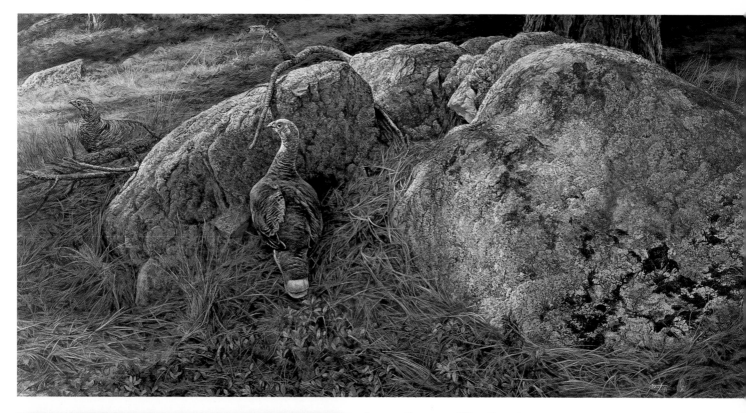

INDIAN SUMMER *(Blue Grouse)*
Oil on Masonite, 22 x 44" (56 x 112 cm), 1991.

This painting of mine exemplifies the benefits of painting outdoors. The entire painting, except the grouse, was executed on location—I made over twenty visits to the same spot in the woods early in the fall of 1991. Each visit lasted about three hours, and the lighting was constantly on the move. To handle this situation, I freeze-framed the elements I wanted. For example, if the sunlight was hitting a particular part of the rock I wanted lit up, I worked on it at that moment. When it moved, I worked on a different part of the painting. Even before I started painting, I made numerous thumbnail sketches, finished drawings, and even watercolor sketches to plan the lighting and focus (see page 52). The actual painting was sometimes exciting, sometimes frustrating, and sometimes boring—I experienced a whole range of emotions in painting this piece. That's why it captures the soul of the place.

I took this slide long after the scene was painted so you could see what the actual scene looked like. But you'll have to imagine how it felt to paint the constantly changing dappled sunlight moving through the forest canopy.

Basic Tracking Procedures

Remember to practice good, basic tracking procedures in the field. Keep downwind of your subject, make as little noise as possible while moving through the brush, and be prepared to sit patiently and wait for the animals to come to you. A pair of binoculars or a good spotting scope on a tripod or car door mount can help you see animals too far away to be observed without aid. A spotting scope may take some getting used to, but it's possible to do complete drawings with it.

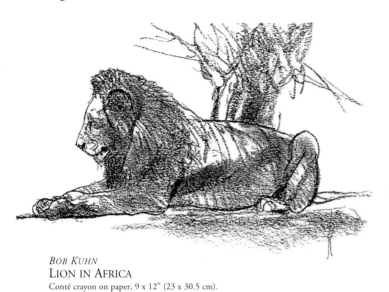

BOB KUHN
LION IN AFRICA
Conté crayon on paper, 9 x 12" (23 x 30.5 cm).

This sketch, done on location in Africa, shows a lion resting in the shade of a tree. With just a few well-placed lines and broad, gentle shading strokes, Kuhn has created great reference material as well as a great drawing.

This is a slide taken where I painted Least Chipmunk. *It's interesting to compare the actual scene with the way I translated it into a painting.*

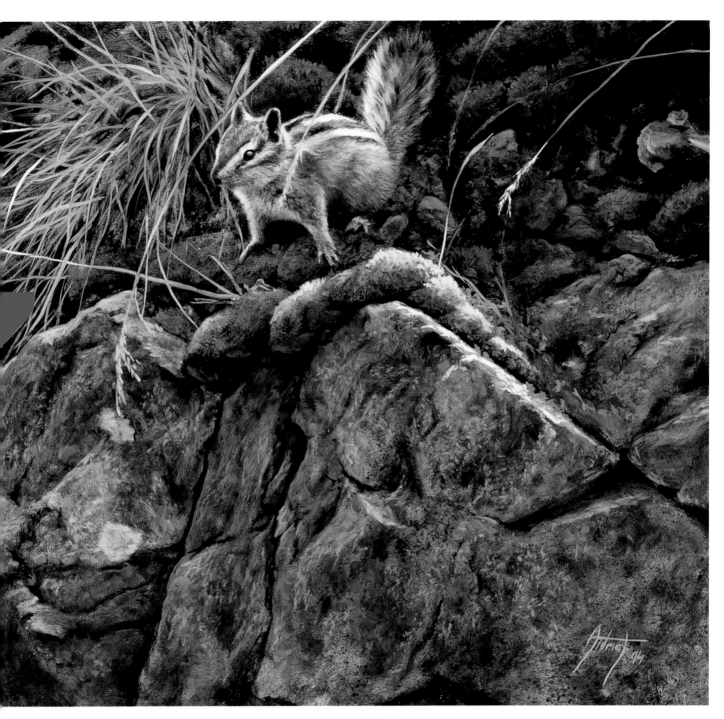

LEAST CHIPMUNK
Oil on Masonite, 12 x 20"
(30.5 x 51 cm), 1994.

This piece was painted completely outdoors. I set up my French easel next to a rocky embankment beside a path and finished it over the course of two years. I actually put this painting away half-finished for a couple of years because I had lost the spark. But I kept looking at it in my studio and, after a while, I knew I just had to finish it. So I returned to the same spot two years later to do just that. I had to decide what animal I wanted to put in it and at first thought of a bird of some sort, and I tossed around a few ideas. Then, one day, while painting this scene, a chipmunk scurried through the area I was painting. I took the hint and made it the subject of my painting. The lighting shown here lasted only five or ten minutes, which meant I had to keep returning at a particular time to put in the final highlights.

AT THE ZOO

Although I always encourage artists to draw in the wild, where the animals live, that's not always feasible, especially if you want to draw exotic species or get close to your subject. This is where zoos come in handy. Zoos are great resources for the animal artist. They're filled with the very thing we like to draw, and the animals are much more accessible than those in the wild—they're confined and you can generally count on them being there! You can also observe a large variety of species in a single drawing session.

At the zoo, choose an animal at rest or one with a predictable repetitious pattern, such as a bird that keeps returning to a particular branch or a tiger repeatedly looking in one direction. It's easier to capture the image where there's a pattern, since you can count on the animal returning to position again and again.

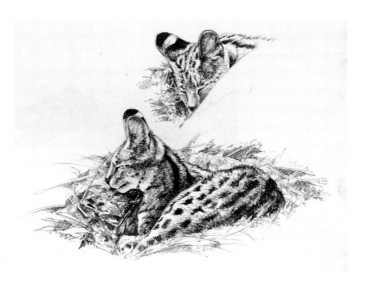

SERVAL
Graphite on Strathmore drawing pad, 14 x 17" (35.5 x 43 cm).

The serval is generally an alert, active cat, but on this occasion he was dozing right next to the glass, providing me with a great opportunity to capture him up close on paper. I started with his head and worked down. Not knowing how long he was going to stay, I worked quickly, indicating broad areas with basic shapes. When I was done, I added the details in the face, and put in the texturing of the fur and spots. As he continued to remain still and I was satisfied with my drawing, I began to work on his "nest."

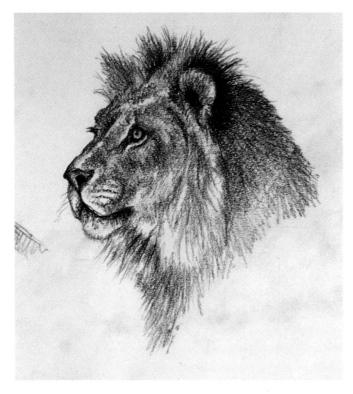

LION PORTRAIT
Graphite on Strathmore drawing pad, 7 x 8" (18 x 20 cm).

This was drawn at the inside enclosure of the Denver Zoo. The lion was intent on something behind and to the left of me for a long time, providing me with the opportunity to do a somewhat finished piece. Even when he moved around, he inevitably came back to look at whatever caught his interest. Each time he returned, I continued the drawing. When I do a portrait, I generally start with the eyes and work outward, slowly watching the face emerge. Sometimes I have time to finish the whole face, but more often I'm left with nothing but a pair of eyes as I watch the animal stroll to the opposite end of the enclosure.

TIM PRUTZER
DREAMING LYNX
Block graphite on Stonehenge paper, 11 x 15" (28 x 38 cm).

This is a classic "Tim Prutzer drawing" showing gesture, form, and line quality. This lynx has wonderful, expressive lines and a great gestural quality. The drawing is fluid and stylized—meaning unique to the artist that drew it, an individual artistic expression, different in style from the work of other artists. "Stylized" also refers to an abstracted quality— extracting the essence of the animal in an unusual linear way.

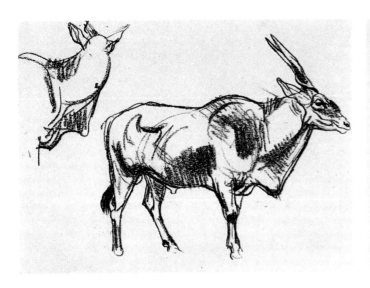

BOB KUHN
ELAND
Conté crayon on paper, 9 x 12" (23 x 30.5 cm).

Bob Kuhn is a master of creating the structure, basic tones, and character of an animal in a minimum of strokes without overworking the drawing. His vast experience, gained from many, many hours of drawing, is evident in his line quality, accuracy, and the emotion he instills into his drawings. Kuhn also has the remarkable ability to capture the essence and likeness of the live animal in his drawings. Notice that the more finished drawing here is accented by a quick indication of the eland turning its head away. This is typical. Animal artists are always trying to capture a fleeting glimpse of some disappearing animal.

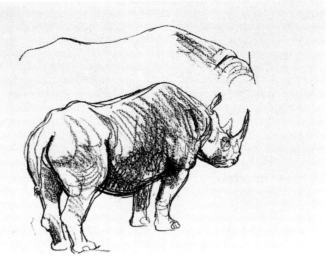

BOB KUHN
RHINOCEROS
Conté crayon on paper, 9 x 12" (23 x 30.5).

This is a zoo drawing that contains both the start of a drawing and a more finished drawing, as frequently occurs when an animal moves after you've started to draw. When that happens, you have to be willing to abandon the drawing and start a new one. Notice the simple yet accurate lines that make up the structure of the animal, especially the face.

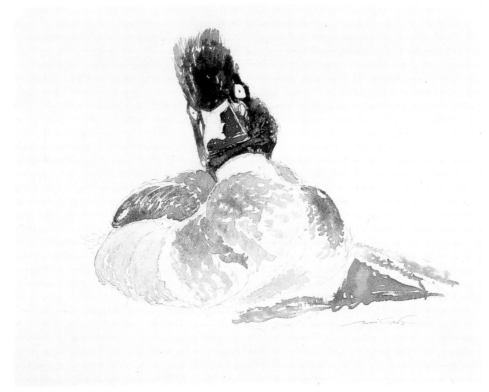

TIM PRUTZER
COMMON GOLDENEYE
Watercolor on 300-lb. hot press Lanaquarelle, 11 x 15" (28 x 38 cm), 1994.

This is really a gesture painting. Working on location at the zoo in a single sitting, this painting has quite a bit of character, and even a little humor. Prutzer has captured the duck in a startled pose—the look of surprise is very evident. Prutzer paints at the zoo for both the study of the animal and hopefully for the outcome of a painting that stands on its own merit. But the zoo is a tricky place to paint, since there's a good chance the subject will move from the position in the initial sketch that inspired the artist, so it takes a lot of patience and great ability to piece together the painting from later glimpses of the animal in similar positions.

DRAWING DOMESTIC ANIMALS

Consider nearby places, such as local farms, petting zoos, stock shows, stables, and even the homes of people who own animals. Domestic animals range from simple house pets to horses, cows, sheep, chickens, and even llamas. Because these animals are generally confined and relatively docile, they make great subjects.

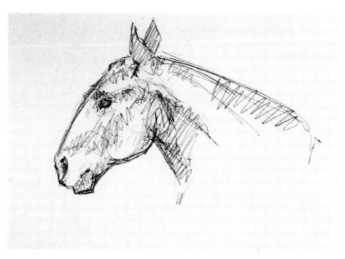

HORSE
Graphite on Strathmore drawing pad, 9 x 12" (23 x 30.5 cm).

I did this portrait purely to capture the character of a horse. Horses make great subjects to draw. Besides their beauty, they are relatively plentiful and easy subjects to find.

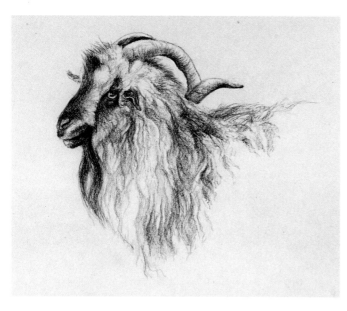

ANGORA GOAT
Graphite on Strathmore drawing pad, 12 x 18" (30.5 x 46 cm).

One great way to get an animal to stay still is to tether it to something. This Angora goat, tied to a heavy weight, was a great subject. I was able to do two drawings and subsequently paint watercolor over one of them in just a couple of hours at a local art show.

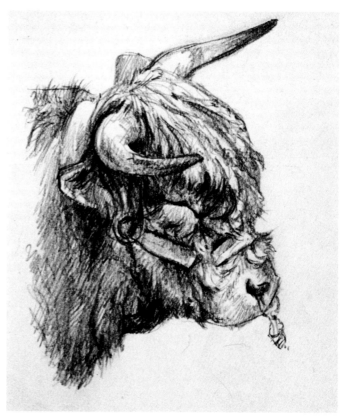

RABBIT
Graphite in sketchbook, 9 x 12" (23 x 30.5 cm).

Standing near this rabbit's cage at the Denver stock show before he was fed, I drew this rabbit in about 15 minutes. This was a difficult venue, since the masses of people shuffling through the area can be both confining and distracting. Nonetheless, a stock show can provide some great species not normally seen.

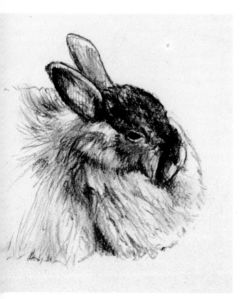

SCOTTISH HIGHLAND STEER
Graphite in sketchbook, 9 x 12" (23 x 30.5 cm).

This is another stock show drawing, this time of a Scottish Highland steer. It was a docile creature. It moved its head quite a bit, though slowly, but I was able to move with it, even though I had to maneuver about quite a bit.

Drawing Your Pet

You don't need to go far for inspiration. Most of us live with animals of all varieties and quite often we know their patterns and subtle nuances very well. This should make it easier to capture their innate qualities, and therefore a good way to start. Cats, dogs, ferrets, lizards, fish, and the many varieties of housebound birds are just smaller versions of their wild counterparts. The structure of a short-haired cat is almost identical to that of a leopard, tiger, lion, or other big cat. The anatomy of some dogs is the same as wolves or foxes. Hamsters behave like squirrels, mice, and other rodents. You can learn a lot by studying and drawing our tame animal friends.

Drawing a pet is an especially valuable experience if you're a beginner. You may find it intimidating and frustrating to draw at a zoo with people looking over your shoulder and perhaps disturbing you with their questions or chatter. Working from life in the privacy of your own home, you can see similarities between your pets and their wild counterparts. So if you can draw your own animal or bird, or borrow one from a neighbor or friend, you'll find drawing domestic animals a good way to get used to the structure and the feel of drawing from a live subject. After a while, when you feel more comfortable with your abilities, you may want to venture out to a more public place.

Notice in particular the different kinds of dogs and cats. You'll see a range of fur length from short to long and a myriad of hair colors. Your dog is great for studying the different colors and textures of fur, the play of light on different lengths of fur, and the way fur sits on a form—from straight to wavy, prickly to soft, velvety smooth to bristly. Yes, pets can teach the animal artist quite a bit.

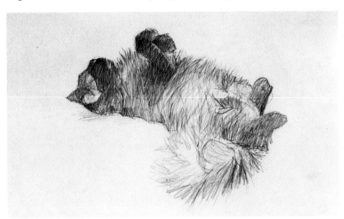

DRAWING OF A CAT
Graphite on Strathmore drawing pad, 14 x 17" (35.5 x 43 cm).

I was able to capture one of my cats in this drawing while he was sleeping. He has the most remarkable ability to sleep in the oddest positions, which he generally holds long enough for me to draw him.

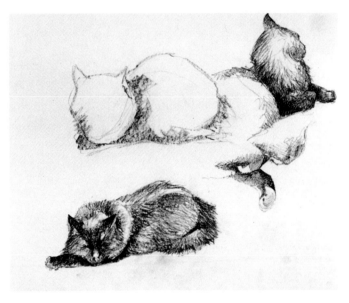

MULTIPLE DRAWINGS OF MY CAT
Graphite on Strathmore drawing pad, 14 x 17" (35.5 x 43 cm).

Here I drew my cat in many different positions. You can tell when it moved by the level of refinement of the drawing. It's disappointing when your subject moves right after you start drawing, but it's just part of the process. With enough persistence, you'll eventually end up with at least one finished-looking drawing, like the one at the bottom of the page.

BOB KUHN
ITALIAN GREYHOUND
Conté crayon on paper, 9 x 12" (23 x 31 cm).

This is a wonderful Conté drawing of a friend's pet. The Italian greyhound is a wonderful species to draw because you can see the musculature beneath its thin, short hair. Kuhn's confident, bold strokes reveal the character of the dog.

AT THE MUSEUM

To supplement my zoo drawings, especially during the winter, I have found that the natural history museum can be one of the best resources available to the animal artist. The opportunity to draw and paint animals that sit still can be unparalleled for training you to see and capture textures and subtle colors. Working from the actual three-dimensional subject offers subtleties a camera can never reproduce: the way colors are picked up in shadows, the interplay of cool and warm colors, and most important, the solidity of the subject. That's why my first choice of a reference is something solidly in front of me, be it a live animal, a taxidermy subject, items brought into my studio, or a landscape.

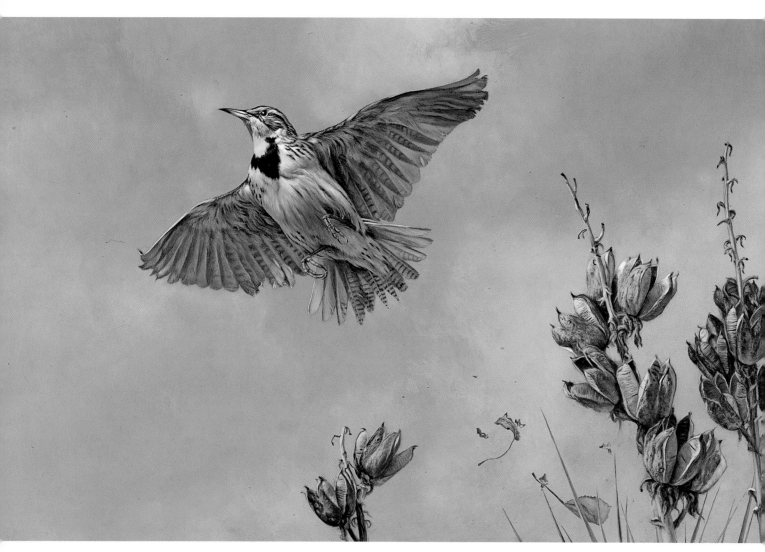

MEADOWLARK MORNING
Oil on Masonite, 18 x 28"
(46 x 71 cm), 1995.

This is one of my more exciting museum paintings. I luckily found this bird in a diorama in the Denver Museum of Natural History before it was moved to another location. It was so well mounted that the real character of the bird was conveyed. The great advantage of working from taxidermy is that you can get close enough to an animal to capture its subtle nuances of color and texture (and the fact that it doesn't move is an additional plus). I found myself getting lost in the layering of its feathers and the way the colors changed as they encircled the form of its body. I also got excited when I saw the rich colors and transparency of its feathers. As I explored the bird, I kept adding more and more detail. I had to capture all the subtleties and couldn't stop until I did! I wanted the colors in the sky—yellows and grays—to be in the bird, and have the yellows in the background create a kind of explosion from the ground, which often happens when birds take flight. I added the yucca seed pods into the foreground later, usingpods gathered from a nearby field for reference.

Mounted Specimens

Mounted specimens, when they're done well, can provide you with incomparable views of an animal. And best of all, they don't move. Thus you can spend time working out the subtle nuances of the animal, like the specific curve of a beak or the way a paw firmly sits on the ground. You can also study the texture of the fur on an animal and note in what direction it lies on different parts of the body—all valuable information for future paintings. One reminder: Look for mounts that are accurate and appear to be almost alive, with no apparent anatomical flaws. Finding a good specimen is half the battle, because if you draw or paint an animal that looks like it was dragged from the attic of a haunted house, you can be quite sure your drawing or painting will look like that, too. When you find a suitable specimen, walk around it and check it out from every conceivable angle to find the most interesting view.

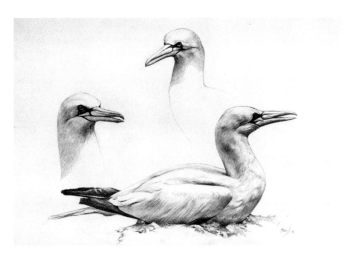

GANNETS
Graphite on Bristol board, 18 x 24" (46 x 61 cm).

Gannets are gorgeous white birds with black masks. I wanted to explore the subtle tones of white and see the way the light affects these tones, so I drew them one day in the Denver Museum of Natural History.

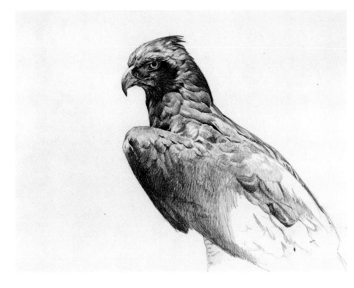

MARTIAL EAGLE
Pencil (2B to 6B) on plate Bristol board, 18 x 24" (46 x 61 cm).

Drawing from a stuffed specimen in the Denver Museum of Natural History gave me time to polish the drawing and emphasize the intensity in the eagle's face. I used a very soft (6B) pencil to increase the depth in the drawing.

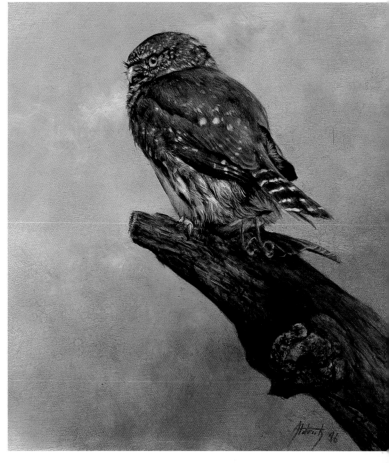

PYGMY OWL
Oil on Masonite, 9 x 10" (23 x 25 cm), 1996.

This little owl had such great character that, despite its size, it stood out among a whole exhibit of raptors. After walking around the mount, I found the most interesting view, set up my stool, and drew it. I made the painting lifesize—about the same size as the drawing. The painting was a good experiment in memory, since the bird was mounted rather high and I had to look up from the board on my lap to the bird and back without being able to see both bird and my painting together. This forced me to recall all the subtle nuances of the bird without mindlessly transcribing them to the board.

Working from Skeletons

As academic as it sounds, it's a good idea to begin drawing animals from the inside out—that is, starting with the skeleton of the animal. You don't have to make a career of it—you don't need to know the names of all the bones, for example—but drawing the skeleton will help you understand the movement and structure of the animal.

Any well-equipped natural history museum has animal skeletons. You'll probably have to ask to see them, though, since they're not always displayed. To understand the mus-culature and bone structure of different animals, look at animal anatomy books at your local library or bookstore (see Selected Bibliography). You can even take them with you when you go to the zoo or museum and compare the pictures with the animal. If you're serious about drawing and painting animals, you should own at least one. Many different animal species are shown in this book, and there are many books just on animal anatomy, so I won't go into detail here, but studying the skeleton and musculature is imperative to understanding animal movement.

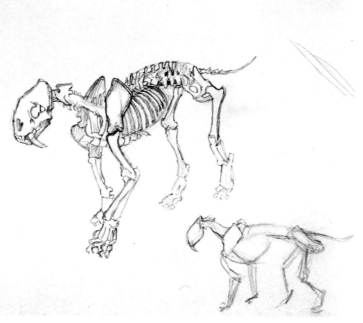

SKELETON OF SABER-TOOTHED TIGER
Graphite on Morilla sketch pad, 11 x 14" (28 x 35.5 cm).

Natural history museums generally have skeletons of extinct species that are similar to existing animals. Drawing a saber-toothed tiger skeleton helps me to understand the anatomy of the existing cat species. It's important to know where the bones lie so your paintings are anatomically correct.

TIM PRUTZER
SPIRIT OF THE LION *(Lion Skull and Portrait)*
Sanguine and black Conté on Gampi paper, 16 x 8" (40.5 x 20 cm).

Both these inner and outer views of a lion's head were drawn from life, though seen from slightly different angles. Having drawn the skull, Prutzer was able to understand the underlying structure of the African lion more fully. He could then incorporate this knowledge into his drawing of the planes and angles of the lion's face. Drawing the bone structure, then the live animal, truly benefits the artist in the long run.

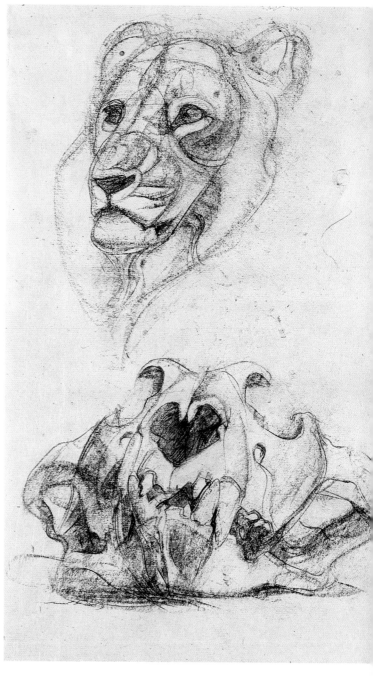

Structure

The skeleton sets up the animal for the musculature and the combination of the bones and muscles creates the underlying structure of the animal. Structure is a very important thing to know. Without the knowledge and application of the animal's underlying structure, a drawing seems flat, off, or appears as if something is wrong. It is easy to simply draw the fur or feathering of an animal, but to fully get it to look as if it is a solid and real creature, we must be conscious of the structure. It is what separates those drawings and paintings that are masterful from those that appear more amateurish.

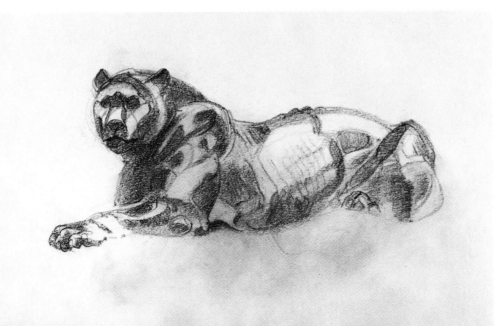

TIM PRUTZER
TUNDRA WOLF
Graphite on Stonehenge paper, 22 x 15" (56 x 38 cm).

Prutzer did this drawing to understand the structure of the wolf. Notice the way he applied the pencil—as repeated lines wrapping around the form—for texture as well as structure. Notice also how the forms are divided into geometric shapes and assigned separate planes for each section, like a two-dimensional sculpture.

TIM PRUTZER
MELANISTIC JAGUAR
Graphite on Stonehenge paper, 11 x 15" (28 x 38 cm).

In this zoo drawing, the form was developed through tone and interpreted in a constructional way. Using both masses and line, Prutzer stylistically defined the various planes and surfaces of this jaguar to show its structural makeup.

Working from Photographs

There are times when it's impossible to find a subject that stands still long enough to paint, and photos are not only handy, they're essential. The advent of photography has brought both advancements and drawbacks. The advancements are evident. In fact, most of the realism we see today would not have been possible without photography, and some spectacular images have emerged because of it.

But the drawbacks are both evident and hidden. The greatest drawback I can see is that photography makes us lazy. Photography has increasingly taken the artist out of the field and into the studio. And the most essential aspect of a painting, what makes a painting truly great—emotion—has a hard time showing when we're feeling lazy, comfortable, and sheltered. How can you accurately and honestly express

the experience of a cold, foggy morning unless you've experienced it firsthand? So, to get paintings with life, passion, and intrigue, you need to supplement your studio paintings from photos with paintings done in the field whenever possible. It will breathe life into your art that cannot be achieved any other way.

That said, I can safely say that photographs have inspired many of my paintings. Photos can capture the expression or look of an animal your eye might never notice. Photos can also capture moving animals with incredible detail. Getting a roll of film back from the developer is like Christmas for me. I can't wait to see what's on it.

Faithfully reproducing a photograph down to every detail can be boring and leaves no room for artistic creativity. So,

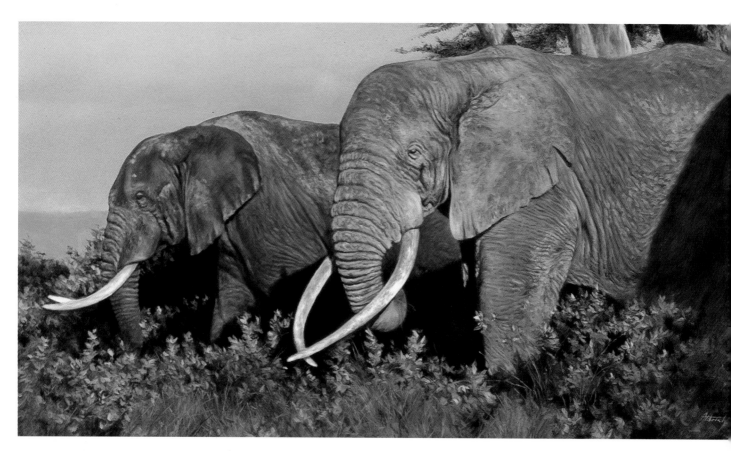

ELEPHANTS AT NGORONGORO
Oil on Masonite, 18 x 33" (46 x 84 cm), 1996.

This was inspired by a trip I took to Tanzania. These are two of the elephants we were fortunate enough to watch for some time. That kind of experience is always beyond words, so I wanted to try to re-create the feeling through a painting. I tried to capture the size and texture of these great beasts with close cropping and selective lighting effects.

when you're painting from a photo, look for ways to make it your own expression—introduce new and interesting lighting, crop the format, add other elements, select parts of one photo and add them to areas of another so you're combining elements from many photos. Create a mood by adding atmospheric effects, or use a photo to supplement the colors or textures in a painting done from your zoo drawing. Whatever you decide, make sure your art is creative and personal, so you're not just reproducing another image (see pages 156 to 159).

WORKING FROM SLIDES

Now that I've talked about working with print photos, I must confess that I generally use slides. Slides provide better color saturation, more detail, and a luminosity than color prints. Prints also tend to throw the lights to pure white and the darks to pure black more often than slides, something that I can't afford to have dictated for me. To view these slides I use a Telex Caramate—a rear projection box that keeps the slides cool even after long periods of use. It also offers a sharp, bright, colorful image of the slide to work from. Or you can work like some other artists and mount a loupe (slide magnifying glass) to a color-corrected desk lamp so all you have to do is slip the slide into a holder behind the loupe and start painting.

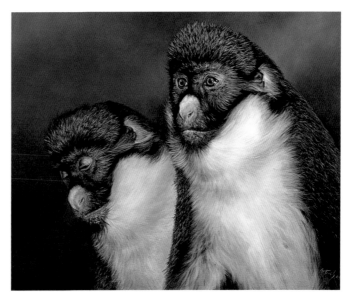

SPOT-NOSED GUENON PAIR
Oil on Masonite, 14 x 18" (35.5 x 46 cm), 1995.

I love to paint exotic animals, especially species of monkeys and birds rarely, if ever, seen in paintings. The colors and shapes of these animals are incredibly intriguing. This painting is one of several I did of this particular species. I just loved their color patterns and even more, their expressions. In this painting I wanted to capture one alert and one not so alert monkey, side by side. The result is almost comical, yet it's a glimpse into the very personal nature of these animals, not a sight you observe every day.

DINO PARAVANO
LEOPARD WITH
IMPALA KILL
Pastel, 28 x 42" (71 x 107 cm), 1993.

Sometimes when an artist goes on a safari or is in nature viewing the very thing that is inspiring, events move too fast to capture it on paper or canvas. That's what happened to Dino Paravano. On one of his many African safari experiences, Paravano saw this leopard in South Africa and had the good fortune to follow it for a while. In an extremely memorable moment, he watched the interaction between the leopard in a tree and a lioness on the ground. The best way to capture this animated and exciting event was on camera. This is one of a few paintings in which he was able to re-create the original experience.

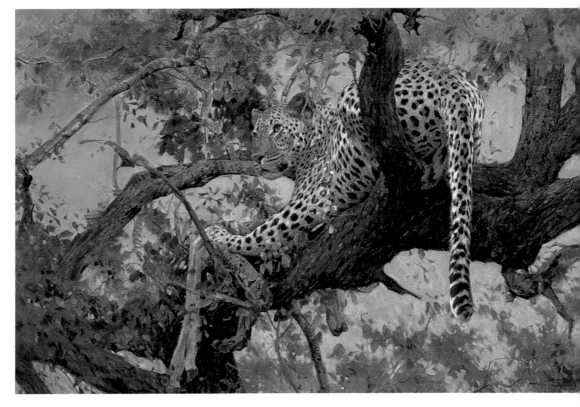

Chapter Three

DRAWING ANIMALS

MANY BEGINNERS consider drawing irrelevant and unimportant. They want to learn how to paint, but they don't think they need to know how to draw or they may think that this is quite a bit of time taken up for something with no immediate, tangible benefits toward a painting. But they fail to realize that drawing is the foundation of all realistic painting. To paint animals realistically, you *must* know animal anatomy and you have to be accurate in depicting the animal. That means knowing how to draw—and to draw well. In fact, the success of your painting hinges on it.

A poorly developed ability to draw shows up in the final product—your painting. If you don't develop a strong foundation in drawing, then tracing photographs will be all that's left to you. The process of developing strong drawing skills (which takes years) will reveal to you aspects of the discipline that you may not have been aware of. An artist willing to go the whole distance in foundational draughtsmanship will also develop a strong identity, or *style*.

Drawing involves more than making pleasant sketches of animals to frame and sell. It teaches you how to create the illusion of solidity on a two-dimensional surface, trains your eye to perceive subtle tonal variations, and helps you to become familiar with the animal. Drawing forces you to look more closely to uncover the subtle nuances, textures, expressions, gestures, and character of the animal. It also teaches you composition and spatial relationships. That's why art colleges insist that students take more than a few drawing classes, no matter what their artistic field.

Drawing also helps you to plan your ideas and composition *before* you paint. This is not to say that you must always draw out your ideas before you paint. Some paintings do begin without preliminary studies or underlying drawings—an expressive way of painting that can free the overly controlled artist and benefit your art in ways you never expected. In this section, however, I'll be dealing with the benefits of drawing for its own sake—benefits you can incorporate into future paintings. I feel very strongly about the importance of strong drawing and I'll be paying considerable attention to it in this book.

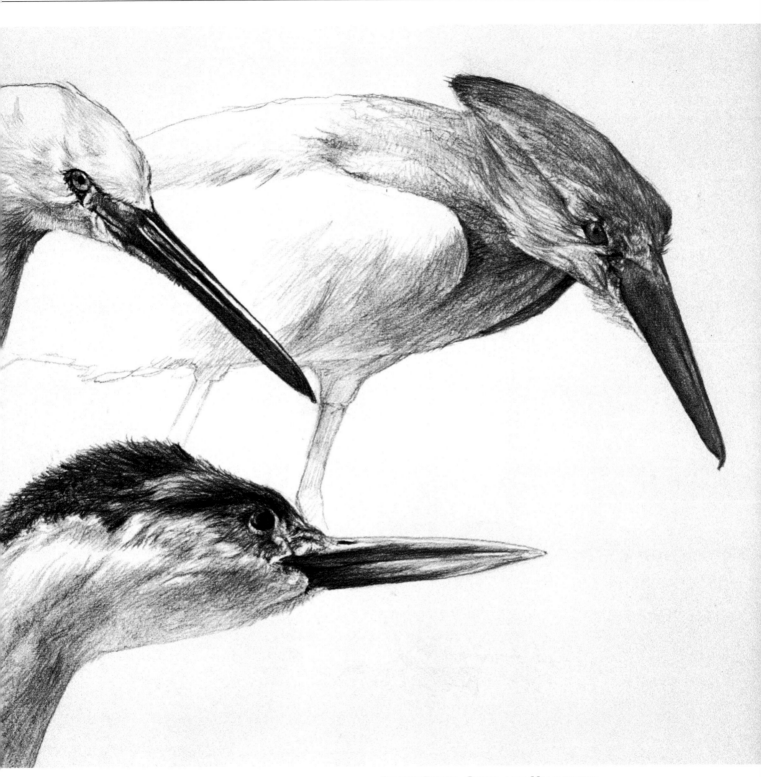

SNOWY EGRET, GREBE, AND HAMMERKOP
Graphite on Bristol board, 18 x 24" (46 x 61 cm).

Types of Drawings

Most drawings fall into three basic categories: gesture drawing, sketch, and finished drawing. Each has a place and importance, so using all three types contributes immeasurably to developing your skills as an artist. I'll also briefly discuss two other types of drawings that actually are offshoots of the three main categories: the study (an offshoot of the sketch, it is an information-gathering drawing, usually for a painting), and the refined preliminary drawing (which can be a finished drawing done in preparation for a painting or a detailed study). Let's look at these types of drawings more closely.

THE GESTURE DRAWING

A gesture drawing is quick—usually under a minute, but is best kept under thirty seconds. In the gesture drawing you pay more attention to the overall impression of the subject than you do to the likeness.

The gesture drawing is designed to "free" you up and train you to ignore a precise likeness in order to understand the overall and essential qualities of your subject. It is the "fleeting glimpse" of the drawing world.

Animals that move about a lot are great subjects for gesture drawings that capture the essence of the animal. Gesture drawings are also good for loosening you up, before tackling more refined work.

To do a gesture drawing, stand back as far as possible from your sketch pad and draw at arm's length, working from your shoulder. Don't move just your wrist; use your whole arm. It's best to work large—with an 18 x 24" newsprint pad—so you can let yourself go.

The Blind Gesture Drawing

The blind gesture drawing is another good exercise. Here you focus on your subject and try to depict it quickly and freely without looking at your drawing paper. Simply stare at your subject and draw without removing your drawing instrument from the page. The drawing should look like a continuous scribbled line, with flowing areas in some places and smaller, more compact scribbles in others. Remember, you're going for an *impression* of the animal, not a likeness.

I suggest at least five minutes of gesture drawings at the beginning of a drawing session to loosen you up and dispel the automatic need for always having an overly refined finished product. It's as important to capture the basic feeling and gesture of a subject as its likeness. This is what breathes life into your art.

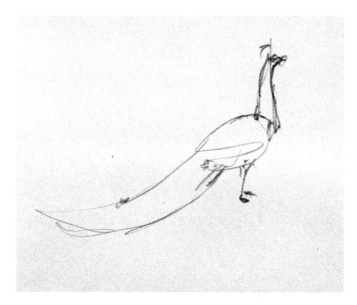

PEACOCK
Graphite on Morilla sketch pad, 7 x 11" (18 x 28 cm).

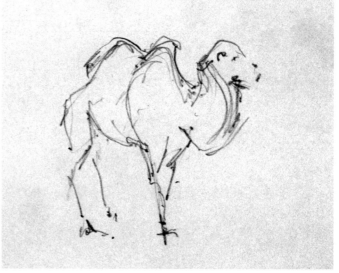

CAMEL
Graphite on Morilla sketch pad, 7 x 11" (18 x 28 cm).

These two simple gesture drawings show an almost continuous, fluid line that reveals the character of the animals. The concern, here, is with the quality of the line.

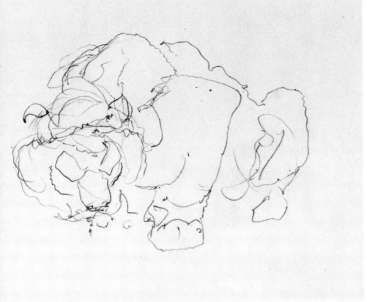

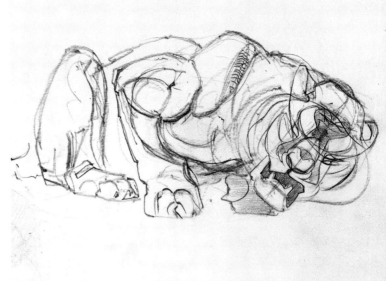

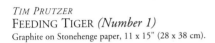

TIM PRUTZER
FEEDING TIGER *(Number 1)*
Graphite on Stonehenge paper, 11 x 15" (28 x 38 cm).

This is a contour gesture warm-up sketch, the first of two drawings Prutzer did at the Denver Zoo. It's a continuous line gesture—for the most part the pencil was never lifted from the paper. Notice how, even with a riot of scribbled lines, the character of a tiger comes through very distinctly. That's what a gesture drawing is all about.

TIM PRUTZER
FEEDING TIGER *(Number 2)*
Graphite on Stonehenge paper, 11 x 15" (28 x 38 cm).

This is a more detailed progression from the preceding drawing. Prutzer's second drawing is much more refined and shows the amount of observation he put into the structural construction makeup of this cat. This is the second drawing during the same sitting time. He paid particular attention to the anatomical forms of the scapula-humerus connection (shoulder and upper arm area).

THE SKETCH

The sketch covers a broad range of drawing styles and techniques, from the few minute notations of a subject you want to quickly capture to more elaborate depictions in preparation for a future painting. Generally, a sketch is a visual snapshot of a particular subject, composition, feeling, or thought. It is the act of transferring the way you see onto paper.

Many drawings done in sketchbooks or on location or in the studio never progress beyond the realm of the sketch. They're just ideas and glimpses of things, or drawings done simply for the experience, to strengthen our ability to draw. But sketches can also be preparation for finished works. In fact, one key to an effective realistic painting is to have as much as possible of the specific details and questions worked out ahead of time.

I always use sketches as preliminaries for paintings, some more elaborate, some less so. You will find that the most beneficial use of the sketch is drawing from life. To capture the fleeting moment of a lion staring intently into the distance or to observe the way an elephant's skin folds around his eye is a most exciting use of drawing. I will dwell on the sketch at length, since it's what I use most in my work.

The Study

A sketch can take the form of a study, which is a close examination of a particular section of a chosen subject, or a closer look at the color or texture of the animal. The study can also become a preliminary study for a painting, where elements of a painting are drawn so as to gain a better understanding of the subject to be painted.

Studies are a very important process of all art. Tim Prutzer is a diligent draughtsman and one of the few artists who will actually go out and spend hours researching his subjects firsthand using the age-old, and, unfortunately, dying, art of life drawing. Prutzer expresses the importance of studies as follows:

> "After much study of art and art history, some of the pieces of work I find most attractive are those sensitive studies made by the masters. Although a study can be made as a preliminary to a final painting or sculpture, many times it's a finished work standing on its own merit. Depending on its intrinsic qualities, a preliminary study can be as much a true work of art as the finished piece, and often possesses a vitality that is sometimes missing in the final product."

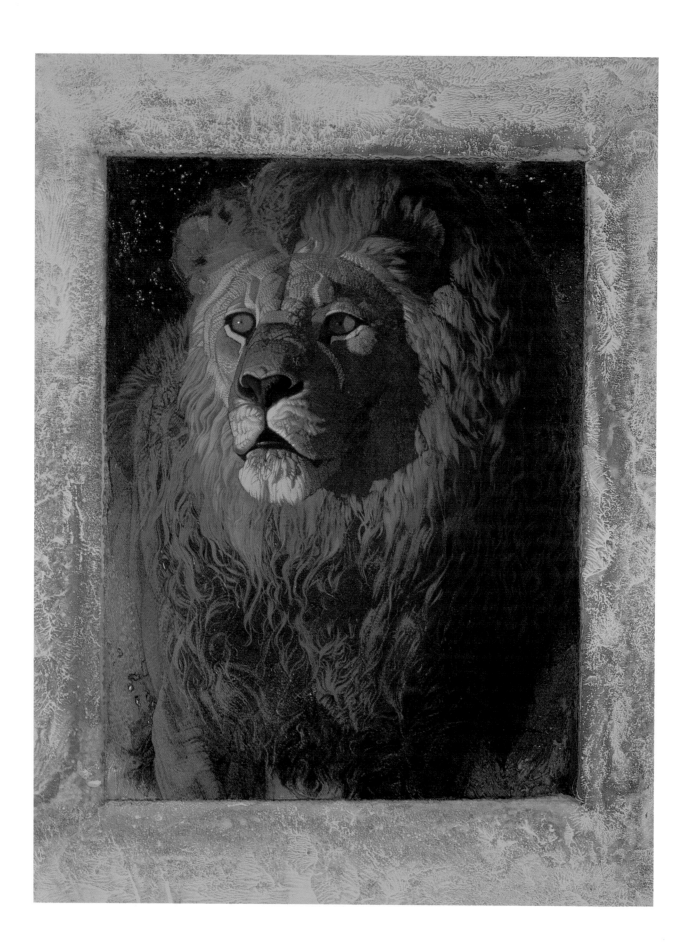

TIM PRUTZER
THE LION OF THE TRIBE OF JUDAH
Acrylic on paper, 20 x 15" (51 x 38 cm), 1997.

This is the major finished piece that all those hours of intensive study helped produce. Without Prutzer's preliminary structural and planar research, the lion probably would have lacked this incredible sculptural quality. This is a truly remarkable painting, a stunning image showing not only the great understanding of the structural makeup of the cat, but also a tremendous sense of mood and presence.

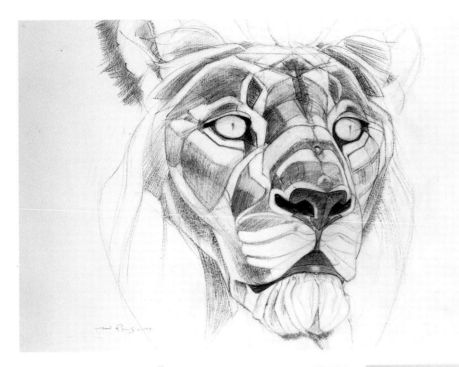

TIM PRUTZER
LION FACE STUDY
Graphite on Stonehenge paper, 15 x 22" (38 x 56 cm)..

This is a preliminary drawing for the painting on the facing page, one of many drawings done over the course of several visits to the Denver Zoo. The number of studies Prutzer made is staggering, and it shows in the quality of the final product. He was able to observe, intimately, all the subtle nuances of this particular lion and has captured its overall character effectively. Remarkably, he did this all without the use of photography, which proves the importance of careful observation. This "multiple-sitting" life study was done to show the lion's expression. Prutzer paid particular attention to the planes of the head, interpreting them architecturally as three-dimensional forms. Then he reversed the image and traced over it to transfer it to the canvas, and began to work in color.

DWARF MONGOOSES
Graphite on Strathmore drawing pad, 5 x 6" (13 x 15 cm).

These mongooses were very cooperative, so I could make the drawing more refined. I was trying to capture the character and texture of these usually rambunctious little creatures.

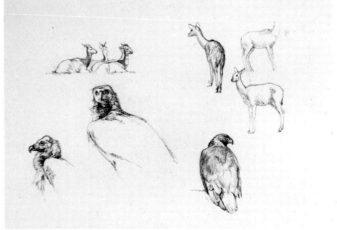

VULTURES, GAZELLE, AND EAGLE
Graphite on Bristol board, 18 x 24" (46 x 61 cm).

This is a typical page of sketches from a trip to the zoo and shows a group of sketches at different stages of development. In sketching animals, the goal is to get the essence of the animal, a basic likeness, and to study the structure and textures of the various animals.

Thumbnail Sketches

Perhaps the fastest and easiest way to plan a painting from a drawing is with a "thumbnail sketch." This is a simple, small, quick sketch—an inch or so wide—in which you work out the basic composition, light and dark areas, and general placement of the elements in the intended painting. Because the drawing is small and fast, you can see the overall graphics of the painting to decide if the basic composition reads well without the color and distracting details. You can also easily compare these drawings, since they're on the same page. If you can work out an effective composition, good lighting, and an overall pleasing image in advance, you'll have a far better chance of creating a good painting than if you had only a limited idea of the finished product from the beginning. That's why a good, solid foundation in drawing is so necessary for creating effective paintings.

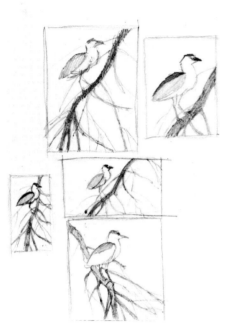

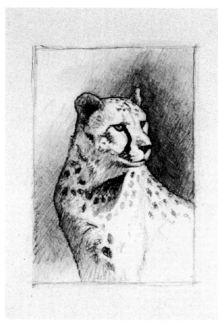

BLACK-CROWNED NIGHT HERON
(Multiple Thumbnail sketches)
Strathmore drawing pad with 2B pencil, 11 x 14"
(28 x 36 cm), 1997.

The thumbnail sketches shown here are from a sketchbook filled with such sketches. Drawing from a mounted specimen, I was able to move around the bird so I could find the most compelling angle. These multiple sketches gave me the chance to plan the format of my painting in advance. Should the painting be vertical or horizontal? Cropped in close or with space around the bird? If space, where should it be? How should the stick move throughout the painting? Notice that I left out all the details; this is just a simple depiction of basic shapes and tones.

THUMBNAIL DRAWING FOR A
CHEETAH PORTRAIT
Graphite on Bristol board, 3 x 4" (8 x 10 cm), 1994.

This is one of hundreds of small drawings I usually make to see what a painting will look like before it's drawn on the board. This is about as small as a drawing gets.

THREE THUMBNAIL SKETCHES
Graphite in sketchbook, 9 x 12" (23 x 30.5 cm), 1990.

These three sketches were designed to put the ideas for two different paintings onto paper. The lower two, in particular, study how different lighting affects the composition in two different ideas for the same moose painting. Notice how the difference in light and dark masses can change the overall feel of the piece. These thumbnails are very useful because I can create many in a short amount of time and compare them side by side. They also give the overall graphic impression without the details. If the image works in this format, there is a very good chance it will be a strong painting.

Preliminary Studies for Paintings

In addition to thumbnail sketches, I also make larger, more detailed drawings of the animal and its setting to make sure it has the look and feel I want. It's easier to work out issues of composition and lighting before the painting size is established, and it's at this stage that I decide if the image should be vertical or horizontal, square or a long rectangle. If there's a weakness in the basics of these elements at the drawing stage, it's far easier to correct them in the drawing than in the painting. These drawings can be small, sketchy, and numerous, or large, detailed, and fully refined. Most of mine are done on smooth Bristol board paper with a 2B pencil.

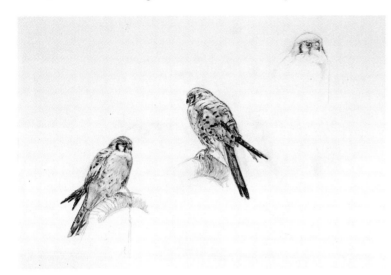
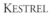

KESTREL
Graphite on smooth drawing paper, 18 x 24" (46 x 61 cm).

I consider these drawings of a kestrel, done at the Denver Zoo, to be more studies than anything else since they helped me learn the structure and feather patterning of this bird for future paintings.

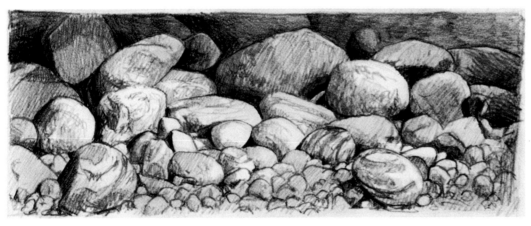

THUMBNAIL STUDY
Graphite on drawing paper, 11 x 14"
(28 x 35.5 cm), 1994.

DRAWING LAYOUT STUDY
Graphite on drawing paper, 11 x 14"
(28 x 35.5 cm), 1994.

PRELIMINARY OVERALL
STUDY
Graphite on Morilla layout paper,
18 x 24" (46 x 61 cm), 1991. (The
finished painting appears on page 31.)

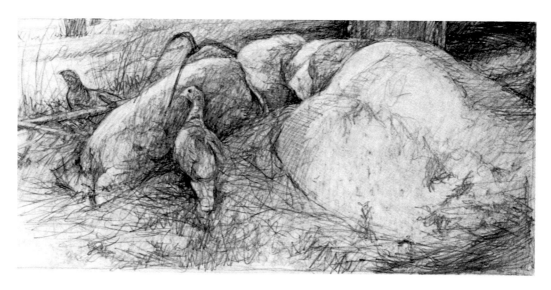

ROCK STUDIES
Graphite on Morilla layout paper, 18 x 24" (46 x 61 cm), 1991.

MOSS PATTERNING STUDY
Graphite on Morilla layout paper,
18 x 24" (46 x 61 cm), 1991.

THE FINISHED DRAWING

When you have plenty of time to draw a stationary subject and want to depict every subtle nuance of its form, you need to do a finished drawing. A finished drawing combines all the elements of composition, tonality, refinement, and emotion. I generally make a finished drawing at a natural history museum or from a photograph. As I stated earlier, the difference between the finished drawing and the sketch is simply one of degree of refinement or finish and has nothing to do with salability. On the contrary, many sketches are far more framable and sellable than so-called finished drawings.

JAVAN MACAQUE
Graphite on smooth Bristol board,
11 x 14" (28 x 35.5 cm).

I wanted to show the subtleties of textures and grays of the monkey's fur, as well as realistically render its face, hands, and the setting. It was drawn from a photo I took and reflects a more polished or finished image. A finished drawing doesn't necessarily have pencil marks extending to each corner of the paper, but it's certainly more refined than a basic sketch.

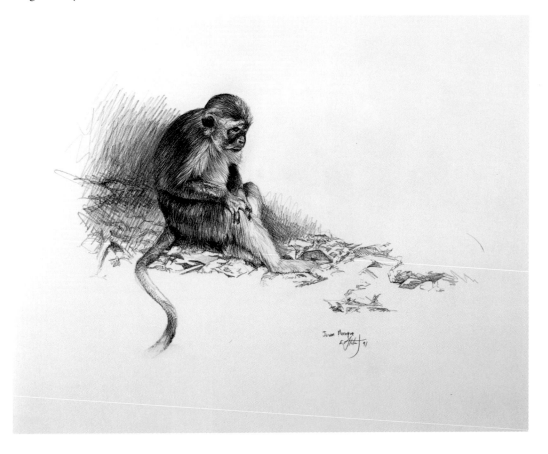

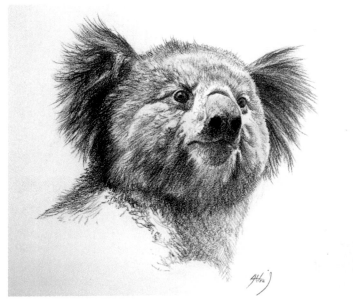

KOALA PORTRAIT
Pencil (2H, 2B, and 4B) onStrathmore drawing pad,
14 x 18" (35.5 x 45 cm).

This is probably my favorite museum drawing. It was drawn in a couple of hours in the Denver Museum of Natural History and captures the feeling I wanted to convey as well as the subtle textures and shading of the fur, without becoming overworked. I lightly worked out the basic positioning with the 2H pencil, did the bulk of the drawing with a 2B pencil, and finished it by deepening areas, like the eyes and nose, with the 4B.

Refined Preliminary Drawings

Preliminary drawings can also have a finished look. Sometimes when I do a drawing I think has a good possibility to be made into a painting, I draw just the basics and add few details to the drawing itself. But occasionally I get so enthralled in the drawing that I start working on it simply for its own sake, adding enough details and subtleties to have it stand as a work of art on its own. The following drawings, which stand alone in their own right, were actually done for paintings that appear elsewhere in this book

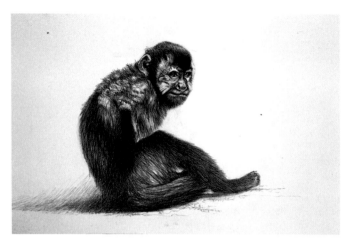

HOODED CAPUCHIN
Pencil (2B) on Bristol board, 11 x 14" (28 x 36 cm).

This finished drawing has everything I want in a painting—character , strong darks and lights, focus, and open areas. Most preliminary sketches for paintings don't get this refined, but this one did. The painting retains the character of the monkey and brings it truly alive. (The finished painting is on page 137.)

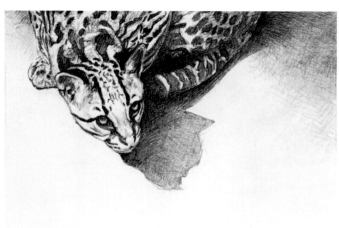

OCELOT
Graphite on Bristol board, 14 x 17" (36 x 43 cm).

This preliminary drawing shows a defined composition and shading. I loved the subject, and the image as a whole is strong, so this drawing is more worked up than most of my preliminary sketches.(See the finished painting on pages 130 and 131.)

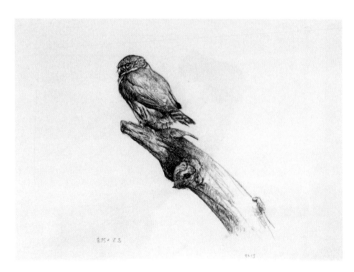

PYGMY OWL WITH WARBLER
Graphite on Strathmore drawing pad, 14 x 17" (36 x 43 cm).

I drew this on a pad in the Denver Museum of Natural History, with a finished painting in mind. A new, large, traveling exhibit of birds of prey had come to the museum for a limited time, and, of all the specimens in the exhibit, I was drawn to this one. I subsequently painted it life-size.

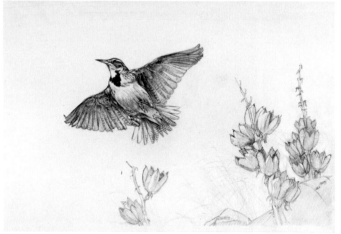

MEADOWLARK
Graphite on Bristol board, 18 x 24" (46 x 61 cm).

This drawing was fully refined and worked out before I painted. I worked in the Denver Museum of Natural History from an incredibly good mounted specimen. In the drawing I worked out the composition, board size, and other elements. When it looked right, I turned it into a painting (see page 38). My preliminary drawings usually don't get this refined, but I had so much fun drawing this bird that I didn't stop until it was very detailed.

Basic Techniques for Drawing Animals

As mentioned in Chapter Two, drawing animals from life (either live or museum-mounted) can be tricky. Training your eye to see animals in such a way that you can successfully translate that image in your mind's eye into a three-dimensional drawing on paper takes a lot of practice.

The tremendous range of sizes, shapes, textures, and physical makeup of different animals is staggering. From birds to predators to aquatic animals to hoofed animals, the task of trying to accurately capture all the many different species in your art can be overwhelming. Eventually, you will come to welcome the variety, as you see how it adds vibrancy, excitement, and intrigue to your work.

I can't emphasize enough the importance of practice and experience for wildlife artists. Getting out there and doing it is the most important thing. You should also seek out hands-on life drawing classes (animal or even human), which will show you how life drawing is done most effectively.

STUDYING YOUR SUBJECT

Before you start to draw, sit and watch the animal for a while. Look for a pattern in its movement. Study the form and basic shape of its body. Notice the characteristics that make this animal distinct from others. Observe its structural makeup—the underlying bones and muscles can be very apparent in many animals. Basically, just sit quietly and familiarize yourself with the animal. Even if you're looking at a mount, don't skip this process of looking closely at the object before you start to draw.

Simultaneous Sketches

As animals move about, you may have to start multiple drawings of different poses on one page and switch back and forth between drawings. This can be a tricky way to draw, but it can provide some wonderful results if you stick with it.

MULTIPLE BIRDS
Pencil (2B) on plate Bristol board, 18 x 24" (46 x 61 cm).

This is a typical large drawing page filled with many different birds of various sizes, species, and stages of completion. Since they're just sketches, I didn't mind filling the page with birds. I just kept starting new drawings as they moved about.

SUN BITTERN
Graphite on Strathmore drawing pad, 14 x 17" (35.5 x 43 cm).

These two drawings are good examples of how to turn the patterned habits of your zoo subject to your advantage. After watching this bird for a few minutes I saw that he was in a very consistent pattern. I sat down and worked on both drawings simultaneously. I kept alternating between drawings as he walked back and forth.

START WITH THE BASIC SHAPES

One of the easiest ways to capture a subject is by breaking it down to its basic shapes. Any cartoon shows a simplified version of this, but to really see this technique used well, examine George Bridgman's work on the human form. Bridgman was a master of mechanics and of breaking down the form into interrelated three-dimensional shapes on paper, and you can learn a lot from looking at his art.

Draw the basic circular shape of an animal's body or head to establish the size and placement and to get the overall shape before adding the specifics and the details. Then add the basic shapes of interlocking elements such as the ears, neck, and head. Only when these are added and checked for accuracy in shape and size (comparing them to each other for size relationships) should you then add subtle nuances and details of the subject. With practice, all subjects are seen as interrelated forms and depicted as such. It is your job to lose what, in your mind's eye, you *think* is there, and to draw what is *actually* there. This is the key to more accurate drawing.

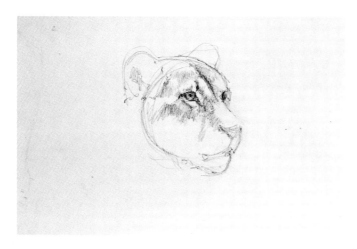

LION PORTRAIT
Graphite on smooth drawing paper, 9 x 12" (23 x 30.5 cm).

At this stage, I've just begun to draw the lion, and you can see my thought process from this drawing. I began with the basic shapes—the basic circular lines of the head and ears are still apparent—and initial suggestions of tone. I also suggest scale—the size of the head on the page. Then I focused on the one eye, moving outward with light pencil lines to indicate the position of the chin, ears, and face.

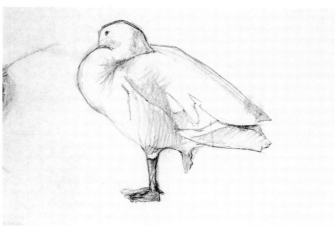

GOOSE
Graphite on Morilla drawing paper, 9 x 12" (23 x 31 cm).

This is the beginning of a goose drawing. I've put in the masses but haven't started adding details or shading. Again, the basic shapes of the body and neck are delineated with simple lines.

LION, RABBIT, AND RED PANDA
Graphite on Strathmore drawing pad,
14 x 17" (36 x 43 cm).

These drawings represent three different stages of the drawing process. The red panda at the bottom is a quick basic representation, with simple outline and shapes indicated. The lion shows the second stage, with some indication of texture and tone to suggest mass. The rabbit represents the third stage. I spent much more time on it and was therefore able to add more textures, details, and depth with darker darks.

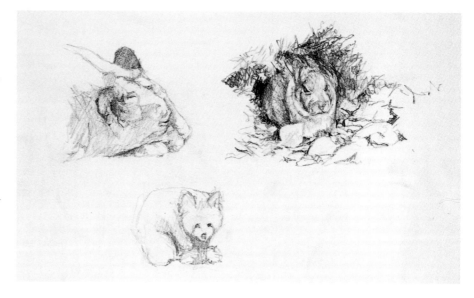

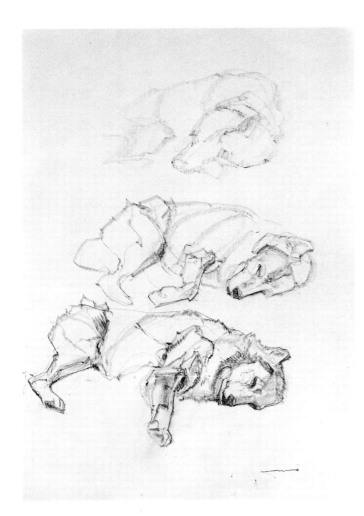

Tim Prutzer
SLEEPING TUNDRA WOLF
Graphite on Stonehenge paper, 11 x 15" (28 x 38 cm).

Drawing just one wolf, who shifted its pose occasionally, allowed for the progression of these three drawings on a single page of a sketchbook. Prutzer started the first with a quick, ghostlike gestural contour of the animal, capturing its basic shape. The second drawing is more sculptural. The structure is defined and there's a greater complexity of line, contour development, and form. The third drawing has the beginning of textures and shading, and the development of the tonality and hair tracts.

WORK OUTWARD FROM A POINT

After years of training and experimenting with different types of drawings, I've found it easiest to start at one point on a subject and move outward from that point, constantly relating sizes and proportions—checking the size of an eye, say, against the bridge of the nose; or lining up the pupil with the corner of the mouth. The more I do this, the more accurate my drawing. When I neglect to do this, I soon notice that various elements in the drawing are grossly misshapen or out of proportion. Regardless of how I choose to tackle the drawing, this size/relationship comparison is critical for the drawing's accuracy. I constantly line up the different elements of the drawing and compare them to the subject.

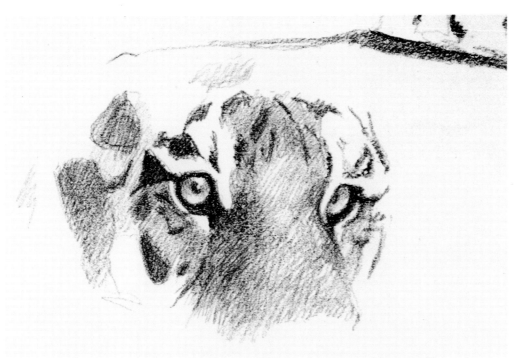

TIGER FACE
Graphite on Strathmore drawing pad,
14 x 17" (35.5 x 43 cm).

I started this drawing, of just the eyes and upper face of a tiger, with the left eye. Moving slowly outward from there, I progressed to the shading on the nose and stripes around the eye. The more time the tiger gave me to draw, the further I ventured outward. I stopped here because the tiger failed to return to the position that provided me with this view.

PLANNING VALUES

By values, I don't mean worth. Value is the term for the amount of light and dark in a drawing or painting. Values range from white (the lightest or highest value) to black (the lowest or darkest value). It's important to be aware of the range of values in your artwork. A drawing or painting that uses only a small part of the value spectrum usually lacks excitement and balance. (This is not always a disadvantage, but it may be just what you want for a gentle and subtle effect instead of a dramatic one.) A high-key drawing uses only light values and may seem washed out and lacking punch or "grab." (Again, that might be just the quality you want for, say, a hot scene in the Sahara Desert.) Conversely, a drawing that is low in key uses just dark values. The effect here can be one of foreboding and confinement, like being imprisoned in a dungeon. (Again, that might be the mood you're aiming for.) A drawing that concentrates on only the middle part of the value spectrum can be gray, muted, and dreary—or gentle and subdued.

For most subjects, try to use the broadest range of values possible. This doesn't mean you always have to use pure black and leave other areas bright white, but you should include at least one note of darkness in a light drawing for interest, or notice when a drawing or painting lacks part of the value spectrum. That's why thumbnail sketches are so important. You can work out all the value considerations in a thumbnail sketch before you start a painting. You can also decide where to put the darks and how deep to make them. With experience, you'll begin to see the drawing as a whole and recognize when a drawing desperately lacks a particular value.

Seeing Color as Value

Drawings are especially useful for observing and isolating values before adding color. Color will make it more difficult to separate value (degree of lightness and darkness) from tonality (variations in brightness and neutrality). Nonetheless, you need to see color as having value as well as hue. For example, a dark blue, like navy, has a low value; a light blue, like powder blue, has a high value. But the navy blue may be brighter in tone and the light blue might be more washed out or neutral. So colors have intensity as well as value.

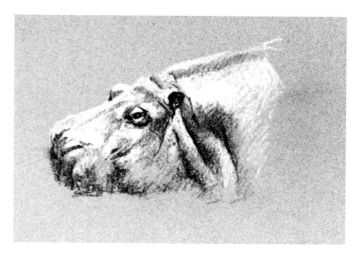

HIPPO
Gray paper with white and black Conté crayon, 14 x 17" (35.5 x 43 cm).

Working on toned paper, deepening the darks and heightening the lights, gives greater solidity to the work than drawing simple darks on a light paper. The lethargy of this hippo gave me a bit of time to work on both lights and darks. Working in this way is tricky with a live subject, but with practice it can produce some exciting results.

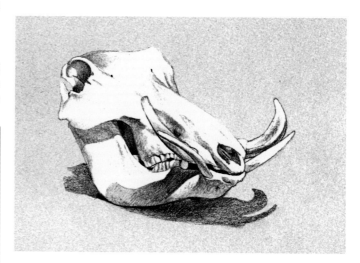

WARTHOG SKULL
Pencil and white Conté crayon on gray pastel paper, 14 x 17" (35.5 x 43 cm).

This is a good example of how white on a toned paper can add solidity and depth to a drawing. Notice that the white is used the same way as the dark, subtly gradating the tones by varying the pressure on the Conté crayon from light to heavy for the deeper tones.

WORK WITH A PLAN IN MIND

Before you draw, think about how you'll begin. Will you start with an overall outline? Or will you choose one point and move out from there? Different subjects lend themselves to different methods of drawing. If your subject is sleeping, which may give you more time, you may tackle it differently than if the animal is moving. Watch the animal and draw in your head for a while. Then when you feel more familiar with the animal, start drawing.

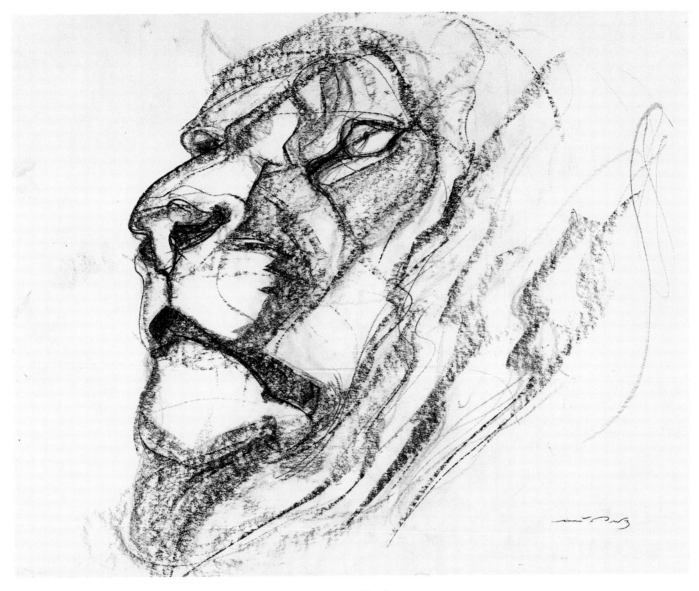

TIM PRUTZER
AFRICAN LION
Black Conté on Stonehenge paper, 11 x 15" (28 x 38 cm).

With Conté crayon you can develop form, structure, line quality, tone, and hair texture all at once. Working on a private ranch, positioned less than ten feet from the lion, Prutzer was able to complete this drawing in fifteen or twenty minutes.

Working on Toned Paper

Using toned paper is one way to force yourself to see and use values. The paper itself becomes the middle tone and you can "pull out" light areas with white chalk or Conté crayon or China markers and add a range of darks with a dark Conté crayon, charcoal stick, or 2B/4B pencil. Once you've established a value range, you can compare the values in specific areas and adjust them.

Using Conté Crayon

Try light and dark Conté crayons on lightly toned paper for a range of values. Also, switch different parts of the stick to vary the line quality—the edge of the stick to cover broad areas quickly, the point for a thinner line. Notice how variations in size, shape, and pressure affect the line. You can also get a variety of great effects by working with two contrasting tones of Conté crayons, a warm and a cool (see *Rhinoceros* on the next page). You can also try different textures of paper to see how it affects the look of the Conté crayon. For example, Conté works especially well on textured paper; it hits just the ridges, creating great effects.

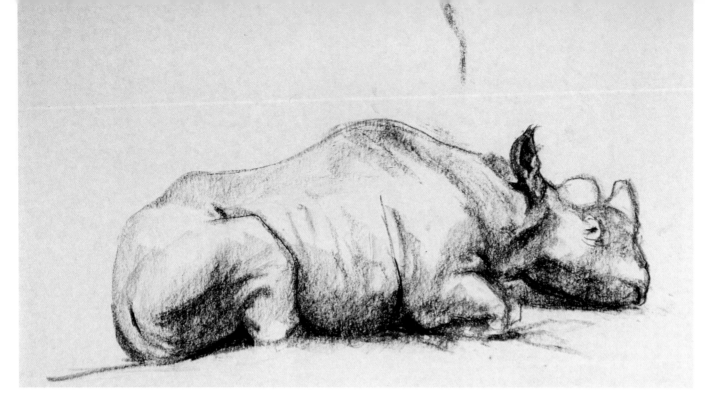

RHINOCEROS
Smooth paper with brown-red (sanguine) and black Conté crayons, 18 x 24" (46 x 61 cm).

The tip and side of the crayon makes both broad and sharp lines, and the tones you can get with Conté vary from soft to deep and rich. Conté crayon works especially well on textured paper. Unless you press hard, it hits just the ridges of the paper, creating great effects.

Bob Kuhn
GRIZZLY BEAR
Conté crayon on paper, 9 x 12" (23 x 30.5 cm).

Even though it is reproduced here as black, Kuhn actually used a deep van Dyke brown Conté crayon called "bistre." Kuhn prefers bistre to black because it has a softer tone and goes on the paper differently. Note the broad range of lines and tones he gets just by using the point, edge, or side of the crayon. The degree of darkness is dictated by the pressure on the crayon.

BOB KUHN
WILD BOARS
Conté crayon on paper, 9 x 12" (23 x 30.5 cm).

Kuhn drew these sleeping boars at the zoo. The drawing shows the wonderful line quality you can achieve with Conté crayon. Quick, parallel lines express the form of the animal, and well-placed darks accentuate the piece.

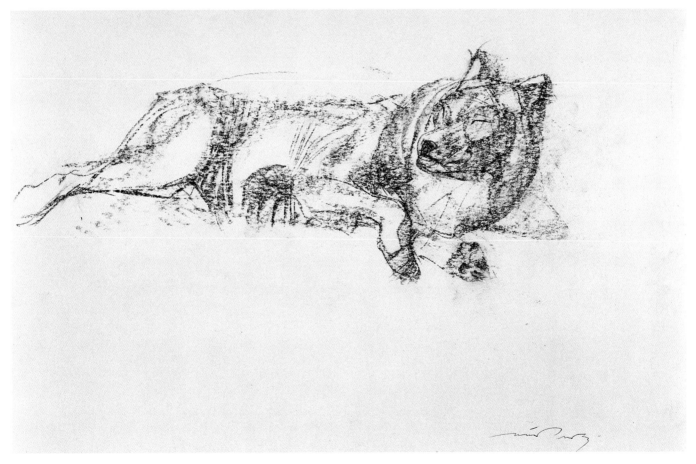

TIM PRUTZER
TUNDRA WOLF
Sanguine Conté crayon on Stonehenge paper, 11 x 15" (28 x 38 cm).

This is a wonderful life study of a wolf in repose. Prutzer uses the side of a Conté crayon on a textured paper and the ridges of the paper catch the color, leaving the valleys white. This texture, when combined with sharp-edged lines elsewhere, produces a very pleasing image. In short, this piece shows line quality, tonal development, hair texture, and structural qualities.

CONSTANTLY CHECKING FOR ACCURACY

To make your drawings more accurate, get used to constantly comparing the size and shape of the different elements. Also, line up parts of the anatomy with each other, using imaginary horizontal, vertical, or diagonal lines. You can also gauge the size of elements in your drawing by shading in darker areas as a shape. Our eyes can size up a dark shape more easily than an outline.

PAY ATTENTION TO INDIVIDUAL DIFFERENCES

Pay attention to the characteristics of various animals. How do animals differ within the same species? How does age and gender affect the look of the animals? How do their proportions vary—the size of the eyes and ears, length of the legs, shape of the snout or beak? In order to make animals look like individuals and not carbon copies of the same animal, you'll have to pay attention to individual personalities within the same species. This means you must draw many different animals of the same species and note their individual differences.

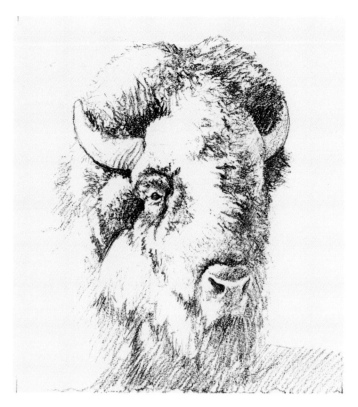

BISON PORTRAIT
Graphite on Strathmore drawing pad, 14 x 17" (35.5 x 43 cm).

The accuracy of this drawing is the result of quite a bit of experience in drawing from life. I constantly compared the size and relationships between different parts of the face. When you train your eye in this manner and do hundreds of drawings, you're bound to get good.

DIK-DIK
Graphite on Strathmore drawing pad, 14 x 17" (35.5 x 43 cm).

The dik-dik is a tiny antelope, and, like many small animals, it's high-strung, so I was fortunate to find this one just resting. Intrigued most by the head, I started drawing it with a 2B pencil. Then I moved down the neck to the body, noticing as I worked that the animal wasn't moving. I added more and more refined and darker lines and textures to the head, then to the body. I loved the way he nestled into this little bush and did my best to include that at the end.

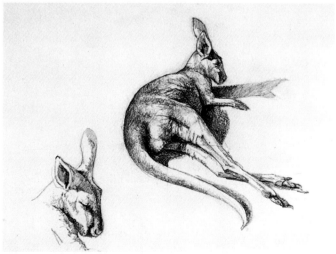

KANGAROO
Graphite on smooth drawing paper, 18 x 24" (46 x 61 cm).

Shading in the shapes was important in helping me understand the structure of this animal and gauge the accuracy of the drawing.

My Basic Drawing Procedure

Drawing is not a static, same-every-time process, but a fluid and spontaneous activity. You must be open to many different forms of drawing to keep your work fresh and full of life. I start drawings several different ways. I may start a small bird, for example, with a simple circular gesture, then quickly add the basic shapes of the tail and head before doing any more refined work. Or I may start the face of an arctic fox with its eye, working my way outward and upward through the face, finishing each area as I go.

Since I work quickly and spontaneously, there's no opportunity to take pictures of an actual zoo drawing in progress, so, to show you my usual drawing procedure, I'm going to reconstruct the steps of a drawing I did of a snowy owl and pheasant at the Knoxville, Tennessee, zoo.

Making a Basic Outline

I began with a light, soft, line drawing showing the basic shape of the bird. Notice my "finding" lines— lines I go over a few times to find the right position. Sometimes I get the drawing right the first time, but usually I have to go back and quickly redraw the line because it's not quite in the right place.

Partitioning and Shading the Shapes

I locate the boundary between the head and the bulge of the back and upper wing, draw the boundaries of the major masses on the body and head, and slowly bring the animal into focus, making it more visible. I quickly shade the area under his tail feathers.

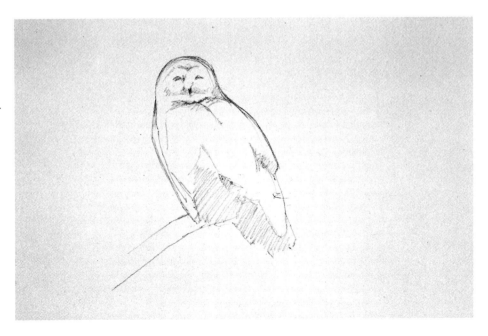

Adding the Darks
Starting with the head, I draw in the spots and feathers. As I become more certain of their location, I darken the lines and other specific areas that need to be darkened.

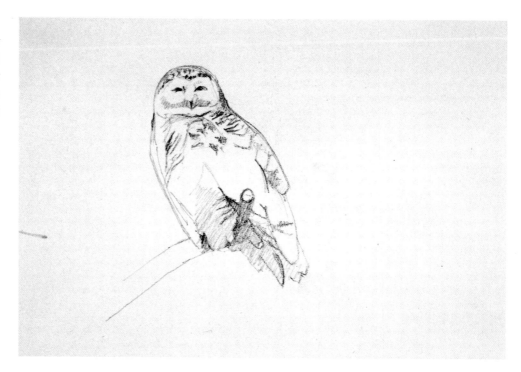

Adding the Details
I continue to add spots and lines to the feathers. Then I deepen the shadows and darken certain lines by pressing harder on the pencil. I also lightly shade the face and body to give it subtlety and form.

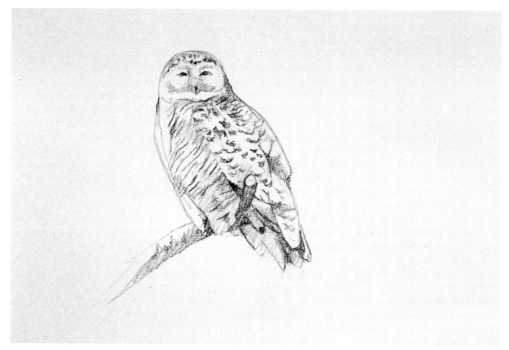

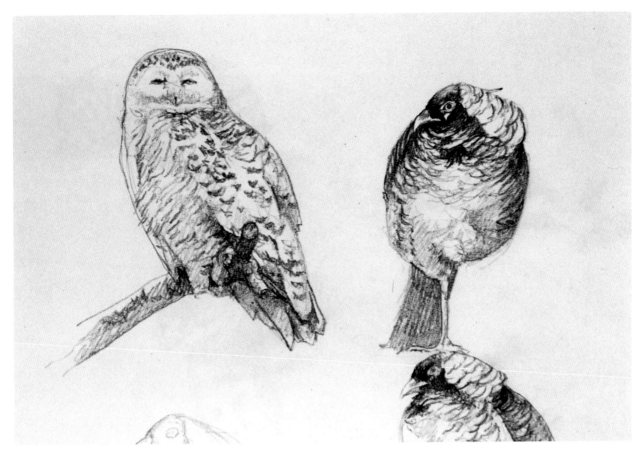

The Final Drawing

This is my actual drawing. I added the deepest darks and a few more details, but the bird moved away and so I left the drawing "as is" and began to draw a pheasant on the same page.

HINTS FOR BEGINNERS

- At first, more often than not, your drawings won't look like what you see—something that even occasionally happens to seasoned artists. This is when you really need patience. When you're not pleased with the outcome, ride out the frustration or take a breather. Mastery comes from experience—and that takes time.

- Avoid using your eraser too much—it can easily become a crutch. Instead, before you start to draw, look closely at your subject, study it, and plan the drawing in your mind. Or make several drawings of the same subject and see which you like best.

- Tips and tricks are no substitute for good old-fashioned practice. After several years you will see more accurately, and render what you see more faithfully. Also, with practice, comes an intuitive sense of how to tackle a subject.

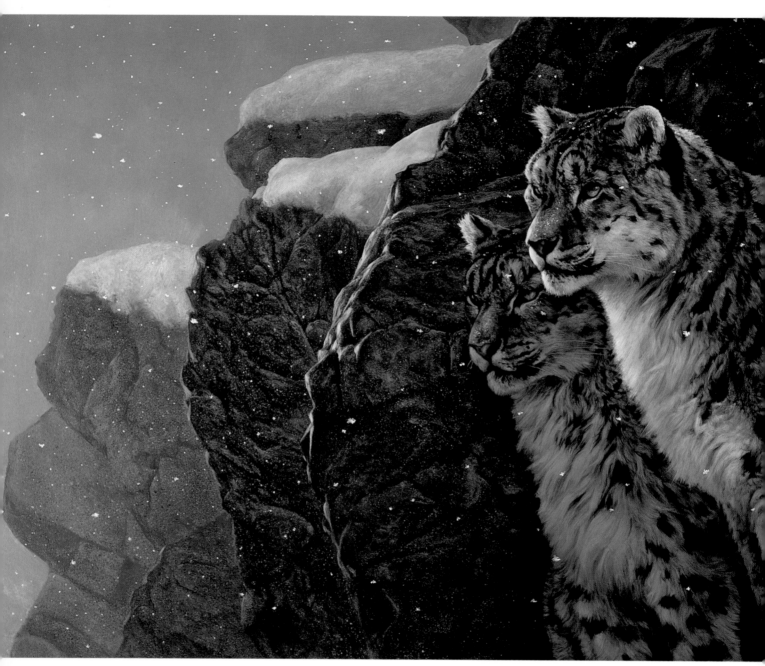

COMPANIONS *(Snow Leopards)*
Oil on Masonite, 25 x 50" (63 x 127 cm), 1993.

THE PAINTING PROCESS

T HERE ARE MANY WAYS to apply paint to a two-dimensional surface. The methods described here represent only a handful of the possibilities. However, the way that I paint, while neither the easiest nor the quickest method, effectively achieves rich and lifelike wildlife paintings.

Try these techniques—experiment with them and expand upon them. If they enhance your art, by all means continue to use them. And if they don't work, discard them for something more appropriate. I say that because, after all, that's what art is about—the personal expression of each individual artist. The methods and techniques of painting are important, but ultimately no more so than the design and emotional requirements of your painting. Pay attention to the design and "feel" of your work, too.

In this chapter I discuss important oil painting techniques—glazes, edges, color, for example, and ways of handling textures (for example, fur and feathers)—and specific areas, such as animal eyes, expressions, beaks, and so on. The last section focuses on painting animals in other mediums, including watercolor.

Oil Painting Techniques

Whether you're starting a painting or just a new painting session, sit down and observe your subject for a while. Before you pick up a brush, take the time to notice the colors, textures, and solidity of your subject. Explore it with your eyes. Someone watching you may think you're just daydreaming, but it's a very important part of the creative process. Studying your subject allows you to plan your painting session, visualize your brushstrokes, and decide how you'll achieve certain textures. This way of working is far more effective than blindly jumping into the painting only to be sorry you painted it a certain way and have to undo it.

Paintings are done in stages—the underpainting (stage one), the meat of the painting where the details are added and concentrated on (stage two), and the finishing touches (stage three). After preparing the Masonite board with gesso (see page 17 for detailed instructions) I will generally begin a painting by laying down a simple drawing that I have transferred directly from the initial sketch on paper. It is on this drawing that I begin the underpainting.

THE UNDERPAINTING

The underpainting is the first stage of any painting. After the preparation to the painting surface, the underpainting is the underlying skeleton to the painting, the framework upon which the painting is built. Underpaintings can be quick and basic or they can be more refined and complex. They can be a basic laying in of overall colors and tones or a monochromatic version of the final painting. We will be

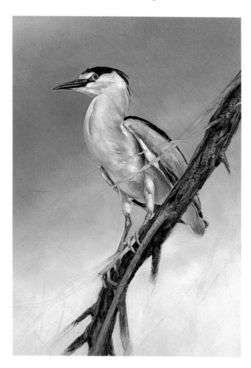

Even though this looks like a worked-up painting, it is actually just an underpainting, completed in a couple of hours. The bird was painted very simply with a couple of ½" flat synthetic brushes. I laid down a medium gray base color thinned with linseed oil, then painted the lights and darks into the wet paint, carefully painting around the forms to create solidity. The finished painting is at right.

BLACK-CROWNED NIGHT HERON
Oil on Masonite, 17 x 25" (43 x 63.5 cm), 1997.

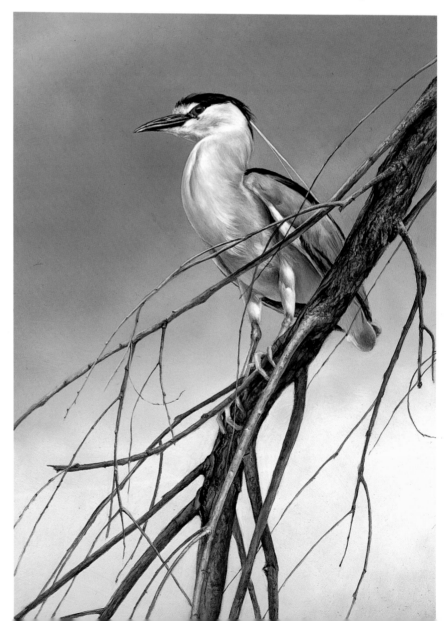

looking at the underpainting in terms of its underlying structural applications.

When you put down the underpainting, don't just slap color onto the board. Use the underpainting as a foundation for building form. Observe the lights and darks and lay them in carefully to create as solid a form as possible, one you'll be adding details and textures to later. Select the right brush for the situation, then pay attention to the direction of your brushstrokes. Think in terms of the solidity of the object you're painting and stroke your brush against the form, to create flat planes on the object (see below). Move the brush as though you're sculpting with clay. Without an underlying solidity, objects and animals may seem flat. The more solid-looking you make them now, the more presence they'll have later.

GETTING LUMINOUS COLOR BY GLAZING

Glazing is a technique that goes back to the days of the Renaissance, when it was used by artists like Leonardo da Vinci, Titian, and Michelangelo. Later artists known for glazing include Ingres and Goya. Their methods were slightly different from mine, but the basics are the same. Glazing is an important way of creating rich, luminous, and sometimes light colors without the addition of white. Glazes are usually worked over a light or "high key" underpainting. (Because of their transparency, glazes usually don't show up over dark colors.) A glaze is often not just put on and left, but is partially worked into with thicker paint in some areas for various effects.

Glazing produces a very different effect from adding white to the same color. White has a tendency to bleach out the colors and make them cooler. It also changes the color. For example, if you add white to alizarin crimson to create a rich, light version of this color, you'll end up with pink, not red. But if you glaze a thin layer of alizarin crimson over a dry white base, you'll get a rich, lighter version of the original color—like the effect of a stained-glass window with the light shining through. Another example: if you glaze a transparent red over a bright yellow you'll get an extremely bright, transparent, and almost glowing, orange.

The degree of thickness or thinness of the paint also affects its appearance. Burnt sienna out of the tube is very dark, but, thinned to transparency, it has a hidden, rich, red glow. Adding white to burnt sienna, however, changes the color and destroys its inner richness.

Try glazes in some areas of your painting to unlock the beauty of your colors, then use thicker versions of these color mixtures somewhere else in the piece. Using both thick and

Applying Glazes versus Adding White

To show you the effect of glazing, I charted six different colors. Each is handled three different ways (columns from left to right): (1) applied thickly right out of the tube; (2) thinned to a glaze with linseed oil, and (3) mixed with white. The six colors are burnt umber, burnt sienna, ultramarine blue, phthalo green, alizarin crimson, and cadmium red deep. (I added the cadmium to show you the difference between an opaque color and the other transparent colors.)

thin versions of a color increases the range of colors on your palette and adds interest to your painting.

To glaze, thin your paint with linseed oil or another glazing medium and brush on one or more layers of this thinned paint, letting each layer dry first before running the next one over it. The glazed color must be thin enough so the underlying paint is still visible but is now tinted the color of the glaze. Don't make the paint too thin or it will run, causing unwanted drips or droplets. (If that happens, just dab off the excess with a clean cloth.) If you want to make your own glazing medium, you'll find a list of formulas in Ralph Mayer's *Artist's Handbook of Materials and Techniques* (see Selected Bibliography).

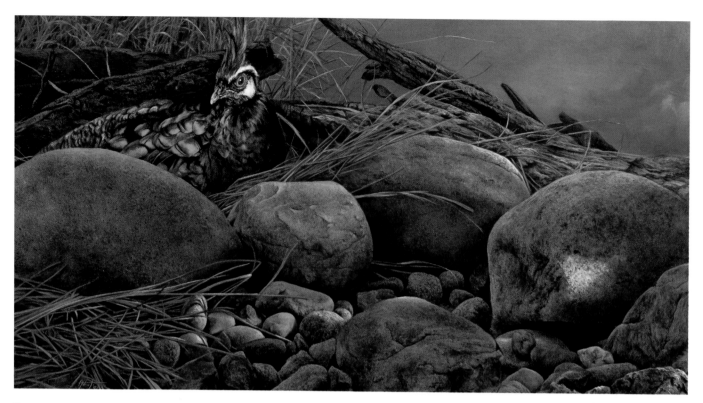

Palawan Peacock Pheasant
Oil on Masonite, 18 x 33" (46 x 84 cm), 1993.

The phosphorescent greens and blues on many bird feathers can only be truly captured by glazing. Since light bounces through the color to the white underpainting and then back to the viewer's eye, it reacts to glazes differently from opaque paint. The effect of glazing is one of richness and luminosity.

To get the green feathers and crest on this pheasant, I glazed phthalo green over a patch of white. Phthalo green, used thickly, is very dark, almost a black. But thinning it brings out its wonderful color, as is true with other transparent colors.

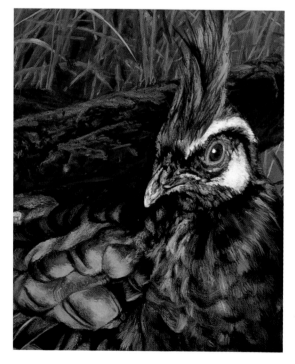

Rock Study
Oil on Masonite, 7 x 9" (18 x 23 cm).

I deliberately left this small study of a rock unfinished to show you the effect of glazing. I painted the rock so it looked like the stage at right. I left it light to prepare it for a glaze. When the paint was dry, I applied a thin glaze of raw umber and burnt sienna (see left-hand side of the rock). Notice how the glaze becomes deeper and richer, yet still shows the earlier brushwork below the glaze. Working into the still-wet glaze, I added a little burnt umber and burnt sienna to the underside of the rock to soften the edges and make the shadow look more convincing.

Glazing Wet-into-Wet

Instead of adding linseed oil to your paint and then applying it, you can put paint into an area prewet with linseed oil. This is called "working wet-into-wet." The result, a beautiful glaze, is the basic technique I use in all my paintings. Before beginning any part of a painting, I lay a thin glaze of linseed oil, either straight from the bottle as a wetting agent, or tinted with a color like a glaze. I also occasionally run several glazes over an area, letting them dry between coats, each time building up more color and richness, glazing until it looks right.

SOFTENING EDGES

One effect commonly overlooked in wildlife art is that of softening edges. When you study the art of the old masters, like Leonardo and Rembrandt, you notice that they direct the viewer's eye around the painting by interplaying sharp edges with soft ones, and by juxtaposing areas of high contrast with areas of subtler tones to create focus and selective interest in a painting. Soft edges add mood and atmosphere to a painting, and sharp, hard edges at the focus of the piece gives it more punch. The edges on much of today's wildlife art lack variety. They're mostly hard, and tightly detailed, with everything in the painting in equal focus.

It's easy to soften edges in oil paint. While it's still wet, simply drag one color into another, decreasing the pressure on the brush where you want the edges to blend. You can also blend two colors together that are side by side by stroking a soft, clean brush along the boundary between them.

Glazing Wet-into-Wet

To show you what a difference working wet-into-wet makes, here are two brushstrokes. The one on top shows a small amount of burnt sienna brushed onto the dry board. Below it, a stroke from the same brush with the same amount of paint was worked into a thin layer of linseed oil (deliberately tinted here so you can see it). The excess linseed oil was brushed away, leaving a stain of color rather than a puddle. Notice the difference in the quality of the brushstroke and fluidity of the paint in the second example. Can you see how glazing wet-into-wet lends itself to depicting fur and feathers.

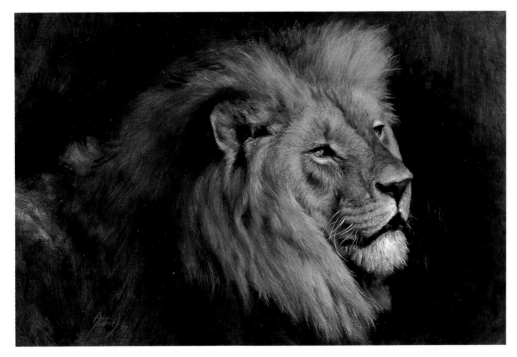

LION PORTRAIT
Oil on Masonite, 8 x 12"
(20 x 30.5 cm), 1992.

I softened everything but the head. To sculpt the head so it looks three-dimensional and create a focus as well, I put the lightest lights on the muzzle and kept the sharpest edges in the face. By letting the rest of the portrait fade away and blur out, I created focus as well as an area for the eye to rest.

PAINTING FUR

Fur and feathers make up a great part of painting animals, so it is a good idea to strive to depict these accurately in your work. There are many kinds of fur, with variations in texture, color, and length. As an animal artist, you must be very aware of these differences and make each type look distinct. In fact, the greatest danger in painting fur is using the same approach for painting all the different types.

Pay particular attention to variations within the fur. Fur doesn't normally lay even, straight, and appear as if it was just washed, conditioned, and combed. It comes in clumps and in a myriad of textures. To depict this accurately, vary your brushstrokes and stroke directions. If all your strokes are the same, and in the same direction, your work will look contrived and unnatural.

To portray the softness of fur, it's more effective to use wider rather than finer brushes. A small fine brush used to cover a large section of fur can make it appear stiff and wiry, looking more like plastic than hair. That's where working wet-into-wet with a flat bristle brush works brilliantly. If your bristle brushes are a bit worn and frayed, so much the better. Each bristle of the brush becomes an individual hair on the animal.

Also, experiment with the amount of pressure on your brush. Slightly harder pressure will increase the area and solidity of the dark color. A lighter touch will create finer, more delicate lines. Also experiment with different kinds of brushes, some more frayed, some more compact, to see the different effects they have. You'll need a variety of brushes and brushstrokes to achieve these differences in texture.

General Procedure for Painting Fur

These are the basic stages of painting fur. This technique is the basis for painting all types of fur and feathers. Differences lie not in technique but in the brushwork. Slight variations in brushes and brushstrokes can produce anything from short, bristly hair to long, soft feathers and anything between.

1. *Applying the Basic Color.* Working wet-into-wet, I mix a basic midtone color appropriate for the particular section of the animal I am working on. Then, because I want a glaze, I thin the color with linseed oil to achieve a slightly transparent color when it's brushed on so there's no build up of paint on the surface. Then I brush the color onto the animal. I only work on one small area, like the head, at a time. Then finish it and move onto the next.

2. *Adding the Darks.* While the area is still wet, I mix a darker value of the midtone color—by adding a dark, such as burnt umber, and a little ultramarine blue to the basic midtone color. Then I put just enough paint on the brush to coat the bristles—don't overload the brush with gobs of paint—and with *no* linseed oil—then gingerly brush the dark color into the midtone on the painting.

3. *Adding the Lights.* Now I apply the light areas of the fur. I mix a light version of the hair color—for instance, yellow ochre, raw sienna, and a little titanium white—and apply it the same way as the dark, letting it bleed smoothly into the midtone color. Working wet-into-wet is effective for painting fur because it leaves a soft edge with no hard lines or sharp delineations. You can always add sharp lines later if you need them.

4. *Simulate Clumped Fur and Hair with a Frayed Brush (optional).* When color is stroked on with a frayed brush, it simulates the natural clumps of fur or stray random hairs on an animal. When you compare the ease and effectiveness of using a frayed brush as opposed to painting each individual hair with a tiny brush, you'll see a real difference in believability, naturalness, and ease of application. Of course, not everyone uses this technique. More than a few artists are committed to rendering hair and feathers with a tiny brush. The results, when they work, can be breathtaking, but it takes practice and a lot of patience.

Painting Fur with Glazes

Now look at the way I build the illusion of fur with a succession of brushstrokes. As before, using the same brush, I paint raw umber into pure sun-bleached linseed oil, creating a glaze. By varying the amount of paint and the pressure on the brush, I can simulate fur remarkably well.

Pushing versus Pulling the Brush

The direction you move the brush also affects the look of texture. The preceding exercise showed a normal brushstroke, created by pulling the brush. Now notice what a decidedly different effect you get by pushing the brush—working the bristles into the board (see photo). Pushing the brush into the paint may be harder on the brush, but the effects are great for simulating short, bristly hair—and far superior to the results you get with a thin, pointed brush.

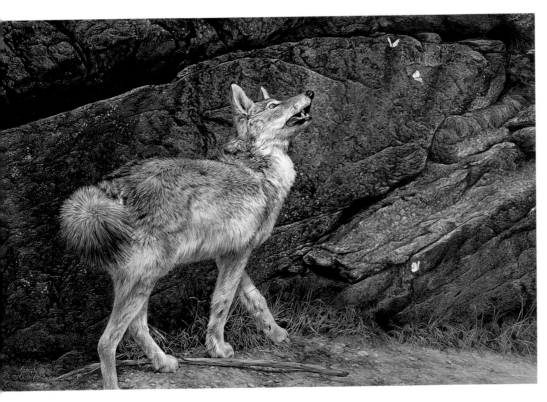

AT PLAY
(Coyote with Butterflies)
Oil on Masonite, 26 x 40" (66 x 102 cm), 1995.

I painted this coyote in the Museum of Natural History in Denver. There I was able to carefully study the various textures and colors of the fur. Notice the difference between the soft white fur on his throat and belly; the longer, coarser fur on his lower spine area and tail; and the short fur on his face. Also, notice how the hair lays differently all over the body. In some areas you can see under and into the hair, while in others you can't see in at all. To effectively portray fur, you must use your power of observation to distinguish all these subtle differences.

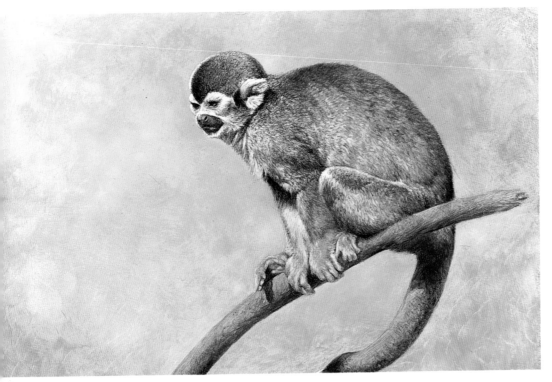

SQUIRREL MONKEY
Oil on Masonite, 10 x 16" (25 x 41 cm), 1992.

This is an example of short, shiny hair. The sheen on the fur is the result of rich highlights and apparent shadows. I kept the light areas bright and clean. The yellowish areas are made with a combination of raw sienna and cadmium yellow. As the color goes into the reddish brown, I added burnt sienna, applying it thinly to keep it bright. This is where glazing comes in handy, allowing the shine on the coat to be as rich as possible.

Wolf

I begin with a basic drawing on gessoed board, then cover it with a thin coat of acrylic paint—here, a light gray—to seal the drawing. When it's dry, I tone the board with a thin coat of oil color—in this case, cobalt blue with a little raw sienna and burnt umber, thinned with linseed oil. I do this just to wet the board so that I can see my values and colors better. Then I let it dry. (I'll cover the drawing and toning process in more detail in the next chapter, page 96.)

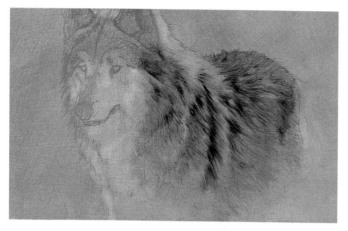

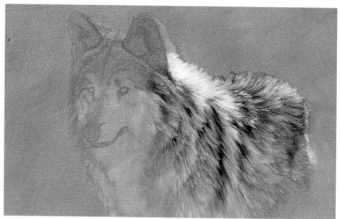

Laying in the Basic Fur Texture
After I apply a base coat, I apply the fur texture into the wet, lightly colored oil. Working with an old, frayed Winsor & Newton No. 3 flat bristle brush, I apply both a black (ultramarine blue and burnt umber) and brown tone (raw sienna and burnt umber). Each color is applied in a separate layer by brushing on a small amount of paint. (The bristles should be just barely covered by color.) By lightly stroking in the direction of the fur, I can immediately simulate fur texture.

Adding the Lights and Shadows
With a similar brush, I apply titanium white to the still-wet base coat. I softly brush it in, allowing the brushstrokes to indicate the direction and texture of fur. Then I add a little of the black mixture and some cobalt blue to the white for the shaded areas and let it dry.

Refining the Tones
I start the process again with a thin glaze of linseed oil into which I brush small amounts of cobalt blue to cool down the shaded parts. I add a combination of raw sienna and burnt sienna for the brown tones. Then I put a little purple (cobalt blue and alizarin crimson) for the section in the light. Finally, I brush black (ultramarine blue and burnt sienna) into this glaze with the brush I used in the previous step.

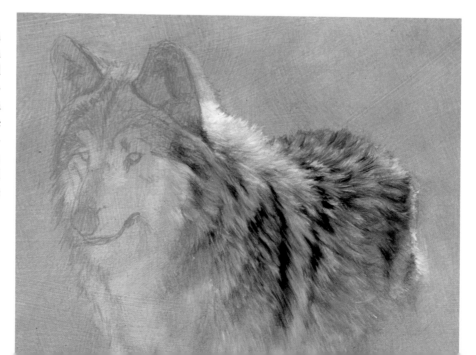

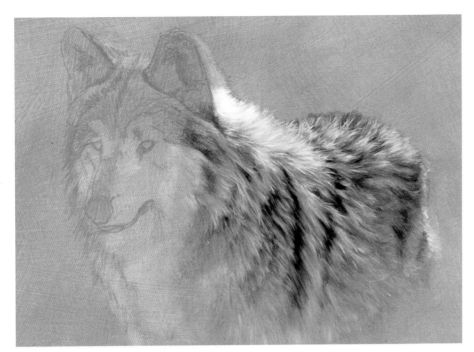

Adding Highlights and Details

For the highlights, I work titanium white into the still-wet paint. With a frayed Winsor & Newton University No. 3 flat bristle brush, I brush various amounts of white onto the fur, more on the light areas on the nape of the neck, and less in shaded areas. Then I use a Winsor & Newton Series 540 No. 000 fine-pointed brush to put in stray and distinct hairs. Then I move to another area of the painting.

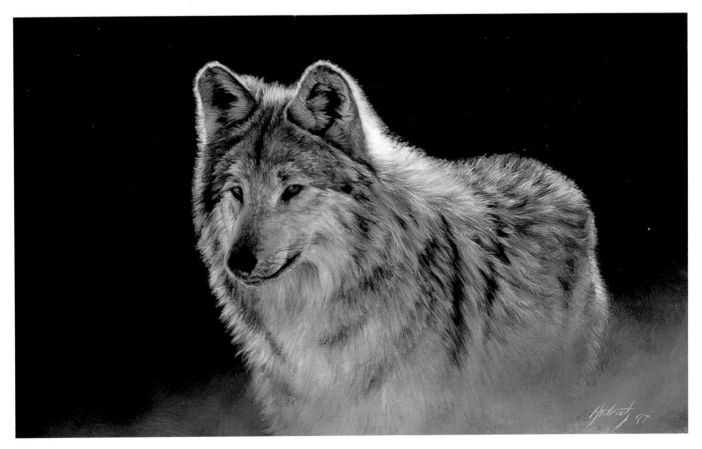

WOLF
Oil on Masonite, 8 x 13" (20 x 33 cm), 1997.

The Finished Painting

I continued the same technique over the entire animal, then put in a black background to really pop the image out.

Painting Feathers

Feathers can usually be handled like fur since many feathers actually look like fur, with multiple "hairs" making up each feather. But on certain birds—like a bird of prey or a duck—the feathers lay flat, making it look almost like a smooth, hard surface. Painting this requires a different approach—paint it as you would any hard form.

PEREGRINE FALCON
Oil on Masonite, 9 x 12" (23 x 30.5 cm), 1996.

The smooth rounded feathers of this raptor lay perfectly flat. Notice the variety of tones in the feathers, and the way the light catches different parts of them.

WHITE STORK
Oil on Masonite, 14 x 18" (35.5 x 46 cm), 1989.

Feathers can be hard-edged and detailed, but if they're soft and flowing, as they are here, don't over-render them and make them too refined or you may lose the soft, loose feeling.

Painting Eyes

Since the eyes are commonly the focus of a painting of an animal, they must appear solid and convincing. An animal's eyes can make or break a painting, especially if it's seen up close, as in a portrait. Eyes have depth, liquidity, and a rich, almost glowing color. Dull, flat, lifeless eyes can drain the life from your painting, while rich, expressive eyes can make your work sing.

Study the eyes of different animals. Notice how the shape and color differs between animal species and between animals within the same species. Also notice that one eye may reflect more light than the other. Learn to look for such subtle differences. Some eyes are a solid color, while others change color from the center to the outer part of the iris or colored section. The colors of animal eyes mirror most of the colors of the rainbow, so it's important to really look at your subject and note the color variations between both eyes and within the same eye.

If you look closely at an eye, you'll also see the surroundings reflected in it. But the most noticeable reflections are the lightest or brightest areas of the environment—usually the sky and the sun. To make an eye look solid, you need to add the highlight and light that reflects on the glassy orb or light part of the eye. You also have to add the reflections.

To make the reflections in the eyes seem real, you must know where to put them and how much information to include. This depends on the sky overhead. If the sky is clear and the sun is in front of the animal and hitting the eye, then the reflection in the eye will be blue with a white spot. If the sky is overcast, the reflection will be grayer. If the eye is in shadow, the sun probably won't reflect in it at all.

The reflection is generally on the top part of the eye, but doesn't cover the whole eye. All you need is a small section of blue or gray. To give the eye an extra punch, you can make the reflection of the sun pure white or white with a dab of yellow.

A Variety of Eyes

Compare the following close-ups of eyes from several paintings and types of animals and birds. Can you guess, just from looking at the eyes, what species of animal or bird it is?

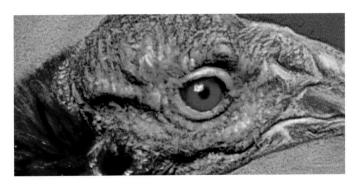

Vulturine Guinea Fowl

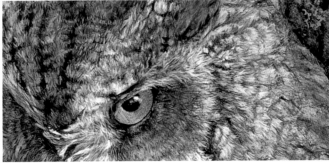

Screech Owl

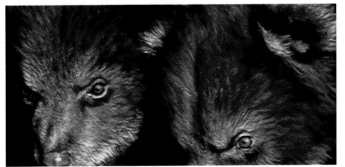

Black Bear Cubs

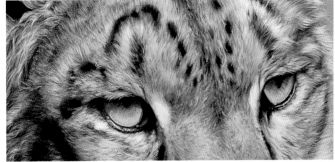

Snow Leopard

Painting Beaks and Horns

Even though beaks and horns are composed essentially of the same material, they come in different shapes, textures, and colors, making it difficult to suggest a basic standard way to paint them.

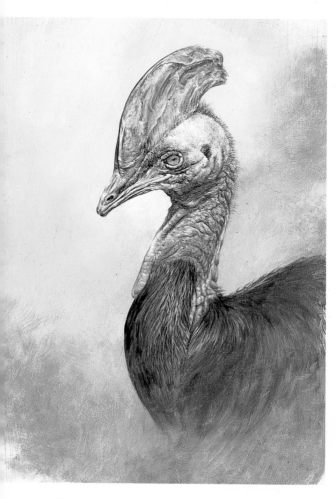

CASSOWARY
Oil on Masonite, 12 x 16" (30.5 x 41 cm), 1992.

This strange-looking bird head is mostly made of the same substance as beaks. The texture of its bony substance varies from smooth on the beak itself to ragged and broken-looking on the "horn." The colors also vary from purple-blue to orangy-brown. The more aware you are of the subtle colors in your subject, the more accurate it will appear. In this case I noticed subtle light blues on the front of the horn and a rich, raw or burnt sienna running down the side.

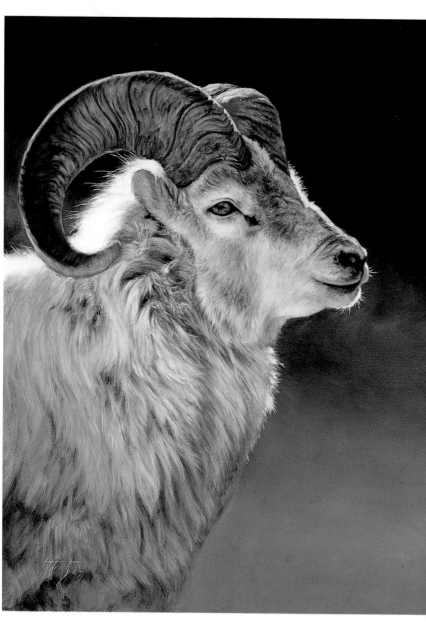

DAHL SHEEP
Oil on Masonite, 11 x 14" (28 x 35.5 cm), 1997.

Look at the curled horn on this sheep. Notice the repeating shape of the growth lines as they move down the horn and the variations in colors that appear around the horn. Rather than being a single color, the horn has patches and blotches of many colors and values. Painting these subtle color variations make the horn look more natural.

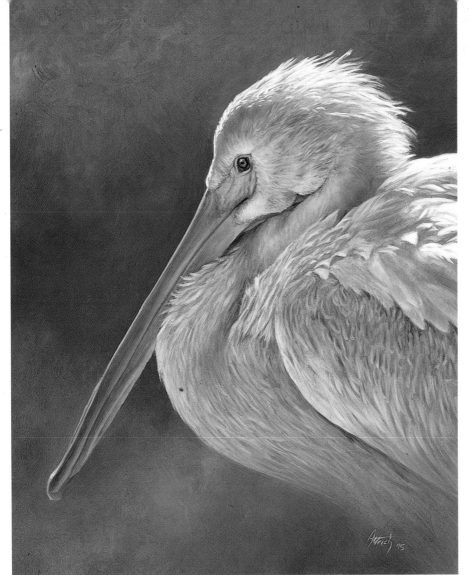

PELICAN PORTRAIT
Oil on Masonite, 11 x 14" (28 x 35.5 cm), 1995.

Most beaks are smooth and colorful, but they have a lot of small valleys and subtle nuances in their coloration. This beak was painted with a basic tone of cadmium orange with a little alizarin crimson, and with some cerulean blue in the darker parts. While it was wet, I worked the light areas into it with a little cadmium yellow light and white. When it was dry, I gave it another thin glaze of orange to make it look deeper and richer.

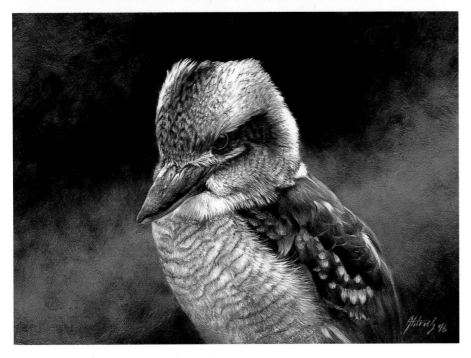

KOOKABURRA
Oil on Masonite, 10 x 14" (25 x 35.5 cm), 1997.

This painting shows how light reflects off a beak. Notice the highlighted area on the upper top of the beak and the dark part along the side, with an almost glowing orange on the underside.

Capturing Animal Expressions

Animals have a broad range of expressions. The slightest change in a facial muscle—the tilt of a head, the direction of an ear, a slightly raised eyebrow—can affect the expression and mood of an animal, shifting its expression from intense to whimsical to thoughtful to powerful. That's why it's so essential to know what you want to communicate and make sure the image and its components support it.

Let's take a moment to distinguish between capturing an animal expression in a drawing and in a painting. When you're drawing (say you're at a zoo, as discussed on page 28), you're very much aware of line, and trying to capture the expression of the animal you're drawing. But when you're painting, you can choose from a range of expressions, an important choice, since it may set the mood of the piece. So if you choose a powerful expression, you'll have a powerful piece, a goofy expression will create a goofy piece, and a soulful expression will turn out a soulful painting. In animal paintings in general, the expression is not always the most prominent thing, but you do have to choose the right expression because it's such an important part of the painting. This is especially true when you're doing an animal portrait.

Notice the difference in animal faces. The faces of some species are more diverse than others. Primates and predatory mammals, such as canines and felines, for instance, have some of the most expressive faces, whereas birds and many small mammals seem to have almost fixed expressions, making it hard to decipher variations in facial nuances.

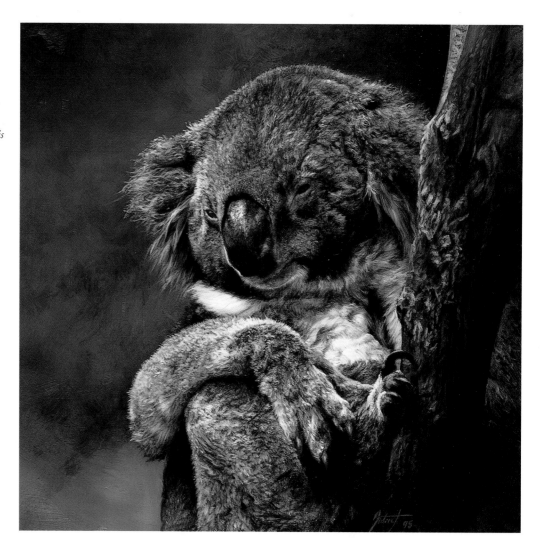

KOALA
Oil on Masonite, 14 x 14"
(35.5 x 35.5 cm), 1995.

The attraction of this painting is primarily the koala's soft, sleepy expression and its vertical reclining posture, with one arm draped over its knee. The whimsical expression is familiar—we've probably all felt this way at one time or another.

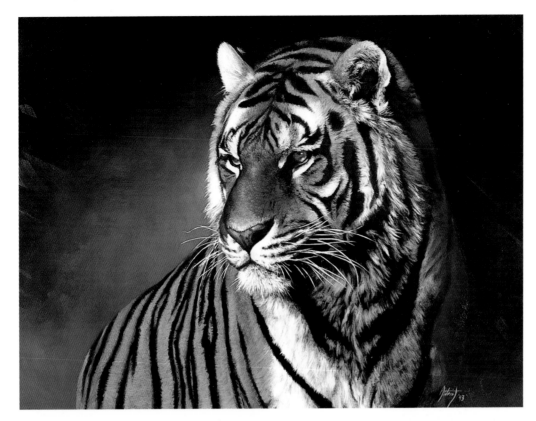

MAJESTY
(Siberian Tiger Portrait)
Oil on Masonite, 16 x 20" (41 x 51 cm), 1993.

Certain animals, such as the big cats, have an innate intensity and appearance that automatically makes an impression on anyone who sees them. A tiger's basic expression is about as powerful as a face gets. The intensity in its eyes, the shape and lines of its face, and its massiveness all contribute to its splendor. When painting these cats or similar animals, be sure to choose the photo references that best express those qualities.

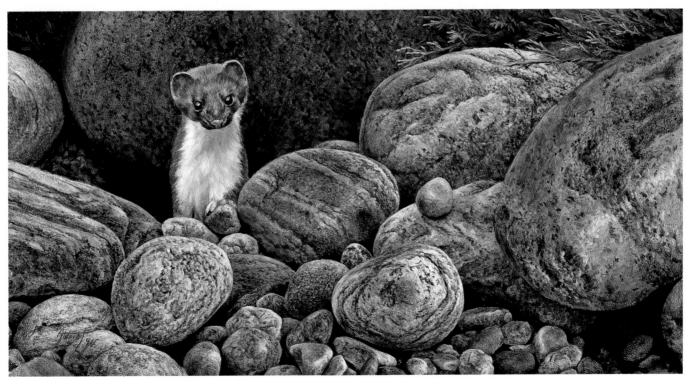

WEASEL IN ROCKS
Oil on Masonite, 10½ x 20" (27 x 51 cm), 1994.

Weasels and related species, such as ermines and ferrets, have very intelligent expressions. In this painting, I wanted to say something about the quixotic, almost human expression of the weasel. The subject of this painting is, in fact, simply, the weasel's expression.

Conveying Body Language

An animal's body can be as expressive as its face, and indicates the activity it's engaged in. Whether its resting, playing, hunting, or simply being alert, its body reflects these states. So when you decide what message your painting will portray, consider how the animal's body will convey that message. Notice if the muscles are taut or relaxed. Pay particular attention to the specific character traits of various animal species. For example, wolves display many communicative body postures: dominant, submissive, inquisitive, aggressive. All the many postures look completely different, and it's important to be familiar with them when painting a wolf.

Each animal species—from monkey to bird to antelope—has its own version of this posture. So become familiar with the animal you want to paint so you can develop an instinctive knowledge of its body language.

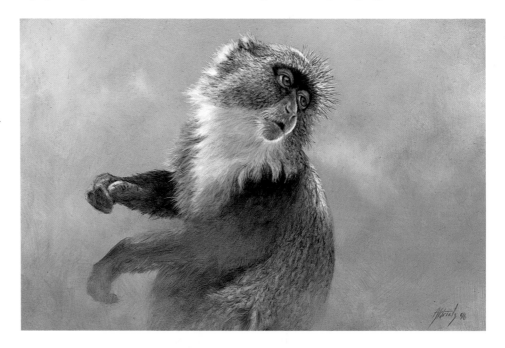

LOOKING BACK
(Sykes Guenon Monkey)
Oil on Masonite, 10 x 15 (25.5 x 38 cm), 1996.

This is a classic primate pose designed specifically to show the characteristic inquisitiveness of monkeys and the way they move their bodies in distinctly primate ways.

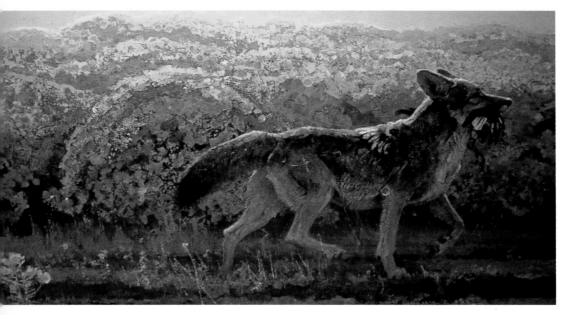

BOB KUHN
KING OF THE ROAD *(Coyote)*
Acrylic on board, 18 x 36" (46 x 92 cm), 1980.

The postkill, almost prancing trot this coyote displays is reminiscent of many canine animals. Notice how, with a minimum of detail, Kuhn captures the solidity and structure of this animal. Placing the coyote practically leaving the scene adds tension and the sense of it being a fleeting glimpse.

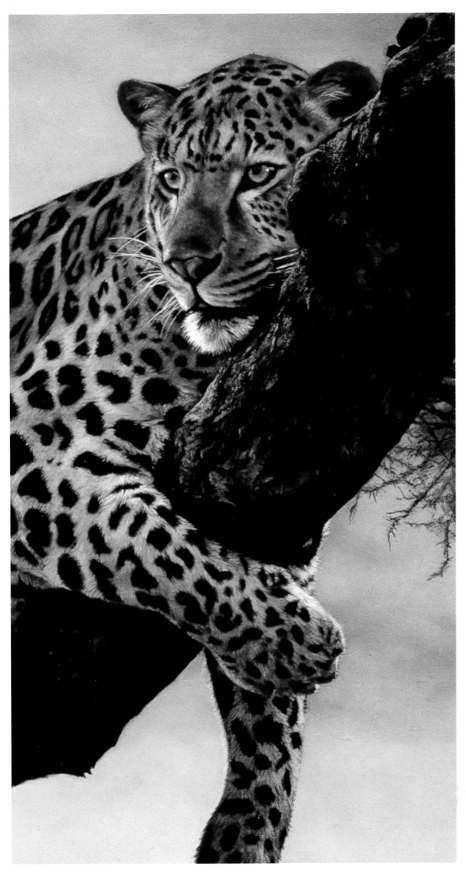

SIESTA *(Leopard in Tree)*
Oil on Masonite, 10½ x 20" (27 x 51 cm), 1994.

The big cats have powerful bodies, built for speed and power. Because of their extreme outlay of energy when hunting, they're quite well known for their capacity to rest. These catnaps and the characteristic, almost comical, relaxed look so familiar to cat owners invites the viewer to empathize with that relaxed state. Despite this look, however, the cat is very much aware of its surroundings. So the painting actually shows two states of mind.

Capturing Action

Capturing an animal in action in a painting is simply a matter of copying a photo of an animal in action. Creating the illusion of motion requires specific methods and skills. One way to do it is by selectively blurring parts of the animal. Another is by repeating other elements in the painting to echo the direction of movement.

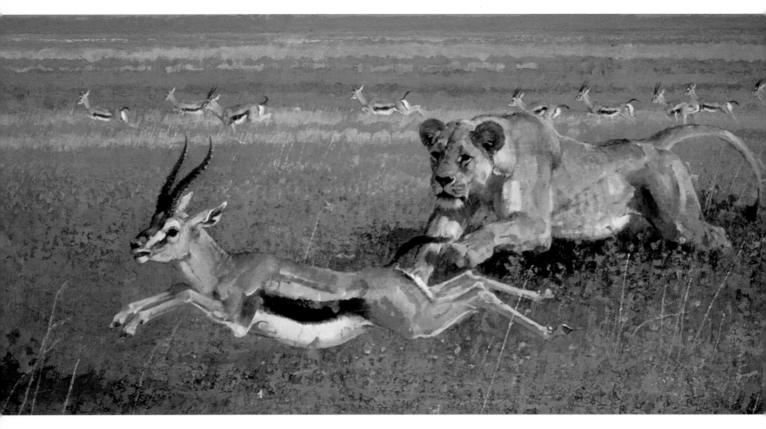

BOB KUHN
LIONESS CHASING TOMMY *(Thompson Gazelle)*
Acrylic on board, 24 x 48" (61 x 122 cm), 1978. Courtesy of the artist.

One of the undisputed masters of action in art, Bob Kuhn can portray a sense of action like nobody else. Lioness Chasing Tommy is a great example of his mastery of action. This painting portrays the hunt and all the activity that the hunt conjures up, and it's simply filled with action. The bodies of the lioness and the gazelle, with their many curves, add to the feeling of the bounding animals. The line of distant gazelles increases the degree of motion in the piece, as does the painting's long shape. The animals are solid and their muscles taut, yet there isn't an overemphasis on detail, which tends to halt action.

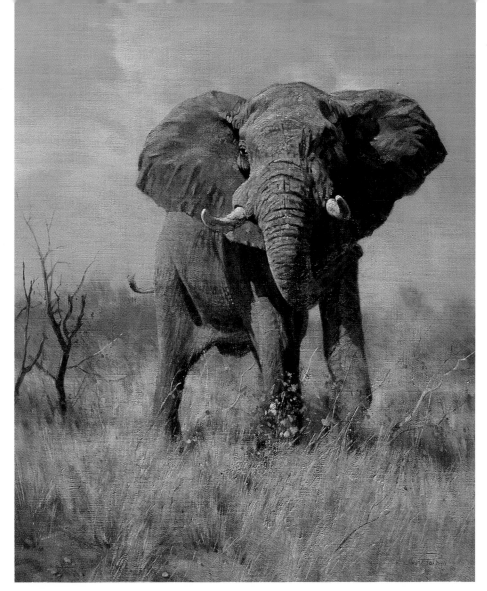

DINO PARAVANO
THE CHALLENGE *(African Elephant)*
Oil on canvas, 30 x 24" (76 x 61 cm), 1996.

Anyone who has visited Africa and ventured too close to an elephant has probably seen this quite impressive body posture. The African elephant can be one of the most intensely intimidating creatures on the planet and this "mock charge" is designed to turn away another animal—very effectively. This image is from an actual situation Paravano experienced. He was able to get so close that the elephant decided to let him know that he was too close. The spread ears, raised head, and alert body posture indicate this classic elephant maneuver. Since the moment of charge is so fleeting and the elephant moves about so much, it's not possible to do a painting right then and there, so this is where having a camera is essential. But, because this moment became ingrained in Paravano's experience, he was able to add this personal element into the painting, thus creating a very convincing and impressive piece.

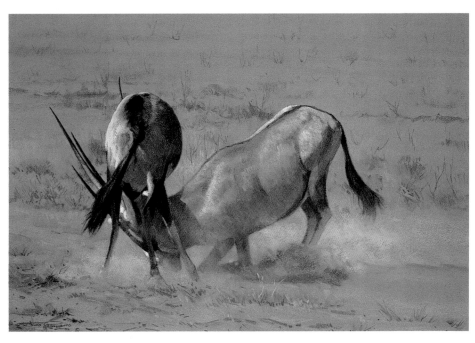

DINO PARAVANO
DUEL IN THE DESERT *(Oryx)*
Pastel, 21 x 29" (53 x 74 cm), 1992.

This is a great example of effective action in a painting. These oryx are obviously involved in a mating duel. Their muscles are taut and standing out. The dust kicked up by their hooves adds to the look of rapid scuffing movement. The rest of the painting is loose and free of overly detailed material, which allows the painting to remain lively and animated. Too much detail stops the flow of the action and confuses the eye. The overall coloration of the animal is also light and doesn't weigh down the painting, as deeper or richer colors might.

Painting Rocks

The granulated look of rocks can be achieved with a simple and effective technique. Generally, after the initial block-in of the rock's basic colors and shape, you can add the granulated texture by spattering paint over it from a small container.

1. ***Preliminary Preparation.*** To begin, I lay the painting flat on a table or floor and mask off the areas with torn paper I don't want spattered. Then I mix the oil paint with a little linseed oil and turpentine until it's about the consistency of cream. Too much turpentine, and the paint will bleed and run; not enough, and the paint will be too thick to spatter. The right consistency should give you little dots of spatter.

2. ***Spattering the Rock.*** Then I dip a bristle brush or toothbrush into the paint and, holding it a couple of inches above the painting, gently pull back the bristles. When they spring forward, the painting is spattered with paint. Spattering with dark colors gives the effect of recessed holes. Spattering with light colors creates highlighted areas and light granules in the rock. A mixture of various colors will tint areas of the rock.

3. ***Final Touch-ups.*** When it's dry, I continue to glaze and add detail to sharpen certain areas and cover up light dots that are too distracting in dark areas.

Here is a painting in progress. At this stage I had just spattered different colors to texture the rocks. It looks like a soft mist, clouding up the sharpness of the image. Notice the large black spots on a layer of finer light blue spots and the white and yellow ochre spots, which might be a bit harder to see.

When it was dry, I repainted the dark and light patches of the rock and refined and clarified the rock without losing the texture of the spattering. I covered up some of the bigger spots. Although the spots aren't that noticeable, they add a textural quality that gives the illusion of pitted rock. The finished painting is shown below.

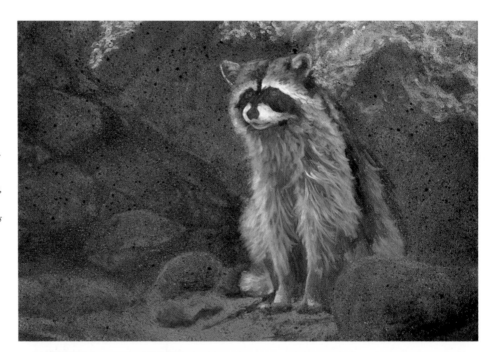

RACCOON
Oil on Masonite, 12 x 18"
(30.5 x 46 cm), 1996.

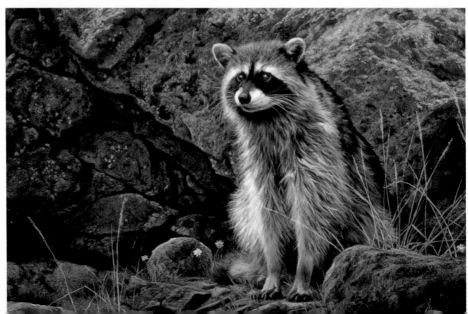

Painting Grasses and Flowers

Grasses and flowers require a different approach than painting rocks or fur, but the basic theory is the same. Plants have a general randomness that should be depicted if you don't want your paintings to look plastic or contrived. This randomness can be achieved by using the illusion of blades of grass and individual flowers rather than trying to paint each and every one.

For example, random and brushy strokes with a large bristle brush as an underpainting can add interesting texture to a field or grassy area. This could be accentuated with a few individual blades of grass using the edge of a University F (flat) brush rather than a fine-tip brush. As is often the case, when someone tries to render every blade of grass, the grass ends up seeming somehow unnatural, looking more like spaghetti or plastic. A large frayed brush can make grass look natural.

You could also depict the natural look of grass with the edge of a palette knife with paint on it, pulling it up in the direction of the grass. This is a slow process since you only get one or two strokes before you have to load up the knife again.

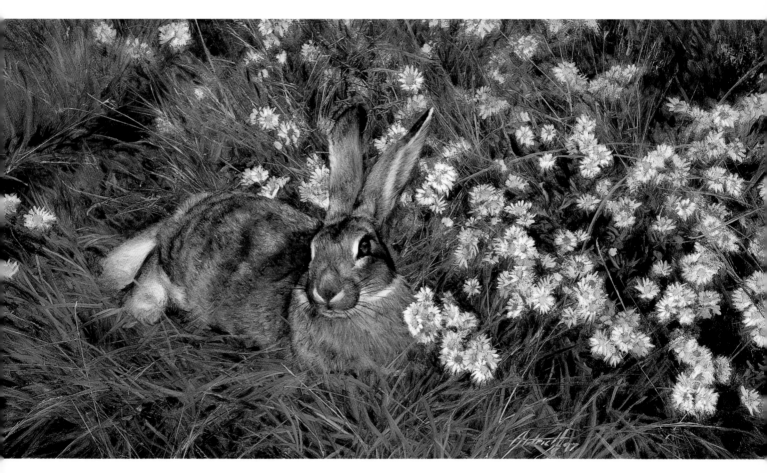

JACKRABBIT
Oil on Masonite, 8 x 15"
(20 x 38 cm), 1997.

In this example, I've used both a palette knife and selective brushstrokes for the convincing look of grass. The grass was painted in layers, and I slowly built up the textures and colors before I added the long grass blades. Notice that the flowers are all different shapes, sizes, brightnesses, and degrees of clarity. Keeping the flowers looking natural—all individual and different—was my utmost concern. They're not all perfect and glistening white in nature, so I depicted them very naturally. Some are in shadow, some are turned to the side, and some are hardly rendered at all.

Working in Watercolor

Although I usually paint in oil, when I start to get stale or too methodical I turn to watercolor. Watercolor is great for studies and certain subjects, or just for a change of pace. By its very nature, watercolor can do things oil can't do, and it's refreshing to do something a little different now and again. I won't be discussing specific watercolor techniques here since my focus is on painting animals in oil, but there are many good books on the subject from which you can learn this (see Selected Bibliography).

One major difference between watercolor and oil paint is that with watercolor you generally work from light to dark whereas in oil you work from dark to light. One of oil's best qualities is its ability to start with a midtone painting, add darks and then pull light areas out of the darkness. But because of watercolor's transparency, you start with a white surface and gradually go darker to create your painting.

LION *(Number 1)*
Watercolor on Arches paper, 7½ x 8½" (19 x 21.5 cm), 1990.

This painting is loose and transparent, in the style watercolors are famous for. I allowed the paint to create textures and patterns on its own rather than force an outcome. I started by laying a wet wash of ultramarine blue on the face, taking care to let my brushstrokes show. When it dried, I added burnt sienna, letting some of the paint overlap the blue and putting some over the rest of the head. After it was dry, I loosely worked wet paint over the head, darkening certain areas while trying not to get too tight. The only detail occurs in the eyes, and on the nose and mouth.

LION *(Number 2)*
Watercolor on Strathmore illustration board,
7½ x 12" (19 x 30.5 cm), 1994.

This painting is opaque and refined. I started it like the preceding painting, with loose washes of color, but my brushwork became more controlled. I mixed the watercolor more opaquely (straight out of the tube without much water) and applied it more thickly. I built up the raw sienna and burnt sienna around the face and mane in successive layers of paint, each one making it look richer. I was much more conscious of minute details in this one and used small sable brushes to render them. The background , a thick mixture of lamp black and burnt umber, with a few spots of yellow ochre, has an opaque quality.

This rule is not absolute, since watercolor can be applied opaquely and oils can be put on transparently, but it is a general approach to the mediums. In the two watercolors of lions on the facing page—and in the wolf portrait—I show two ways of handling watercolor: loose and washy versus tighter and more opaque.

TAKING ADVANTAGE OF WATERCOLOR'S ASSETS

Watercolor has a mind of its own. It runs, bleeds, and is harder to control than other mediums. But these very characteristics can lead to some wonderful effects. Watercolor is at its best when it uses its assets. The medium has such a wonderful range of abilities, it's a shame to not let these strengths shine through.

Take its fluid, washy quality, for example. Many artists are afraid to pick up the medium because they can't control it. Well, that's the point. Areas of washy color in one area can accentuate detail in another area and give focus to a piece.

Watercolor is versatile. It can be used for the loosest of washes or the tightest of detail. It can be free, uncontrolled and spontaneous or thoughtfully manipulated to achieve stunning clarity. It can be used for quick sketches in the field or for meticulous finished paintings in the studio. It's this diversity that gives this medium its wide appeal and intrigue.

It's always fortunate when an artist uses paint so the viewer can enjoy the subject as well as the paint quality and great brushstrokes. What's striking about the paintings here is that the artists let the paint run and bleed while still retaining the detail and focus. These artists use watercolor in a way that gives their art life, spontaneity, and rich color while still retaining the solidity and realism of their subjects.

WOLF PORTRAIT
Watercolor on hot-press watercolor block, 7 x 11" (18 x 28 cm), 1995.

This wolf portrait is a good example of combining thin washes with tight detail. The background was a simple wash of color with spatters of paint applied into the wet wash, a technique that creates great effects. Much of the wolf was painted with a dry brush technique. In doing drybrush painting, much of the water is squeezed out of the brush before it is used, giving the illusion of each bristle on the brush making an individual hair.

TIM PRUTZER
BONGO
Watercolor on 300-lb hot press Lanaquarelle paper, 11 x 15" (28 x 38 cm), 1996. Courtesy of the artist.

This watercolor shows the richness watercolor can achieve. This painting was motivated by color alone and is a good example of the glow of watercolor, which is what watercolor does so well and is unique to the medium. Prutzer wets the paper in specific areas then paints into it with richly pigmented water. The pigment disperses into the prewet area and, as more and more pigment is added, can become very rich and saturated. The texture of the paper adds to the look of the paint. It is a wonderful effect when dry.

THE WATERCOLORS OF ROLAND JONSSON

Roland Jonsson is a young artist who produces watercolors that have the look and character of the work of master artists who have been painting their for entire lives. He paints primarily on Arches paper or on a Swedish handmade paper called Lessebo that has a fine grain. He says the primary advantage of Arches is that it withstands many washes and layers of paint without breaking or getting rough. He does quick sketches and studies in the wild, then finishes the painting in the studio, using both his studies and models he has collected (dead, frozen birds) or borrowed from a conservator. His painting process is time-consuming and difficult to reproduce in the field.

Jonsson's paintings generally go through several stages before they're finished. Each stage takes a long period of time. Many paintings are made up of multiple washes. Some are left, others removed in the final painting. Sometimes he works into certain areas and, as it dries, concentrates on an area that interests him, adding more color and details to it. Each painting offers a different challenge and thus a different approach and process. There are no set procedures. Each painting demands its own solutions in order to become good.

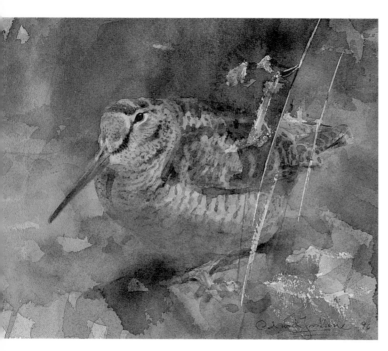

Roland Jonsson
WOODCOCK
Watercolor paper, 6 x 8" (15 x 20 cm), 1996.

In another example of his remarkable ability with watercolor, Jonsson shows us a scene of a woodcock with a simple background tone and an indication of foreground grass and leaves. This style of painting—just indicating subjects rather than showing every little detail—lets the imagination create the scene for you. In this way, Jonsson creates a mood and the piece takes on a life of it's own.

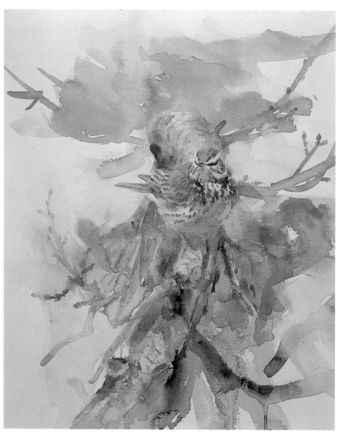

Roland Jonsson
REDWING
Watercolor paper, 15½ x 19½" (39 x 49.5 cm).

In his bold, fluid strokes, Jonsson is able to convey something more than just an image of a bird on a branch. The painting is as much about the paint as it is about the subject. He is able to let the quality of the watercolor stand out powerfully without losing the image of the bird. His colors are rich and flavorful, yet not outlandish; his strokes expressive, yet controlled. This way of painting scares many artists because it's not easy to let the watercolor do its thing while keeping the subject looking real. But artists like Jonsson remind us that it's very possible to create this kind of effect. It just takes quite a bit of experience.

USING WATERCOLOR FOR STUDIES

Thanks to its quick drying time and fluid application, watercolor makes an excellent sketching medium, great for color notations and quick sketches. The following studies were done on location in the museum, zoo, and even at an art show.

THE VIGNETTE

A vignette is generally an image of a subject drawn or painted against a white surface, with no background. The subject may appear to "float" on the surface—swimming in the middle of the page, or may be "weighted down," connected to one or more edges of the paper—for example, a bird perched on a stick that goes off the page on one side.

The vignette is an effective and elegant way to paint or draw. Its very simplicity makes the image really stand out. Birds are the most commonly vignetted subject because their elegance and grace lends itself well to this. The watercolors of Fenwick Lansdowne, Raymond Ching, and Chris Bacon are remarkable examples of the use of the vignette. I find that watercolor lends itself better to vignetting than oils, but some artists have made some very effective vignettes in other mediums.

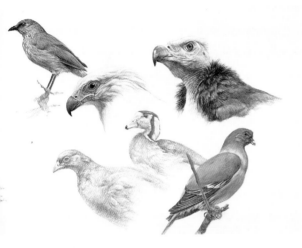

MULTIPLE AFRICAN BIRDS
Pencil and watercolor on hot-pressed watercolor block, 18 x 24" (46 x 61 cm), 1993.

I did these studies from museum mounts. I wanted to go one step further to show color. Watercolor is a wonderful progression from pencil. I applied the watercolor in thin, controlled washes, building up tones and colors gradually. Rather than just describing the colors you see with penciled notations of color, you can actually indicate the colors that are there in watercolor and use it as a very accurate reference.

FIELD STUDY
Watercolor on cold pressed watercolor block, 14 x 18" (35.5 x 46 cm), 1994.

This is a quick study, done in the field, indicating the colors and overall impression of the view I chose. Its portability, quick drying time, and ability to make broad, loose, expressive strokes makes watercolor an excellent medium for studies.

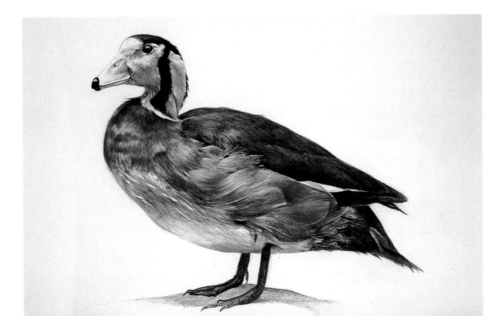

PYGMY GOOSE
Watercolor on hot press block, 13 x 17" (33 x 43 cm), 1993.

This was painted entirely on location in the Denver Museum of Natural History. I used thin watercolor glazes, built up gradually. This kind of painting uses no broad washes and starts at one point and literally is completed as it goes down the bird. It shows the details of the feathers very effectively and really even better than a photo as reference for future paintings.

Experiments in Mixed Media: Crayon and Oil

Working in a new medium expands my artistic boundaries and allows me to see things in my work I might not have seen before, such as different ways to depict form, colors never before used, and a variety of textures not easily created in my usual mediums.

One technique I learned in college that has generated interesting results involves using a mixture of crayon and oil. This unorthodox technique combines the best of drawing and painting. I don't use ordinary crayons but work with a wax/oil-based crayon made by Caran d'Ache. Between coats I spray the surface with a fixative like Crystal Clear.®

1. *Drawing the Forms.* I begin drawing right away on the brown, ungessoed, smooth (unsanded) Masonite. Working in white and purple, as I usually do on the brown surface, I draw in all the forms.

2. *Indicating Lights and Darks.* I draw indications of lights and darks, working until the surface is solid and refined.

SUNRISE *(Canada Geese)*
Mixed media (crayon and oil), 25 x 42"
(63.5 x 107 cm), 1988.

This painting was done in an oil-wax crayon technique done exactly as described above. Notice the many colors I used throughout the painting. This technique worked especially well for grasses because the crayon strokes simulate blades of grass so wonderfully.

3. *Sealing the Drawing.* Then I spray fixative over the surface to seal it. If I worked colors over an unsealed underdrawing, they'd mix with the colors below and get muddy.

4. *Creating a Colorful Base.* Then I cover the board with a dozen or so colors (usually the lighter primaries, secondaries, and other bright colors), applied in no particular direction, just putting the colors all over to give a colorful base to the drawing—something I normally don't do.

5. *Restating the Colors.* Then I spray on another layer of fixative and restate different areas of the painting with the appropriate colors, working slowly toward a realistic painting. If I wanted to go one step further, I'd fix it again and continue to paint thin glazes of oil paint over it to deepen the colors and increase the illusion of depth.

GREAT BLUE HERON
Mixed media (crayon and oil), 18 x 40" (46 x 102 cm), 1989.

This was also done in the crayon and oil technique. Again, note how well the bushes in the winter show with all the crayon strokes. You'll also notice a significant difference between the overall look of the painting at a distance and close-up.

Seen up close, the crayon strokes become very obvious and the colors are seen as separate, but, seen from afar, everything blends together nicely to create a pleasing effect. This is certainly a technique to be enjoyed at multiple distances.

Chapter Five

CREATING A PAINTING FROM BEGINNING TO END

T HE PAINTING PROCESS is slightly different for each artist. This is what gives individuality to the work. Even though artists slowly refine and change their ways of painting over time, they generally follow one basic method or pattern that they have developed and perfected, and there's no need to greatly deviate from that way of working. They become comfortable with applying the paint in a certain manner, with a certain brush, using a certain medium. The differences between artists are dictated purely by what makes each artist most comfortable. Within these different step by step demonstrations you'll see that the basic methods and approaches are similar. This is what makes up my particular style and, consequently, the look and feel of my paintings. Dino Paravano's approach (which we'll also take a close look at in this chapter) is slightly different, resulting in yet another look. Yours will be unique to you.

There's nothing magical going on here. It's pure and straightforward painting. The use of paint strokes and other applications of paint that seem "right on" or happen to have the appearance of "How did he do that?" are purely a result of a hand that has done this for many years. Art is something that is difficult to describe, but it can be experienced with enough practice. Nonetheless, these demonstrations should give you a good sense of the particular procedures that make up these two different styles of painting.

Whether I work in the studio, at the museum or zoo, or outdoors on a finished painting, most of my paintings are done the same way, though, as discussed before, I will change styles completely when painting alla prima (one-sitting, outdoor painting) or working in another medium.

In this chapter I will go through the making of five different paintings. We will also see the multiple stages of two of Dino Paravano's paintings for an insight into his way of working. The first of my step-by-step examples—*Royalty* (Siberian Tiger)—is more detailed than the others to better explain my basic method of painting.

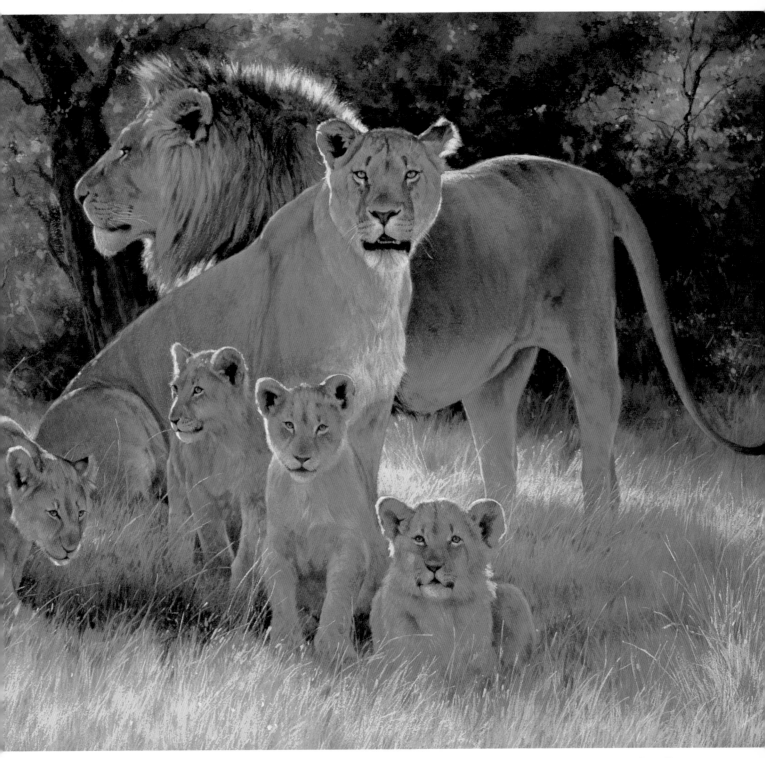

Dino Paravano
PRIDE'S PROUD FAMILY *(Lions)*
Pastel on paper, 28 x 42" (71 x 107 cm), 1995.

Getting Started

I do most of my oil paintings on Masonite panels (which I prepare in the manner described in the boxed section on page 17). I start by making preliminary drawings of my subject until I arrive at one that captures the image and composition I want to paint. My next step is to transfer the drawing to my gessoed painting surface and seal it with a thin layer of acrylic paint so that it won't rub off. Then I tone the panel overall with a transparent layer of oil color.

TRANSFERRING THE DRAWING

To retain the character, the accuracy, and the feel of the drawing, it's best to avoid redrawing it. Instead, I transfer it to my painting surface by copying it with an opaque projector in a few simple steps.

I measure the drawing, increasing the length and width in the right proportions to the size I want the painting to be. Then I photocopy the drawing at a reduced size that's small enough to fit my opaque projector.

Next, I tape the copied drawing to a board to keep it flat, then slide it into the projector, aligning the prepared panel so the projected image fits perfectly onto it. I then trace the image onto the surface with a No. 4H pencil. If I see flaws in the drawing when it's enlarged, I correct them.

The image on the board is now the perfect foundation for my painting, with the same basics as the drawing, and almost identical in shape and structure. That's why it's so important to make a good preliminary drawing.

If you don't have an opaque projector and want to transfer your drawing to the board accurately, you can use the age-old technique of a making a grid. Draw a vertical line down the center of your drawing, and add two more lines at the quarter points. Then do the same horizontally. (Larger drawings may require more squares.) For increased accuracy, draw lines diagonally through the corners of the squares. Now make a grid of the same number of lines on your panel. Then, carefully noting the drawing in each square, transfer the contents of each square from the drawing to the board.

SEALING THE DRAWING

When you brush oil paint over your pencil drawing, the graphite will probably lift up and discolor your paints. To avoid this, seal the drawing using this quick and easy process:

- In a small dish, add water to white acrylic paint until the mixture has the consistency of thin cream. (If desired, you can tone this mixture with raw umber or yellow ochre to a light, neutral color.)

- Then with a 2"-wide flat synthetic brush, apply the mixture over the entire painting so that you can still see the drawing below.

- Once it's dry, you are ready to begin the oil painting.

TONING THE SURFACE

I tone my painting surface to establish an overall warmth that subtly "bleeds" through to the final painting, creating a harmonious and consistent overall tonality. I usually use a medium brown color (siennas and umbers) adding different colors sometimes for variation but keeping it in the medium (not too warm or too cool) range. This paint should be very thin when applied so that the underdrawing can still be seen. Toning also prepares the surface for painting in what I call a "push-and-pull" method. Called a "grisaille," this is an old master technique used, for example, by Ingres, and is essentially the same technique described in Chapter One, though as a drawing.

To tone a painting, you begin work on a midtone surface, then first "push" darks (any dark—preferably a deeper version of the midtone) into the midtone, and "pull" out the light areas either by adding white or, as I sometimes do, wiping out the paint with a rag to a light value. That makes the lights pop out and the darks recede. It's also a great way to prepare the underpainting for glazing. Once the surface is dry, I'm ready to begin. Once the surface is dry (this can take from one to three days), I'm ready to begin.

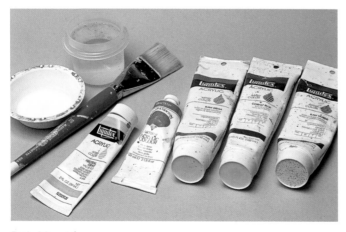

Basic Materials

Acrylics, brush, water container, and mixing bowl

The Painting Process

My paintings are done in essentially three stages. Each stage repeats the same steps, but each time I'm tightening up and adding more details. This procedure is the key to my painting technique. I use it to paint animals, backgrounds, textures, fur, feathers, rocks—just about everything.

After preparing the Masonite and doing the initial drawing, I broadly lay in the main colors. In the second go-around, I get more specific in color and detail, working to achieve and/or improve accuracy. Finally, I add the smallest details and whatever touch-ups are needed.

Each stage ends with a drying period of several days, then this sequence of steps is repeated. Within each stage, before I begin to paint, I apply a coat of linseed oil and a thin wash of color to the area I'm working on, and work the base color into the area. Then I brush other colors into this base color while it's still wet.

The very last step in my painting process is applying the varnish. Varnishing should be done only after the paint is thoroughly dry, which can take up to six months for thick paint. But thin glazed colors dry considerably faster, so when I'm painting for a show deadline, I may varnish a painting within days or weeks of its drying to the touch. I think it's better to varnish a little prematurely than to neglect varnishing at all.

PRELIMINARY WORK

All the work done before the laying in of the initial tones is known as the preliminary work. This includes cutting, priming, and gessoing the board, drawing the drawing on the board, sealing it with acrylic, and finally sealing it with a tone of oil color, and, finally, letting it dry.

STAGE ONE: INITIAL TONES

I usually make the background a nondescript color, particularly in animal portraits. Here it's deep red, almost black . Since I'll be glazing the background color into the tiger, I don't want the initial wash too dark. (If the background were lighter, I'd make the initial color light and transparent.) Then I apply the base color on the tiger with a 2" bristle brush. This base coat (burnt sienna, cerulean blue, and Naples yellow, thinned with linseed oil and turpentine) is essential for the luminosity and detail that follows. I let it dry three or four days while I work on something else.

STAGE TWO: REFINEMENT

At this stage, I get much more specific in color and in detail, working to achieve and/or improve on accuracy. This is also when I put a lot of energy into refining the various textures in the painting (for example, snow, fur, rocks, and so on).

STAGE THREE: FINAL DETAILS

At the final stage, I look for areas of the painting that lack the effect that I like. This is when I will punch up the lights and highlights, deepen the darks, and intensify the glazes with richer colors. I will also now add the finest details, such as specific eye colors, whiskers and feathers, or fur that may be out of place.

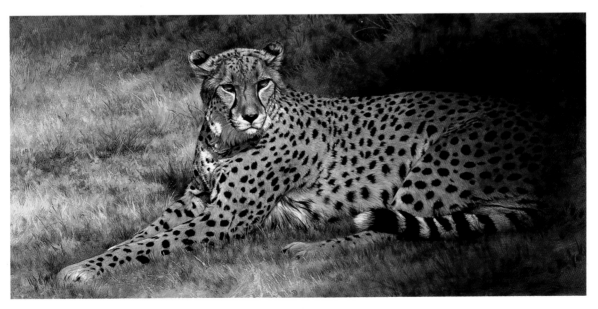

CHEETAH RECLINING
Oil on Masonite,
20 x 42" (51 x 106 cm),
1995.

Siberian Tiger

Every once in a while I see a subject that I think would be spectacular in a large-format painting. The Siberian tiger is one such image. Since the size of the image should enhance the feeling of power and majesty I wanted the painting to have, I chose the large, 2 x 4' format. The painting was inspired by a series of photos I took of a captive tiger. I wanted to show the tiger as regal and as exhibiting a tremendous, controlled power. To heighten the effect, I selectively controlled the lighting, focusing light on the front of the cat and allowing most of the rest of the painting to recede into darkness. This focuses attention on the cat and adds a sense of mystery that is more interesting than the overall lighting in my reference photos. I chose the color of the bed of leaves on which he is lying to complement his tawny stripes and to make him fit well into his habitat. What follows here is an in-depth demonstration of the creation of this image that even includes the amount of time each step took and many subtle nuances of the painting process that I hope you find useful in your own painting.

Tracing and Sealing the Drawing

I sketch the subject, reduce it, project it, then trace it onto the gessoed board, then wash a thin layer of acrylic *paint* (not gesso) over the drawing with a 2 to 3" synthetic brush to seal it. (Clear acrylic medium also works.) This step took about an hour.

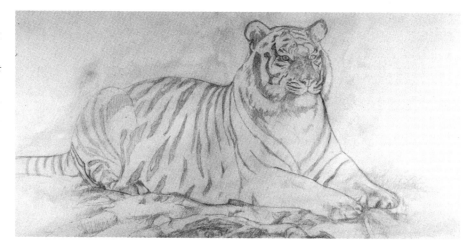

Toning the Masonite

I apply a thin layer of cerulean blue, Naples yellow, and burnt sienna oil paint thinned with linseed oil and a tiny amount of turpentine, thinned enough to let me see the drawing, then let it "cure" for a few days. This underlying tone lets me "push and pull" the paint later. (An excessive amount of linseed oil at an early stage may not work as well on canvas.) This step took about two hours. It then took three to four days to dry thoroughly.

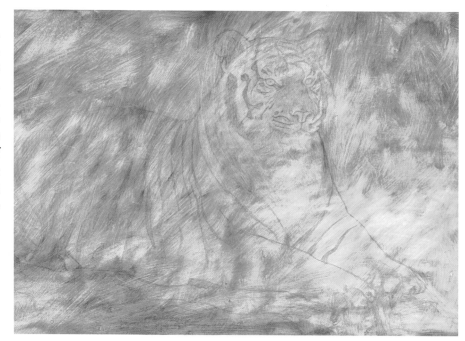

Application of Base Color (Detail)

After the painting is dry, I apply a thin wash of linseed oil, wipe off the excess, then work the base coat (this time a brown mixture of alizarin crimson, burnt sienna, and raw sienna) between the eyes and down the nose. I am interested in shapes and color now, not detail. (This step takes about an hour.)

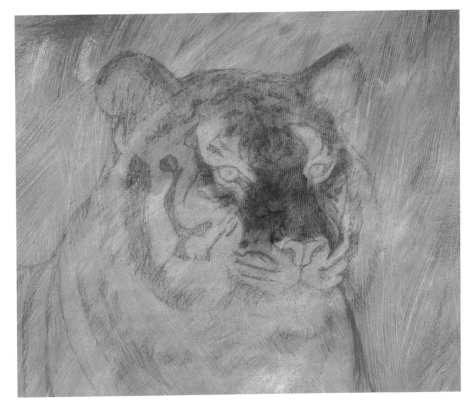

Stripes

While the base coat of color is still wet, I work more refined colors into it, gradually creating a sense of form and solidity. I run some umbers into the right side of the nose and add light areas on the brows and between the eyes (cadmium yellow, raw sienna, white, burnt sienna, and cadmium red). I glaze darks and lights with ½ to ¼" soft, white synthetic flat brushes, working around the whites and stripes. The stripes are a thinly applied layer of my "basic black"—a mixture of ultramarine blue and burnt umber; I never use tubed black. The whites are pure titanium, brushed on with linseed oil and a bristle brush. I add red to the nose last. I put some background darks (burnt umber and cobalt blue) behind the head to better judge the values and colors of the face. The oily surface gives a smooth, soft tone instead of a patchy drybrush, and the paint is still thin enough to show the drawing.

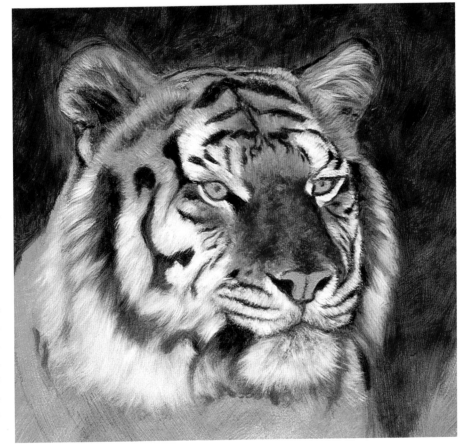

Painting the Body of the Tiger

The rest of the cat is done in this manner, section by section. By now the sequence should be familiar: Brush each area with linseed oil. Wipe off the excess. Go in with a brownish base tone, paint the darks, then the lights, into the area, working downward and outward from the head. Refine the tones, patch by patch, over the entire animal, constantly checking the painting against the slide, continually improving the accuracy of the drawing. The basic anatomy must be correct—the earlier in the process, the better. (This part took two hours.)

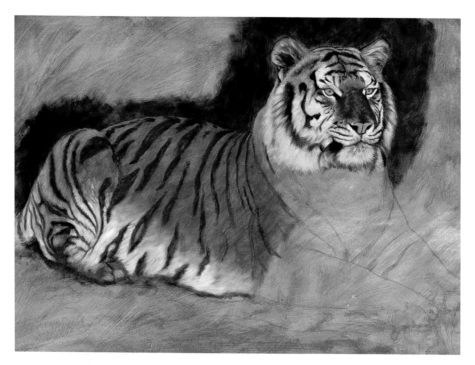

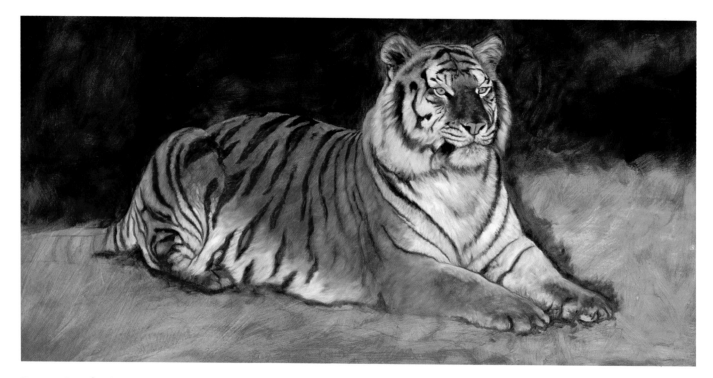

Improving the Accuracy

As I block more darks (burnt umber and cobalt blue) into the background, I correct a few errors: The hindquarters are off by a half inch; and the tail is too low and too big—I correct it with the background color. Other areas, such as the front paws, stripes, and position of the hind foot are corrected in painting the animal. I rub off the paint with my thumb or a cloth (the linseed oil base makes wiping out easier) and repaint it until I'm satisfied. The longer I work, the more subtle the painting becomes.

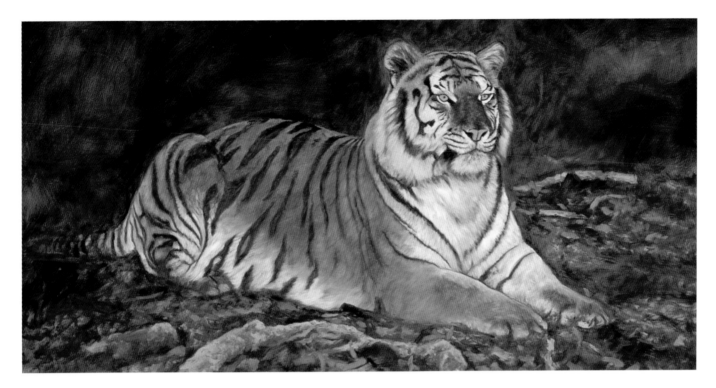

The Foreground

Using the brownish mixture of the light areas of the tiger on the foreground, I loosely suggest leaves and sticks, letting this area bleed into the background. Then I let the painting dry for two days while I work on something else.

When I return to the painting I indicate shadows beneath the fallen leaves and block in the sticks as blue, with some white—a little cobalt blue, yellow ochre, and burnt umber. This takes most of the day.

Adding Warms and Cools

In this subtle but essential step I create a wet painting surface, and, perhaps even more important, I establish warms and cools that literally give the animal a sense of life so it's not plastic-looking. Working into my usual light coat of linseed oil, I wash a dark reddish brown over the head to add warmth and softness. Then I add a bluish purple (cobalt blue with a hint of alizarin—though ultramarine blue and alizarin crimson with a little yellow ochre to gray it would also work). To cool the white areas I start to put cool tones in the cheeks and under the chin.

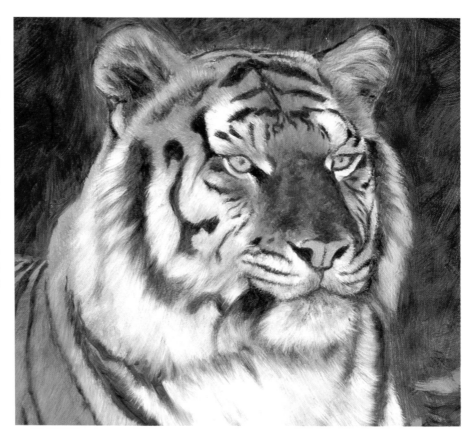

Refining the Features

At this stage I'm conscious of details. Working into the wet paint with more accurate color, I brush dark brown into the reddish area of the nose and between the eyes, put more white in the white areas, and add more black in the stripes. When I add shading and eye color, the eyes become more solid and start to come alive. I underpaint them in raw sienna and darken the blacks around and inside the ears.

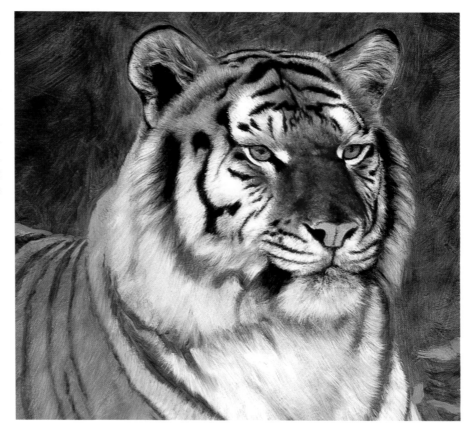

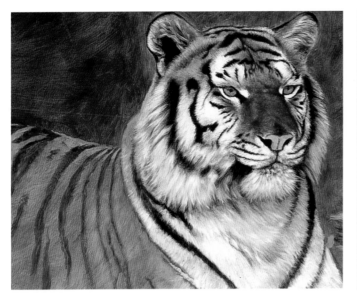

Texturing the Fur

Working wet-into-wet with stiff ½" to 1¼" hog hair brushes, I brush white strokes into the black stripes and vice versa to suggest a soft furry texture. This time I'm not interested in a quick coat of paint, but I'm adding a different hair pattern— for example, the hairs around the neck. I quickly brush some bluish purples on the cheeks and in other white areas on the far side of the animal to make the stripes even blacker.

Working the Crux of the Spine

In preparation for another basic glaze, I lighten the spine. Moving down the spine, you can see the three dark stripes and the start of lighter texturing. (From where I refined the details of the foreground through this stage took seven hours.)

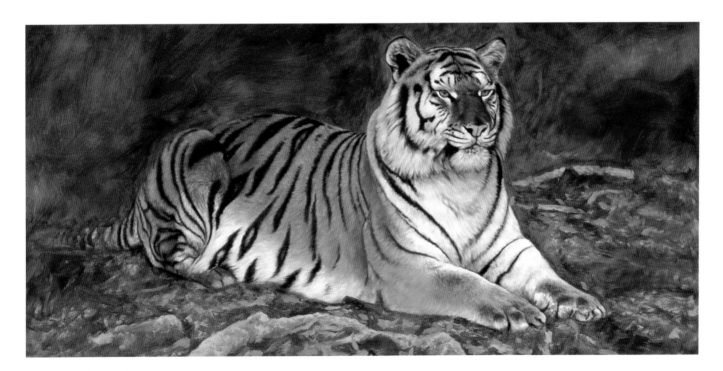

Finishing the Body

The texturing is complete and lights and darks are established. Again, I let the painting dry for a couple of days. I don't have a title yet, but I'm thinking of something kingly and royal.

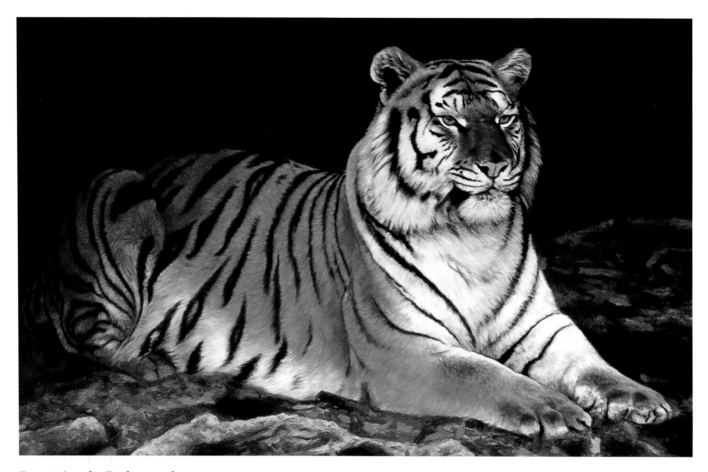

Deepening the Background

In the reference photo, the tiger and background are lit almost equally by a soft overcast light. But to focus on the tiger and add atmosphere and mood, I decide (on the fourth day) to put his body and head in the light and let the tail and haunches recede into darkness. To do this, I brush background color—burnt umber, burnt sienna, ultramarine blue, a touch of cadmium red, and a little linseed oil—into the tiger to model the head and to add depth and character. (I spent four hours on the background.)

Dealing with the Blahs

Now I hit a stage I go through in nearly every painting I do. I lose heart and want to quit. The painting totally lacks subtlety. The tiger is too orange compared to a real tiger, and there's too much contrast—the whites are too light and the blacks are too dark. Only sheer discipline and will (and previous experience) keep me going. If I'm just looking at the painting, I don't know what to do. I have to look at the painting and the reference and see the differences in tonality and color. I want the subject more tangible. I add a little more of this, do a little more of that. That's what gets me to go on. I just sit down and look at the difference between the reference I'm working from—whether it's a museum mount or a photo—and the painting to see what I need to correct, then I start fixing it. Proceeding on sheer faith, I add foreground details—leaves and sticks. Four hours have passed since I put in the by-now-dry background (burnt umber dries quickly), which shows up as a filmy layer on the slide. This is where discipline comes in. Discipline is the difference between making it and not making it. It kept me going back to the board. I didn't give in to the temptation to quit. Remember, you can critique yourself. Painting is a very analytical process. So is the process of applying the paint and adding the detail. Working free-form and loose is not enough.

Refining Leaves in the Foreground

Working in 6 to 8" squares, I rub the area with linseed oil to bring out the original color, and then add the foreground, leaf by leaf. I start with an orangy color (burnt sienna, both pale and deep cadmium yellow), then add darker and lighter leaves—a combination of yellow ochre, cadmium red, cadmium yellow, and white.

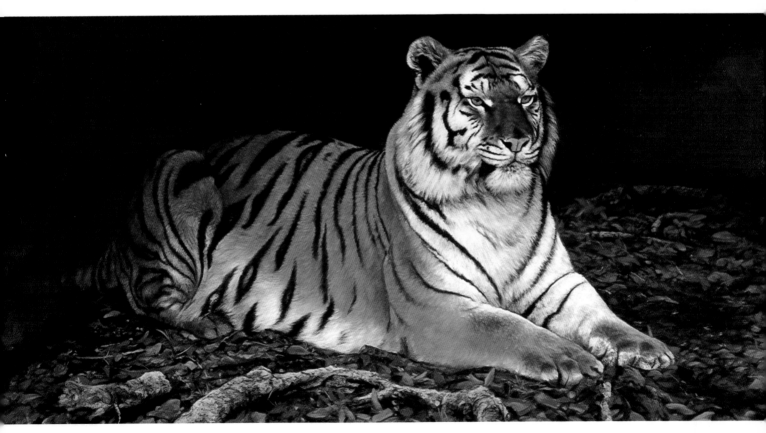

Finishing the Foreground

I finish the ground, making sure the detail and modeling is consistent on both sides of the tiger. (The two steps on this page took four hours.)

The Finishing Touches: Hairs, Fur, Eyes, and Nose

During this last stage I add the smallest details and do whatever touch-ups are needed. I use a 1/4" bristle brush, switching to a finely pointed 00 round brush for a few hairs above the eyes, eyelashes, and areas going into darkness, such as individual white hairs that move into black stripes. I correct some areas by removing the paint with my thumb, painting black over it, then painting into it. For thicker whiskers, I press harder; for tiny hairs, I use a lighter touch—and you already know about my worn, frayed 1/4" brush for painting fur. Working wet-into-wet creates a wonderful, soft texture. To paint white into a stripe, I dip the brush in white and run it into the black; then clean the brush, dip it in black, and run the black hairs into the white. Obviously, painting individual hairs would take eons, while this way I can do a whole section in just one stroke—which is why this 2 x 4' painting took only seven to ten days.

At this stage I also paint the eyes and the nose. They are so important to the success of the painting that I'll discuss them at length here.

Eyes are part of the animal's expression and make the painting come alive. Here they're kind of an off-yellow green—yellow ochre, a little ultramarine blue and cadmium yellow quickly brushed into the iris, with some whiter tones, perhaps Naples yellow, added to the middle of the bottom loop of the eye. Then I add a little black to soften and tone the top of the eye and clean up the edges. The highlight—cobalt with a little white—placed next to a very bright white reflects the sky color and makes the eye look solid and glassy. The other eye is in shadow. It doesn't have a light Naples yellow color but it's still greenish, with a more brownish black.

The nose is cadmium red, alizarin crimson, and yellow ochre with just enough cobalt blue to dull the brightness. The nose on every animal is different. Here I use just a little cobalt blue with some white to cream it up a bit. Then I run a light wash of cadmium red light over the whole nose. Working just in the darks, I add burnt umber with a little ultramarine blue into the sides of the nose to give it some dimensionality, then come in with a lighter tone—maybe the same red with some Naples yellow and white in the highlights to make it pinker—and I model it to suggest a three-dimensional effect. This is when real richness and softness appear in the fur. While this is the most meticulous stage, it doesn't take any longer than other stages because most of the texture has been added gradually in earlier stages.

Tightening Up the Painting

At this point the details are applied, glazes are finalized, and the effect of light is added. The details are handled as earlier, but I'm working much tighter now. I lightly wash linseed oil over the top of the head, then tone down the reddish areas with a thin coat of yellow ochre and raw sienna. To make the orangy areas creamier and more yellow, and tone down the whites, I run a wash of dusty yellow ochre and raw sienna over the nose area and under the ear. I brush burnt umber into the darks for greater contrast and depth. To make the chin pop, I add a wash of dark blue-purple (alizarin crimson and ultramarine blue, toned with a little burnt umber). I add lights on and between the eyebrows, working into the orangy areas, including areas of pure titanium white near the eyes and muzzle. Then I deepen the blacks with a final coat of burnt umber and ultramarine blue.

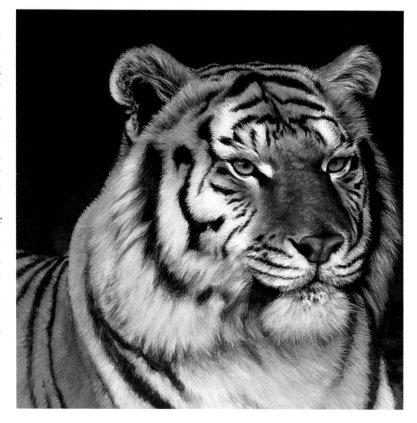

Finishing the Head

I work the left side of the head, chin, and upper chest simultaneously. Note the detailing and nuances in the shading. Compare the creamy yellow head to the body, which is too orange and flat. Also compare the tiger in this stage to the previous one. Now the animal has validity and dimensionality—a sense of fullness and life.

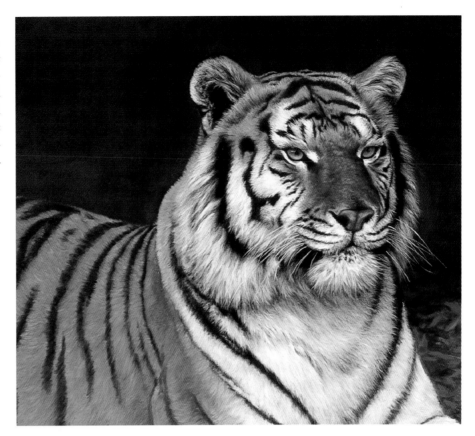

Working on the Body

Again, after a coat of linseed oil, I cover the animal's body with a thin glaze of yellow ochre and raw sienna, then work a little burnt umber in small flicking strokes into the glaze to create fur texture. Then I reapply black hairs into the stripes, making sure the hairs follow the flow of the body. Note the patch of fur on the animal's back is more finished than the surrounding area. (These adjustments to the body took a day.)

Creating Texture and Tightening Up

Look at the difference between the two pictures on this page as I add texture and continue to tighten up the details.

Doing the Final Touch-ups

At this stage the painting comes alive as I add a lot more depth, reality, and solidity. I add pure white to the tiger to increase its brightness, glaze yellow ochre and raw sienna to intensify the richness of color, and darken the blacks to strengthen the contrast. I create soft, furry texture with the frayed bristle brushes.

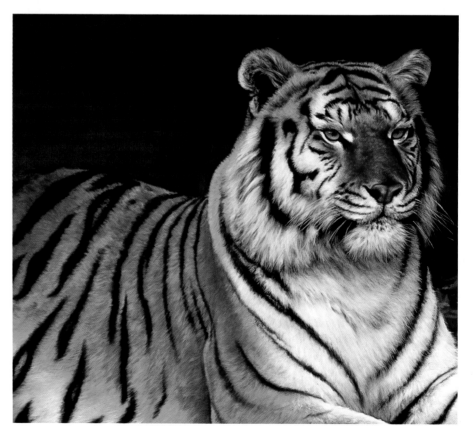

Adding Foreground Details

I add details to the foreground, varying the greens by adding more blue or more yellow, and adding yellowish highlights to various leaves. Stepping back, I notice that the painting needs something of interest on the left, so I add a fallen stick to prevent the eye from wandering out of the painting—and I'm done.

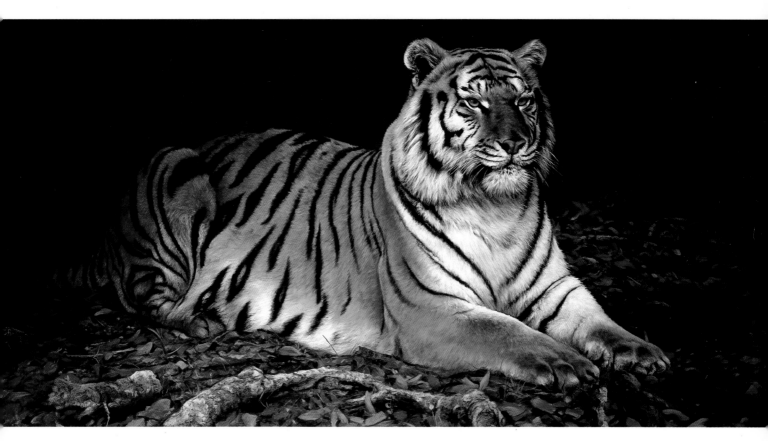

ROYALTY (*Siberian Tiger*)
Oil on Masonite, 24 x 48" (61 x 122 cm), 1996.

The Finished Painting

It's hard to know when to stop, but a sense of it comes with experience. I aim for a rich, layered effect, which is why I glaze so much and use darks. (Rembrandt was a master at this.) The darks make the lights really shine by contrast, so the deeper I can get, the more intensity the painting will have, and the more the tiger will shine. I don't stop painting until I "oooh" and "aaah" over it—until it's so soft and tactile, you can feel it.

Demonstration
Snow Leopard

Big cats are some of the most impressive and beautiful of all predators or, for that matter, of all animals. A feline face, therefore, is a wonderful subject for a portrait because it allows the viewer to focus on the elements of its beautiful head without the distraction of other subjects or elements. Since I only wanted to focus on the face and head here, the painting consists of nothing more. I chose the background colors to enhance colors of the cat—they're soft and similar to the shadow colors. My reference photo was particularly good, but I wanted to increase the three-dimensional feeling through selective details and colors, while focusing on the eyes, which are very intense.

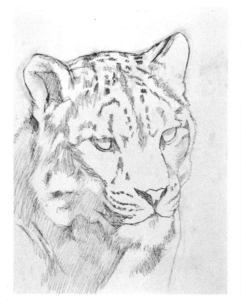 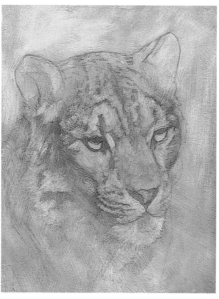 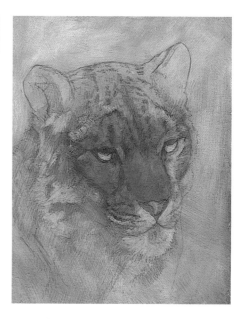

Pencil Drawing

I prepare a 14 x 18" Masonite board, and project my quick pencil drawing onto it. Then I trace the main lines with graphite and seal the drawing with a thin milky coat of acrylic. Then I let it dry.

Underpainting

I next use a wide brush to apply a warm, neutral transparent mixture of burnt umber, sap green, alizarin crimson, Naples yellow, and a little yellow ochre, thinned with a heavy dose of sun-bleached linseed oil. While it's still wet, I quickly wipe off areas I plan to keep light—eyes, cheeks, eyebrows, tops of the muscles, and the like—with a dry ½" synthetic flat brush. As you can see, this immediately gives the effect of solidity to the painting. (This took about thirty minutes.)

Foundation Glaze

My plan now is to set up the basic colors in the face and then paint into them. I apply a patch of tone (a "base coat")—here, a nondescript gray-brown with small patches of raw sienna and powdery blue—to the center of the face. This is the tone I will paint the next layer of colors into while it's still wet.

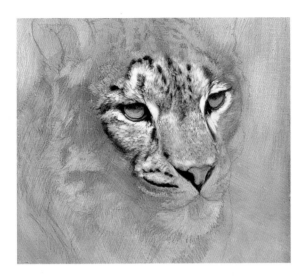

Adding the Darks and Lights

I now work more accurate colors into the wet tone. First I add the darks (burnt umber and ultramarine blue), then titanium white, with a bristle brush. The brush bristles suggest the hairs on the snow leopard—long, fluid strokes make longer hairs and small, dabbed strokes (slightly pushing the bristles into the board rather than pulling it out in more fluid strokes) suggest short, bristly fur. I'm not concerned with the accuracy of the color at this point, since I'll be correcting it by glazing later. This is simply a textural layer. (This stage took about forty-five minutes.)

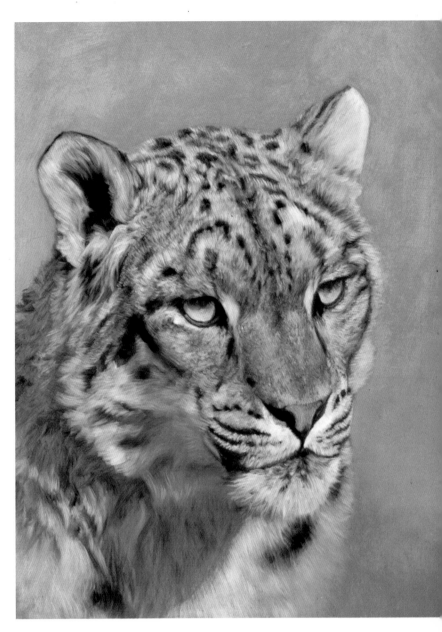

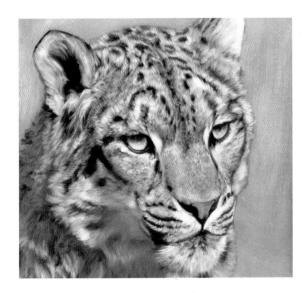

Completing the Foundation Glazes

I work the rest of the cat in the same manner, section by section. (This took about two hours.)

Background Washes and Facial Tones

I brush the background in with thin washes of a muted powder blue at the top (sky color), gradually blending into a Naples yellow, and finally into a slightly darker purplish gray at the bottom. I add a little alizarin crimson to the sky blue with a bit of Naples yellow for the purple gray. Then I let the piece dry completely for two or three days. Returning to the face, I re-cover the patch around the eyes and on the eyebrows and nose with just a thin glaze of linseed oil to bring out the original colors, then start modeling the face. To do this I run thin washes of raw sienna and burnt umber between the eyes and beside the nose, and tone the sides of the nose and the area above the eyes with a blue-green wash (ultramarine blue with sap green and a little burnt umber).

Adding Fur Texture and Solidity to the Head

While the area is still wet, I add depth to the head, sculpting it with darks (black washes of burnt umber and ultramarine blue) around the eyes and on the spots, and I add texture to the fur on the nose and around the eyes by applying titanium white with a ¼" bristle brush.

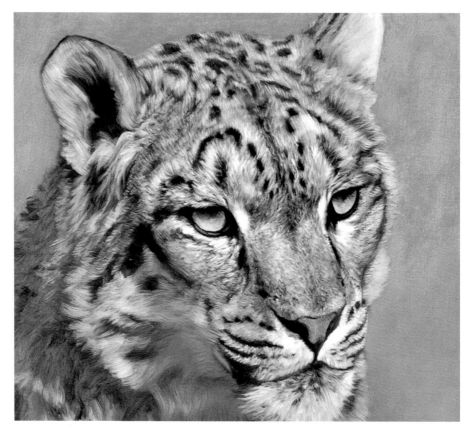

More Texturing

I finish the rest of the fur in this manner. (These stages took three hours.)

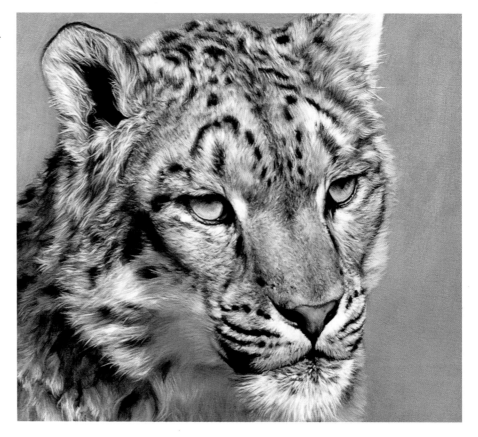

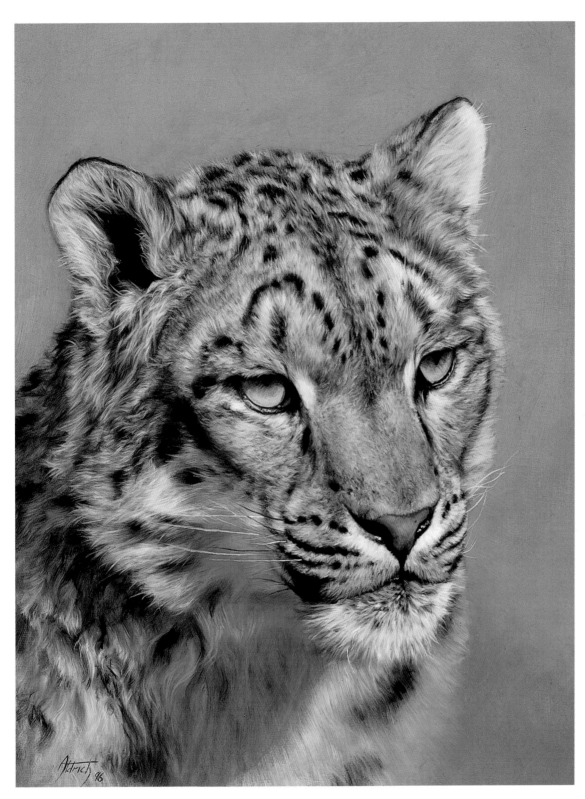

SNOW LEOPARD PORTRAIT
Oil on Masonite, 14 x 18" (35.5 x 46 cm), 1996.

Adding the Details
Finally, I add the whiskers and other long hairs with a fine-pointed brush, deepen the reds on the nose, and I'm done. (This stage took thirty minutes.)

Demonstration
Bison

A bison is a powerful, imposing creature, and I intensified that quality by painting him from the side, yet looking at the viewer. He is standing on a knoll, partially obscured by dust. Initially my concept for this painting was to do a painting of a bison standing in shrubs and grasses. But as I worked, the painting took another direction and it began to become a painting about atmosphere—the dust the bison kicked into the air. As interesting as my initial idea might have been, I think the new idea creates more of the emotion of the bison that I wanted to express. It certainly helped my understanding and experience of the animal to be in the field with him for a while, watching him, photographing him, and just getting to know him. I had the good fortune to accompany a researcher friend on an outing to a large ranch, in the foothills of northern Colorado, where bison roam. I was able to use this experience to help with this.

Painting the Underpainting and the Head

As per my usual technique, I project the drawing and transfer it to the panel. Then I seal it with a thin coat of yellow ochre and light gray acrylic and, when dry, begin to paint in oil. Starting with the head, I run a wash of burnt umber, alizarin crimson, and a little ultramarine blue thinned with linseed oil over the head and while still wet, brush a black wash (equal parts of burnt umber and ultramarine blue) into it. Working into the wet paint provides some interesting textural effects—you can actually see the texture of hair forming. I also began applying highlights to the head with titanium white added to the initial head color mixture. I add highlights to the head wherever necessary.

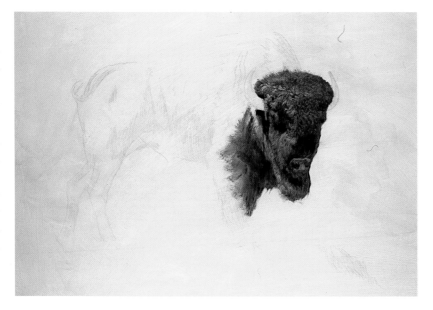

Painting the Body

I complete the bison's body the same way I did the face—with a thin base color, then darks and lights are brushed into the wet paint. For the base color on the furry shoulders and back of the bison, I added some raw sienna to the original mixture (burnt umber, alizarin crimson, and ultramarine blue—essentially the primaries). Then I quickly brush in the general colors in the foreground to suggest various plants. I keep my brushstrokes pretty loose since most of this preliminary tone will be covered up later.

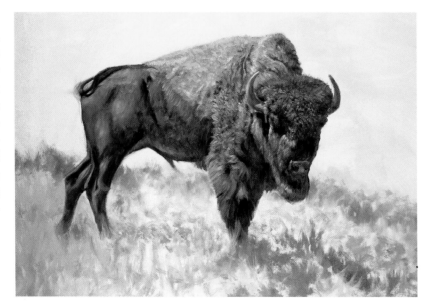

Adjusting the Background and Foreground

This is when I decide the painting requires a moodier effect, so I cover up the background and the foreground with light and dark washes of color—titanium white, yellow ochre, a little cadmium yellow, and burnt umber—to suggest dust. I tone the background and, using very thin color, obscure parts of the body with the dust mixture. Then I add pure titanium white to the wet paint in the background on to the right of the face and to the upper right-hand corner to lighten these areas. I also brush pure burnt umber into the lower left-hand corner to darken it.

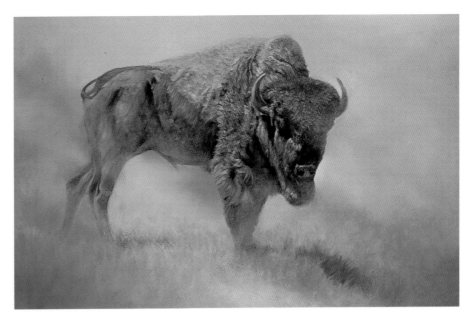

Adding Detail

I start with the light-colored hair on his back, laying in a thin mixture of linseed oil tinted with raw sienna over this area. This wets the area and tints it a slight yellow rust color. While wet, I brush burnt umber into the areas I want darker—such as beneath the clumps of fur and wherever else the fur turns darker. Then I add titanium white to Naples yellow and a little raw umber and apply the mixture more thickly to the lightest parts—along the top of the back and to individual clumps of fur. Then I mix a base color (again burnt umber, alizarin crimson, and ultramarine blue) thinned with linseed oil, and apply this mixture to the darker fur on the head and forelegs. Into this color I add black (equal parts of burnt umber and ultramarine blue) and apply it to the deepest parts of the body, pushing it into darkness. Since I notice that the highlights on the fur had a bluish tint, I mix some cobalt blue into titanium white and add it to the base color for the highlights on the head and upper foreleg. Finally I run the same color mixtures over the rest of the body, beginning with the thinned base color, followed by the darks, and finishing with the highlights.

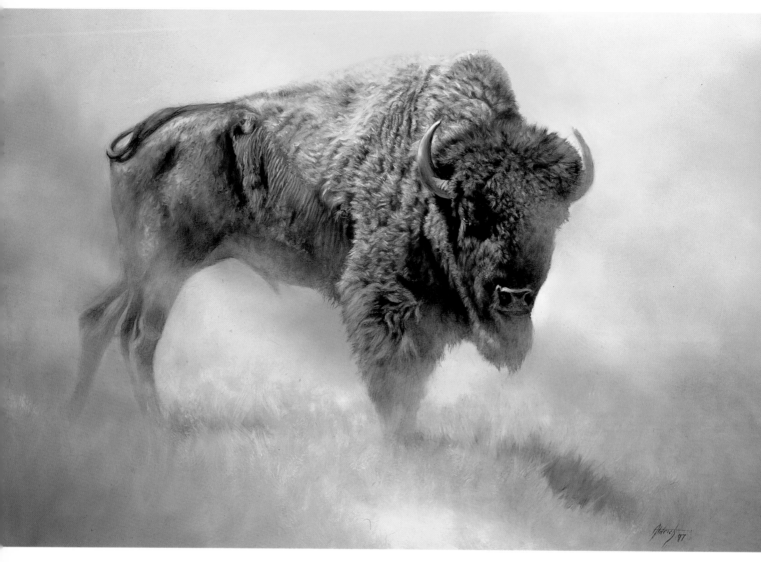

BISON
Oil on Masonite, 22 x 34"
(56 x 86 cm), 1997.

Adding the Final Touches
After waiting a couple of days for the paint to dry, I cover selected areas of the bison with some of the original light dust color from two steps ago, deliberately saved for this purpose. I thin the color so it isn't quite so opaque, brush it on, then rub off the brushstrokes with my finger. I also add a little more light dust color mixed with more white to lighten the upper right-hand corner and the painting is done.

Belted Kingfisher

This was painted from a preliminary drawing done in the Denver Museum of Natural History, working from a mount that was made by a remarkable taxadermist, Tom Shankster. This particular mount was brand new, with incredible lifelike qualities. I spent some time looking at the mount from different angles and lighting conditions before I decided on the angle I wanted. I was looking to capture the feeling of motion and the intensity of the bird just before it plunges into the water for its prey.

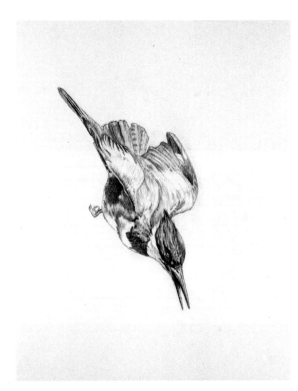

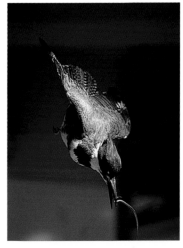

This is a picture of the mounted bird taken in the museum. It shows the approximate angle and lighting that I witnessed while painting.

The Preliminary Drawing

In the museum, I place the mount (which was not in a closed case) at eye level with a light positioned above it. The drawing, done in a single afternoon, helps me understand what I need to know about the bird in order to paint it. It also helps me decide how to compose and place the bird within the boundaries of the panel and my composition.

The Underpainting

I transfer the drawing to the gessoed board, cover it with a thin coat of light gray acrylic paint, then tone the board with a layer of raw umber and sap green oil paint thinned with linseed oil, and let it dry. I deliberately leave the brushstrokes to show, so I'd have an interesting surface to paint into.

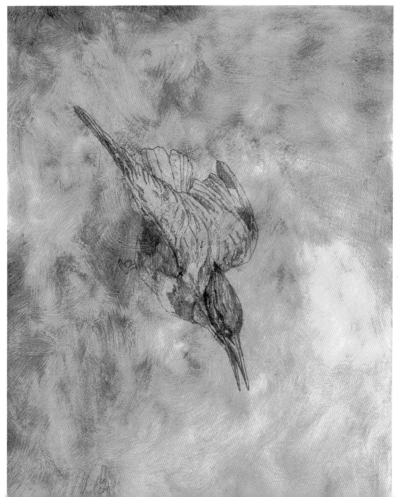

The Base Layer

I cover the head with a base layer of cobalt blue and a little burnt umber with a touch of white, thinned with enough linseed oil to see the drawing. Then I stroke pure burnt umber into the deeper areas, and apply a soft black (burnt umber and cobalt blue) to the darkest spots with a No. 1 Winsor & Newton University flat brush. Then I add an off-white (titanium white plus the initial patch color) and block in the light areas with a No. 3 Winsor & Newton University F brush. At this point I am consciously sculpting the head, making it appear as solid as possible, noticing where the feathers are lighter and darker, and painting it the way I see it. I repeat this process over the entire bird— beak, neck area, and upper backs of the wings, primary and secondary feathers.

To paint the tail feathers, I mix a base color of burnt umber and a little cobalt blue, then add the lights and darks (by adding white or more burnt umber/cobalt blue to the base mixture). For the underbelly, I mix raw sienna and burnt sienna with a little yellow ochre brushed into it. I use an "observational technique" here, painting everything just as I see it, constantly comparing lights and darks so all areas work together as a whole. (This stage took about three hours.)

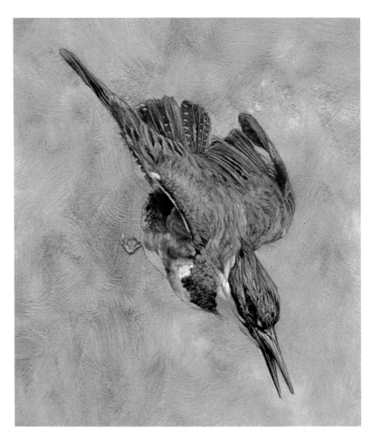

Correcting the Colors and Adding Details

I model the background with light and dark mixtures of cobalt blue, alizarin crimson, Naples yellow, titanium white, and burnt sienna, keeping it thin enough so that the underpainting can still be seen in some places. Now that I have established the basic structure of the bird, I'm ready to improve the accuracy of the colors and add the details.

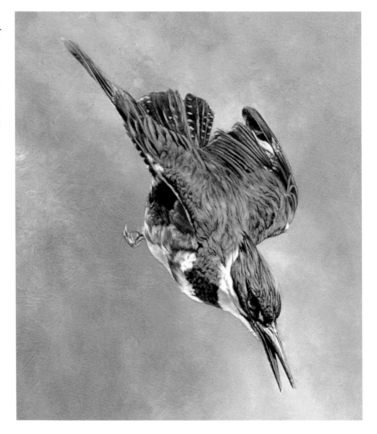

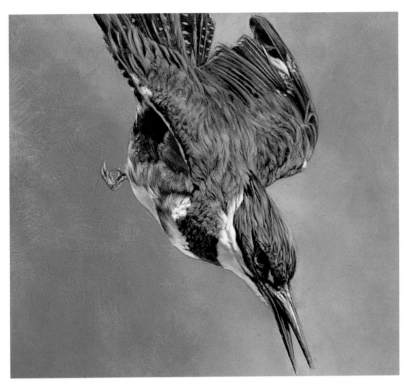

Adding Detail

To work on the underbelly and throat area, I cover it with pure linseed oil. It immediately enlivens the colors. (Oil colors tend to dull when dry.) I brush burnt sienna and raw umber into the brown areas. Then I deepen the dark gray areas under the wing with the same mixture of colors I used there before and highlight the edge of the underbody with a warm light reflected from below (white and a little cadmium yellow light and raw sienna). I also pump up the white (sunlit) areas with pure titanium white. Then I mix a blue-green (cobalt and ultramarine blues plus some yellow ochre), add linseed oil, then glaze over the blue patches on the body, head, wings, and other blue-green areas. Into this I work an almost black mixture (cobalt blue and burnt umber) for the darks, and with white and the original blue mixture for the highlights. I continue to work these colors over the entire bird. I then let the painting dry for a few days. (I spent three hours on the bird and one hour on the background.)

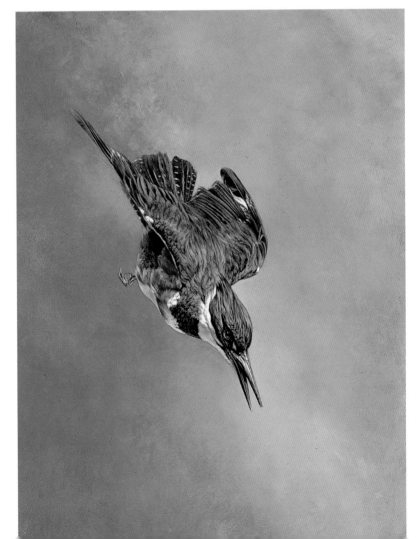

Deepening the Colors

When it's dry, I put a thin layer of linseed oil over the entire bird to bring back the rich color so I can see where it needs more work. I add a few details and pop out certain areas, adding more titanium white to the areas in the light, putting a dab of pure burnt sienna in the lower part of the eye, and adding a little raw sienna with some Naples yellow into the bottom of the eye for an extra dimension. I dab light blue (a touch of sky color) into the upper part of the eye to make it look more solid and touch up the body, adding small details where appropriate. Finally, I work on the background, adding a darker bluish purple below the bird (ultramarine blue, alizarin crimson, a little yellow ochre, and titanium white), and a little very light gray into the upper right-hand corner (the same mixture with much more white), and a creamy yellow behind the bird (Naples yellow, a little sap green, and various mixtures of yellow ochre, alizarin crimson, and white). I model these areas slightly, leaving the brushstrokes visible because I want the background to look as animated as the bird.

THE DIVE *(Belted Kingfisher)*
Oil on Masonite, 15 x 20" (38 x 51 cm), 1997.

Demonstration: Dino Paravano

Leopard

At about 11:00 a.m. on the second day of a safari in South Africa in 1996, the group Dino Paravano was traveling with came upon two young leopards. This sighting made their day. For this oil, Paravano chose one of the siblings in a relaxed attitude on a tree. He was also looking forward to the challenge of composing and painting a pastel of both leopards playing together on the same tree branch. He hoped to see them again in the next two days of this trip, but that unfortunately wasn't to be. The following step-by-step demonstration of this painting by Paravano is described here in his own words.

Blocking in the Main Colors

I began with a quick outline drawing in acrylic, locating the spots on the leopard and broadly indicating the texture of the tree branches. Then I ran a thin wash of tinted oil painting medium over the entire painting to create a color harmony. With a broad bristle brush, I blocked in the masses in the background in middle tones of ultramarine blue, a touch of light red, and gold ochre in the sky, and the same colors plus burnt sienna and viridian green for the trees.

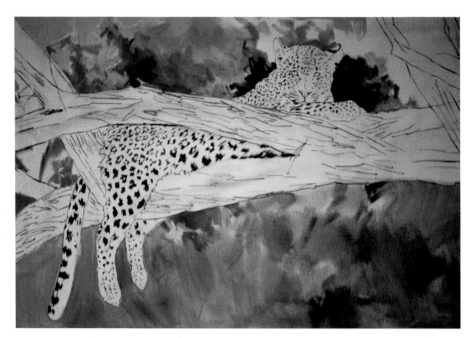

Continued Blocking In

I continue blocking (underpainting) the tree and cat, deepening the sky and putting in a cool shadow tone on the leopard, thin enough so that I could still see the spots underneath.

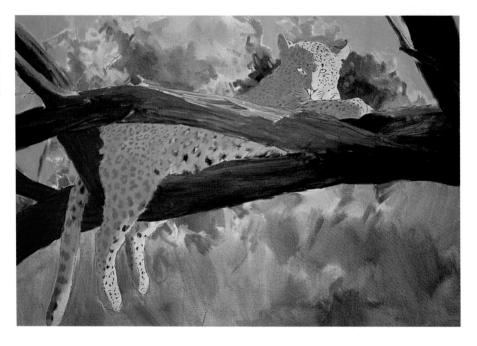

Adding More Elements

I continued to work on the background trees and started on the refined paint application of the cat's spots. I start to expand the color range of the trees, interplaying warms and cools and lights and darks to get a rich background feel. I also began to add more specific branches and leaf forms.

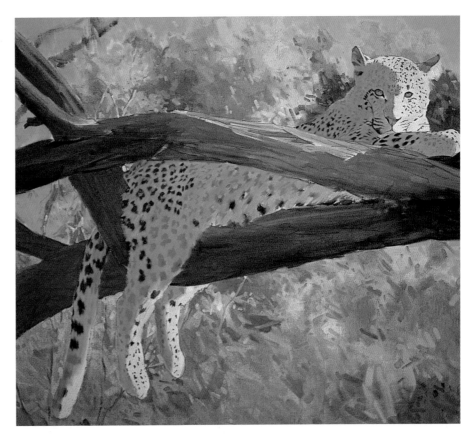

Developing the Painting

I continue to work on the painting overall, especially on the cat, modeling and painting most of the detail. I added cadmium yellow medium and flake white to the color range in the light.

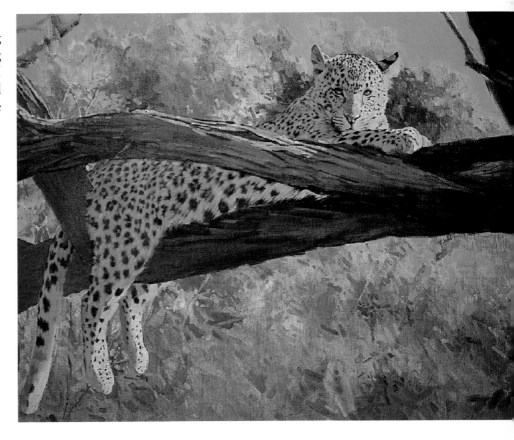

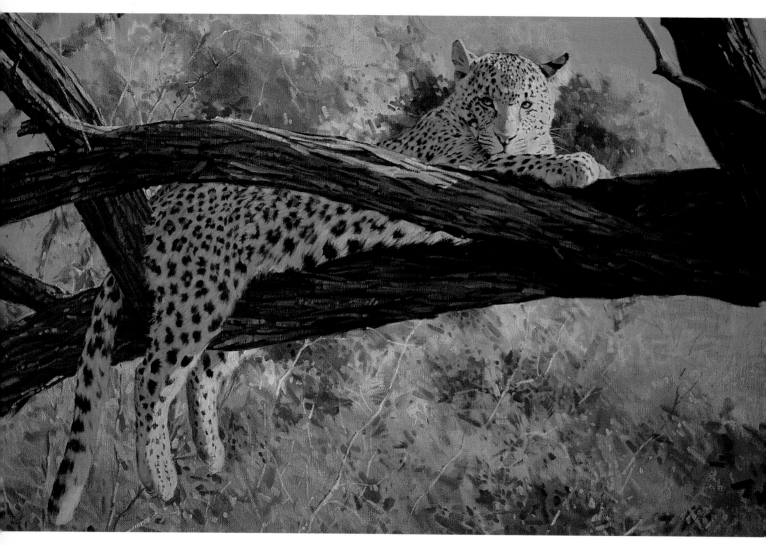

DINO PARAVANO
LEOPARD ON TREE
Oil on canvas, 20 x 30" (51 x 76 cm).

Refining the Painting

This is the refinement stage. I am working in all the details, emphasizing the contrast of light and shade, adding tree branches and overall highlights, and working the darkest tones in the shadows. For my darkest color, I mix burnt sienna or umber, ultramarine blue, and alizarin crimson.

Cheetah and Her Cubs

The first thing Dino Paravano wanted to do on his return from a yearly visit to South Africa was to compose and paint a mother cheetah with her cubs. After the initial sighting at a game reserve, and following the cheetah family for two days, he spent a lot of time going through many photos and making sketches and drawings until he was satisfied with the composition. This step-by-step demonstration, describing the painting process of this work, is written in Dino Paravano's own words.

Getting Started

I chose a large sheet (30 x 43") of Canson Mi-Teintes paper in a warm bisque color, which I let show through the pastel strokes so it would influence the color and tone of the entire final image. The warm bisque color allows for a warm overall final work. If a darker, lighter, or cooler paper was chosen, it would influence the final work accordingly, but here I want a warm tone. I began by sketching the cats in the foreground, then blocked in some spots on the cheetah.

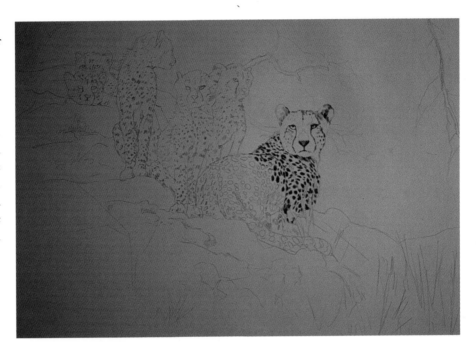

Establishing Overall Color

I proceeded with broad strokes, coloring in different parts of the picture, establishing the correct color and tonal values, including the brightest light and strongest dark. Working on all areas simultaneously harmonizes the painting. Depending on the availability of colors, I use semihard Nu-Pastels at the start, and finish with soft pastels and pastel pencils for the fine details. Once I'm satisfied with the tones and colors, I paint the background (the sky) quite heavily with blues and grays, then blend the pastel, adding reddish grays and ochres for the clouds.

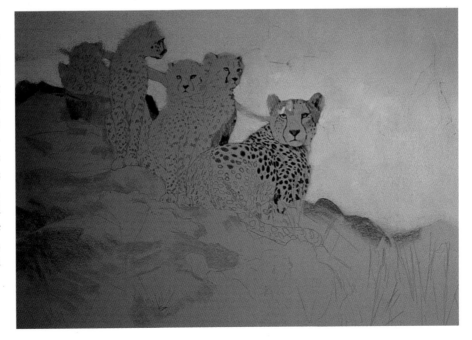

Building Up Form and Color

I next work on the animals, adding detail, modeling form, and checking that the spots follow the shape of the body. The spots are painted mainly with black and gray pastel pencils. I continue to work on the middle ground, then the foreground, establishing the overall temperature and location of the major forms and shadow areas. I indicate the branch, linking the animals like beads on a necklace.

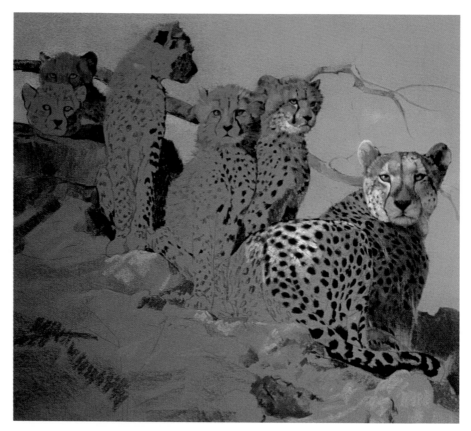

Adding Details

I build on these forms, adding lights and shadows, and more detail, working on the painting as a whole without finishing any one area. Notice how the foreground is developed and details such as rocks and grasses are suggested mainly through warms and cools, while leaving the focus—the strongest contrast and greatest detail—on the cheetahs.

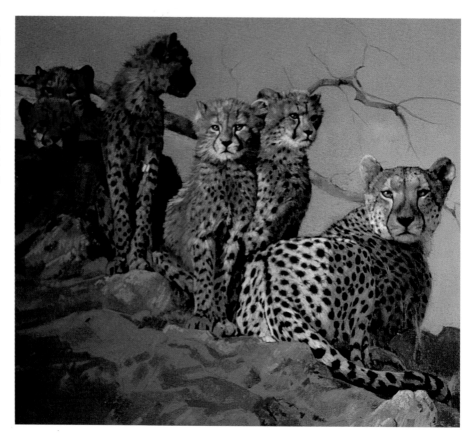

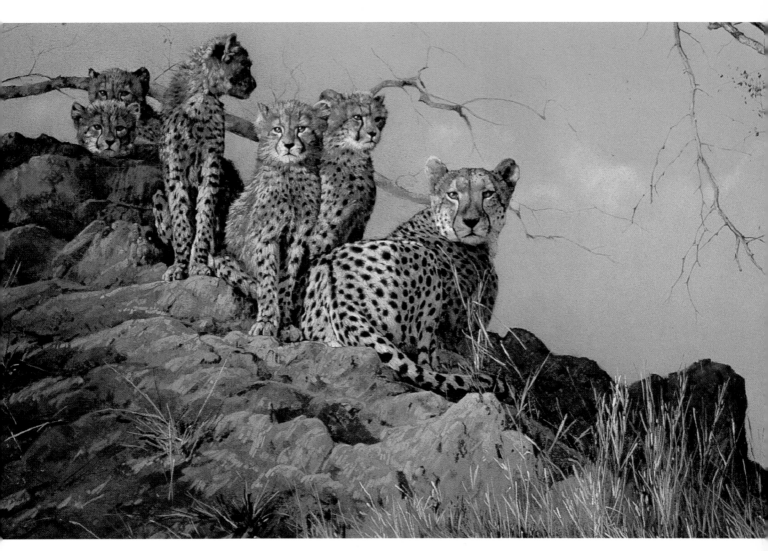

DINO PARAVANO
FULL HOUSE *(Cheetah and Her Cubs)*
Pastel on Canson Mi-Tientes paper,
24 x 38" (61 x 96.5 cm).

The Finished Painting

I finish with the highlights and darkest tones throughout the painting, including foreground grasses, branches, and other miscellaneous details. As I generally do with most of my paintings, I put this one aside and check it from time to time to see if there's anything I'd like to change, delete, or add.

OCELOT *(detail)*
Oil on Masonite, 15 x 28" (38 x 71 cm), 1993.

BEYOND TECHNIQUE

A PAINTING IS THE CULMINATION and the orchestration of many elements: technique, composition, mood, story, plus emotion—the artist's personal response to his or her subject and the painting. In much of wildlife art, which is realistic and representational, we have additional elements that come into play, such as focus, lighting, details, and other aspects of the painting, like illusion of distance and structure.

In Chapters One through Five we discussed the basics of painting and drawing. Now we've come to the trickiest part of the book because in this last part we're not going to be discussing the *craft* of painting, where performing a series of steps produces a predictable outcome, and where specific techniques are taught. Instead, we'll be dealing with the *art* of painting, with intangible qualities such as the emotional quality of brushwork and with personal, intuitive ways of seeing and painting. Here we will examine the almost unteachable—the elusive, artistic factors that make the difference between a competent, well-painted work and an extraordinary one.

It may take you some time to incorporate these aspects of art into your work. While some things may come with experience, unique personal expressions don't come overnight. They evolve gradually, after lengthy struggles with technique. But don't be discouraged. After a while, with concentration and determined effort, these ways of seeing will become automatic and you'll find yourself creating compositions and effects you never dreamed of—learning to visualize a painting where most people see just an ordinary scene.

In my painting of an ocelot (seen here), I was intrigued by the graphic shape of the cat and its shadow. I was also taken by the play of light on the texture of fur and rock. To keep the focus on its face, I put the greatest contrast—the brightest whites and blackest blacks—and the most detail there. I also faded the light around the edges of the painting to return the eye to the center when it strays. This painting is particularly interesting in that the animal is facing out of the painting and emerging from the top, creating intrigue.

Inspiration and Interpretation

No matter how photographic, precise, and realistic, a work of art is not a literal translation of reality. It's an *interpretation*. Perhaps the artist changed the lighting or colors, or moved objects. Maybe the brushwork or style of painting added a distinctly individual "flavor." If you compare a painting with the actual scene, not only does it look different, but the painting probably looks better than the reality. The artist's interpretation is what makes a painting special—or we would be satisfied with just a photograph.

Making a painting is like playing music. Why does one concert pianist or violinist move us deeply while another, playing all the same notes, doesn't stir any emotion in us? Notes are just notes. It's the emotion, the inflection, and the feelings the artist arouses in us that makes the music special. It's the same with art. When we see a great painting we're moved by such intangibles as great brushwork, rich colors, and powerful compositions. A good wildlife painting is more than an accurate depiction of an animal, or just a pleasing picture. It should have spirit, something from within that the artist feels passionately about and then shares with the viewer.

Inspiration is subjective. An exciting subject for one artist may not be worth a second look for another. And artists find inspiration in many locations: some at the zoo, others in the wilderness, and still others in a museum. A painting may be triggered by sudden, momentary effects—a flash of a color, the shape of an animal, the play of light on a landscape, or along a bird's back. It can be inspired by a trip to an art gallery—by an unusual angle in a photograph or an exciting lighting effect in a composition. You don't need to copy the work of others to be inspired by their art. That's why it's so important to always keep a sketchbook handy, so you can jot ideas down before you forget them. These ideas are precious and fragile and, like dreams, easily forgotten. Even if they don't turn into new paintings, they can be incorporated into existing ones.

MOOD AND EMOTION

A painting is a form of communication, conveying a message or telling a story—even if it's only the look in an animal's eye or your response to a scene or experience. Many paintings never get beyond technique. They're well painted because the artist has learned the techniques of painting, but the results are ordinary, just pleasing pictures of animals, because the artist lacks a personal response to his or her subject. Technique without feeling is empty and results in paintings that look lifeless, stale, and contrived. Creating an exceptional

painting, a painting with mood and emotion, one that makes the viewer stop and take notice, goes way beyond technique.

When I speak of emotion I don't mean the animal's emotion. I mean the artist's emotion regarding the subject or the painting. The paintings that end up intriguing me most are the ones I get lost in, where in painting them I lose a sense of

WINTER WIND *(Barred Owl)*
Oil on Masonite, 26 x 34" (66 x 86 cm), 1992.

One day I came across a thick, old branch next to the hiking path and was so enthralled, I just had to paint it. I was excited by its character, by the shapes of the wood where it had been broken off, by the few spindly sticks that jutted out at odd angles, and by the deep crevices so characteristic of an old willow. So I lugged it back to my car and set it up in my studio to paint it, choosing an angle and light direction that best revealed its character. Before long, I painted an owl sitting on it, like an extension of the branch. So even though the stick was long since dead, it started to take on a life of its own. To intensify the mood that that craggy, barren piece of wood conjured up, I placed a cloudy, tumultuous sky behind it and entitled the painting Winter Wind *for the dry leaves that were blowing by. The painting was truly incomplete without them.*

time and begin to explore the world I'm creating. It's not so much in the act of painting as it is in the ongoing search to find my subject through mood, texture, and color. To me, that's art at its highest level. And these paintings inevitably turn out to be my finest works.

Paint something you're passionate about, even if it's not what others are painting. That's how you are going to put life into your art. Feelings make an experience stand out, make it special. And painting is about feeling. If you feel nothing for your subject, why paint it? When you're attracted to a particular subject, the first question to ask is: What is it about that subject that attracted you? Why do you want to paint it? What do you want people to observe about it? What do you want to say in your painting?

Study the work of exceptional animal artists like Edwin Landseer, Carl Rungius, Wilhelm Kuhnert, and Bruno Liljefors. These artists painted with passion and power. Since the reality is rarely as compelling as the paintings, ask yourself what they did to improve on nature. How did they give the art added dimension? What gave their paintings life and depth? Look at Andrew Wyeth's work. Wyeth's paintings convey mood, emotion, thoughts, and feelings. They say as much about him as a person as they do about his subject, and that gives his art great presence and power.

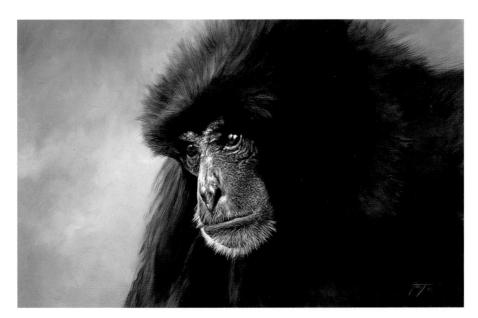

GIBBON PORTRAIT
Oil on Masonite, 14 x 22" (35.5 x 56 cm), 1993.

Emotion obviously influenced my selection of this subject and the close cropping of the composition. In choosing a subject, ask yourself if the image strikes a chord in you. Does it make you feel joy or intrigue or pensiveness? Even a simple look can say volumes. For me, this gibbon portrait brings up an emotional connection and a sense of identity (on the part of the viewer) with the animal.

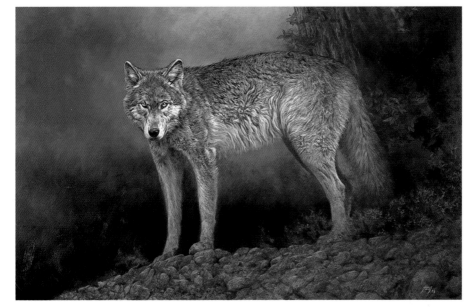

EMERGENCE *(Timber Wolf)*
Oil on Masonite, 24 x 36" (61 x 91 cm), 1993.

I think this is one of my most powerful paintings. I was working from an image that had more presence than most, and I wanted to capture a mood and feeling rather than make a pretty picture. I deliberately placed the wolf in the middle of the painting and left the background unplanned so I'd have to paint it spontaneously. I focused on the intensity in the wolf's eyes and the way it held its head, and chose dark and brooding colors as a backdrop, to set the mood. I covered the wolf with a thin wash of these background colors, then worked the fur into it wet-in-wet. I painted the ground and tree purely from my imagination, keeping them dark and with little detail. I rarely paint this way, but it worked this time.

Composition and Design

Volumes have been filled with advice on these subjects, and I'm not going to rehash old literature here. Instead, I'd like to take an unconventional approach and say that composition is something you have to discover for yourself. Composing a painting is part of the ongoing search for communicating meaning, for finding a way to make the painting say what you want it to say. Formulas and rules are great starting points, but they should never become so confining that they exclude unconventional forms and expressions.

Composition is an intuitive process that takes years to develop. Even so, we generally know if something looks off, or if one painting is better designed than another. We may not be able to say exactly why, but we do see it. So ask yourself what makes one painting compelling and another one dull. Look critically at the scenes you're painting. Ask other artists, too, especially those with a lot of experience. They don't have to be painting the same subjects as you. In fact, some of the best advice can come from artists who have trained their eyes to spot good qualities of design and composition in paintings.

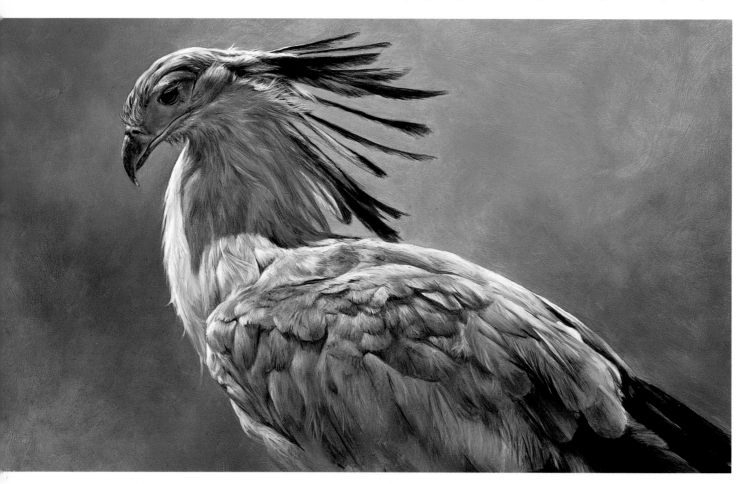

SECRETARY BIRD
Oil on Masonite, 12 x 20" (30.5 x 51 cm), 1996.

Many of my paintings start as stark black-and-white drawings. Without color to worry about, I can focus on the overall impact of the image in a purely graphic sense. The painting of this secretary bird is a good example of this, as its power lies not in its color but in its glorious shape, with curves cascading from beak down the neck to its body, topped off by a wonderful spray of feathers behind its head. I painted it from start to finish entirely on location at the Denver Museum of Natural History. As in many portraits, I look at what is already there and make these interesting qualities more apparent. Thus, while I add nothing new, I bring out my subject's inherently beautiful qualities and focus on them.

DIRECTING THE EYE AROUND THE PAINTING

When you're designing a painting, don't stick objects in arbitrarily. Place them so they keep the eye moving around the piece as a whole, then back to the primary focus, without letting the vision trail off the side of the painting. This keeps the viewer focused. The opposite of this, a stagnant painting, has no visual flow. Instead, eye movement is stationary or halts at a particular spot. You can direct the eye with objects such as sticks and grasses, or with value contrasts, such as light and dark areas. The darks become mysterious sections for the viewer to discover and explore.

Sometimes the format of a painting can also move the eye in a direction that continues the general thrust of the composition. So, when you're planning the outside shape of a painting, consider a long rectangle as in *Rest Time* (on this page), or even a diptych—or triptych—where two or three paintings continue each other and are hung side by side as a unit to read as one large piece.

Another way to add interest to a painting is to create a second, less important focal point in addition to the primary one. It could be as simple as a bright fruit or flower in a painting of a bird, or a colorful rock on a stretch of beach. It could even be the bird on a rhino's back. Whatever it is, it adds interest to the piece and allows the eye to travel back and forth between areas, holding the viewer's interest.

STUDY COMPOSITIONAL DEVICES

Analyze the composition of one of your favorite animal paintings. How have the various elements been organized into a harmonious whole? What makes the image compelling? How does your eye move around the painting? How has the artist used light and dark values to convey mood or to focus the eye? How do the various elements in the painting echo each other or relate to each other? How have they used negative space? Although you probably won't find answers to all these questions in any one painting, it's important to be aware of these compositional devices.

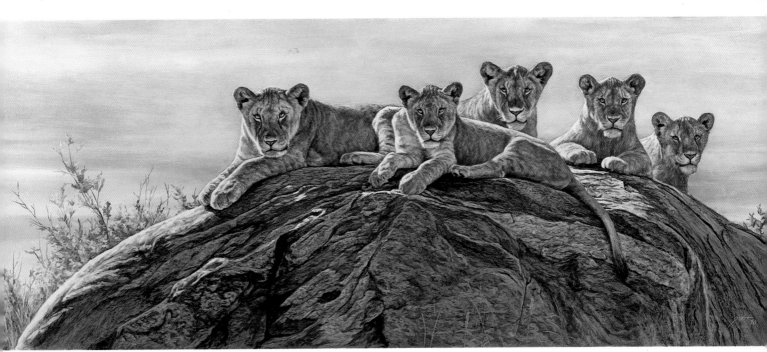

REST TIME *(Lion Cubs)*
Oil on Masonite, 16 x 40"
(41 x 102 cm), 1990.

The long format of a painting can be very interesting and works particularly well here. The arching rock, with a line of cubs along the top and the echoing shapes in the tail and paws of the lions, sets up a wonderful, elongated rhythm that moves the eye across and along the painting.

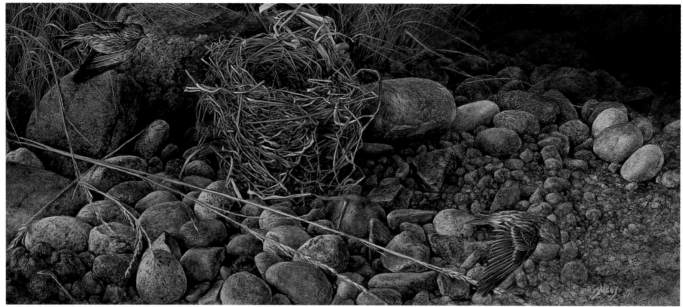

THE NEST *(Pine Siskins)*
Oil on Masonite, 14 x 32" (35.5 x 81 cm), 1991.

The true subject of this painting is the blackbird nest, which has fallen to the ground, and the bed of rocks it's sitting on. The two birds are important as secondary elements. They're almost unnoticed, but they add a lot to the painting in the way of movement and interest. Notice how the eye is directed around the painting by the use of lighting and by the rocks and grasses on the ground. The red dot in the diagram shows the focal point and the arrows show the most likely eye direction (not everyone has the same eye movement).

TOM QUINN
THE TYRANTS *(Owl and Hummingbird)*
Acrylic, 24¼ x 15½" (62 x 39 cm), 1997.

This is a classic example of how the eye can be directed within a painting and how important a second focal point can be in adding interest and complexity to a work. Without the hummingbird, it would have been simply a nice painting of an owl, but, with the hummingbird added, the painting has an entirely different impact. The owl is still the main focus, but the hummingbird now attracts the eye from the owl to the lower right-hand corner, then up through the branches and back to the owl's head. Quinn's mastery in leading the eye from place to place is quite evident here. In the diagram the red dot shows the focal point and the arrows show the most likely eye movement.

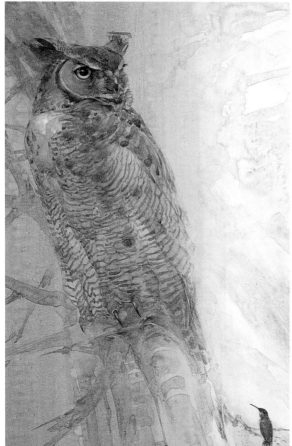

SUBJECT PLACEMENT

Where does your eye go when you look at a painting? Does it wander excitedly around the whole work? Or does it get caught up in one area, stay there, then get stagnant and bored? Does it find unnerving or vacant areas in the painting? Or is it mesmerized by what it sees?

Where you place your main subject—in this case, an animal—in the painting is a critical decision if your composition is to be interesting. It can affect the feeling of the piece, the tension, the flow of eye movement, and it describes the animal's activity.

The Rule of Thirds

One of the standard considerations in design is the one-third rule. The rule says to place the subject not in the middle of the composition but one-third of the way into the painting because it's more interesting to view a space broken into unequal areas than to have the same amount of space on all sides of the animal. This is not only true for top, bottom, and sides of the subject, but it can be used for all elements of the painting, from sticks on a branch to clumps of grass in a field. You may even want to place an object so that there's a lot of space on one side, a smaller amount of space on another, and an even smaller space on yet another side. This lets the viewer enjoy a big open space, with a little more tension in the smaller space, creating a more interesting image than if the subject was in the center of the painting.

The Rule of Thirds

This is a drawing of a rectangle broken into thirds, a good basis for placing animals.

HOODED CAPUCHIN
Oil on Masonite, 10 x 12" (25 x 30.5 cm), 1995.

This simple example shows a good way to break up the space of a painting. The largest area of negative space is at the upper right. There's a slightly smaller negative space area below the monkey, and an even smaller space at the upper left. The sketch shows how the monkey works with the surrounding space.

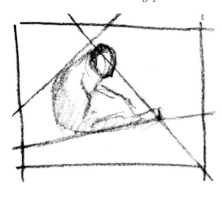

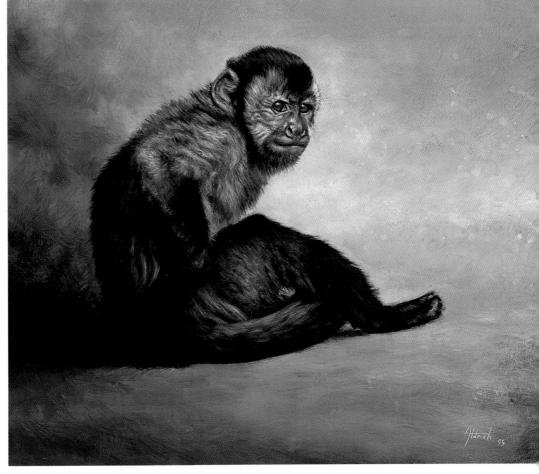

EXPANDING YOUR SCOPE OF INFLUENCE

Since there's no all-encompassing formula to determine the right placement for an animal in any given composition (except for the rule of thirds) it's a good idea to study animal artists who do it best. Look at their paintings and ask yourself: How do they place the animal? Where do they put space around the animal? Do they butt them right up to the edge? If so, why? How do they incorporate the animals into the landscape? Do the animals flow with and complement their surroundings or do they look like they were just thrown in? Expand your horizons in your quest for artistic knowledge. Look at all forms of art, from realism to abstract art, from landscapes to still lifes. The visual truths in these paintings are universal and you can learn from them all.

Facing In or Out

Another rule says that when you paint an animal (or person) looking even slightly to one side, you need more space in front of it (looking into the painting) than behind it. While this works most of the time, an animal looking out of a painting can convey longing, intent, or an imminent exit. So in the planning stage, make several sketches to see the effect of the animal looking in or out of the painting, and use your instincts when making the final decision about placement.

One technique to determine placement of the animal in a painting is to put the background in first, then move around a piece of paper in the silhouetted shape of the animal to visualize how it would look in each area. As a general rule, avoid placing the animal smack in the center of the painting. The center can be very static, so it's best to keep the subject somewhat off center so you can break up the spaces in the painting.

Adding Tension

Tension in a painting is caused by something out of balance—a subject poised to move or perched precariously. Anything that instills a feeling of anxiety in the viewer adds tension to your painting. Tension is not a bad thing. In fact, it can have a wonderful effect on a painting, adding intrigue and interest.

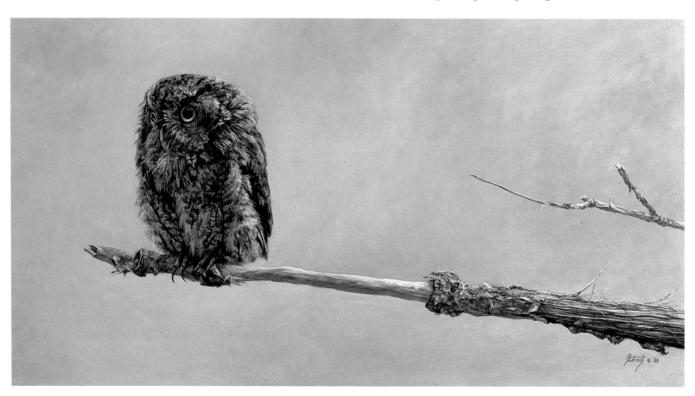

IMMATURE SCREECH OWL
Oil on Masonite, 15 x 28" (38 x 71 cm), 1988.

The tension here comes from the combination of an off-balance composition and an animal looking out of the image. Notice the stick jutting out on the right. This little accent balances the painting. The twig echoes the big stick and the owl's talons. The owl, with its huge eye, is intriguing to the viewer. What is it looking at? If the owl were looking into the painting, it would have a very different effect.

Creating a Backdrop

From the very beginning, a painting needs to be seen as a whole. You can't decide to paint an animal and then haphazardly place it anywhere in the painting, trying to add elements to balance it as you paint and expect the painting to work. An animal is an integral part of its environment and must relate to its surroundings harmoniously within the painting.

Choosing the appropriate backdrop for the animal is important. The backdrop can convey the feel of the animal, complement it, or detract from it. It must also reflect the animal's natural habitat, including plants and other appropriate elements. A monkey from Borneo, for example, would be out of place in an African savannah. Also, consider the season. Some animals change their coats, antlers, and even colors with the season, so be sure to reference your animal's seasonal behavior.

Animals in nature (for the most part) are designed to blend into their environment. Their colors and markings, and even sometimes their shapes, afford them the wonderful ability to hide. You can take advantage of this natural concealment as a way of adding interest to your paintings.

Notice how an animal's shape echoes elements in its environment, and the way its colors are repeated (and reflected) in nearby elements. (In Chapter Five, note how the colors of the Siberian tiger's coat are echoed in the leaves below.)

Think of the backdrop as a stage set where your role is set designer, lighting director, and director of the mood and character of a play in which the animal is the featured actor. For your stage set, choose materials that are consistent with the animal's natural surroundings. Also be sure to select items that are interesting for you to paint and explore—such as smooth rocks, the textures and shapes of branches, and the rich colors of certain plants. Then set them up to create interest in the scene. Vary the sizes and shapes of rocks, or put several rocks of one color with one or two different-colored rocks for interest. Arrange sticks or grasses to move the eye around the painting. Use lighting selectively to focus on certain areas while leaving others in shadow. Feel free to move elements around or even change the entire thing until it pleases you. Also be careful to leave a spot for the animal that works compositionally and shows the animal as an integral part of the scene.

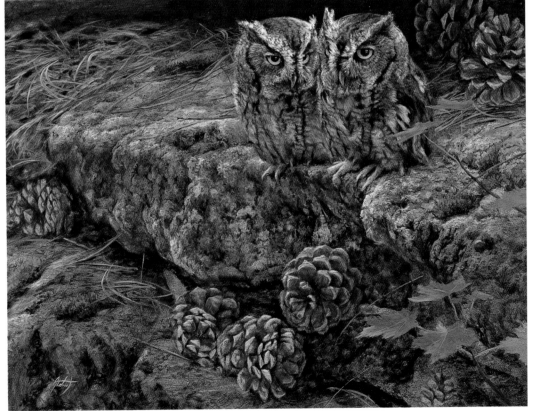

SCREECH OWL PAIR WITH PINECONES
Oil on Masonite, 12 x 16"
(30.5 x 40.5 cm), 1992.

I got the idea for this painting while I was outside looking for an appropriate habitat for an owl and came across some round pinecones. I wanted the shape of the two owls to be echoed by the surrounding pinecones. I painted the entire scene outside, arranging the pinecones so that they worked with the composition I had planned out.

Bob Kuhn
Mara Landscape with Lions
Acrylic on Masonite, 20 x 32" (51 x 81 cm), 1984.

This is a good example of the effective repetition of shapes. The primary focus of the piece is the foreground lion. He is not only echoed by the lioness but even more so by the shape of the large kopje (outcropping of rock) directly behind him—a good foil for the lion's head and mane (setting it off, yet repeating it). Also notice the shapes of the bush on the top of the kopje and the bush in the foreground—more echoing. Echoing makes your eyes go back and forth between elements and it creates an overall sense of harmony in the habitat, giving you the feeling that the animals belong in the setting.

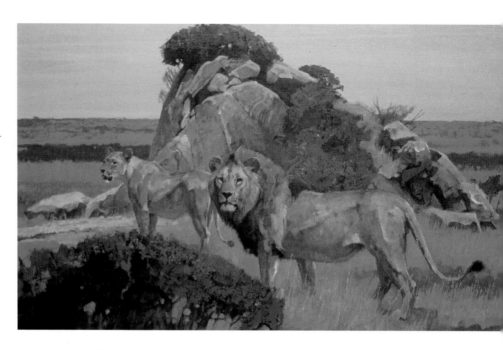

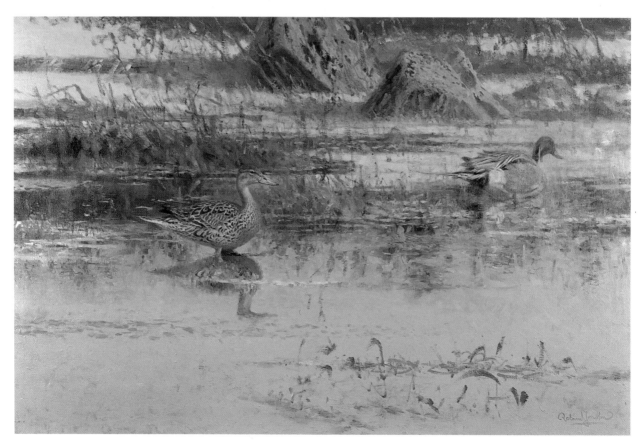

Roland Jonsson
Pintail
Oil on canvas, 43½ x 60" (110.5 x 152 cm).

Careful observation of the habitat of an animal is critical for the accuracy of a painting. You have to get the elements right and arrange them so that they complement the animals. This painting offers an elegant glimpse into a very typical scene. The ducks are posed naturally—one is even swimming away. They're pleasingly grouped among the water plants and rocks of their natural surroundings. They don't look posed or staged or plopped into their environment. They're a part of it.

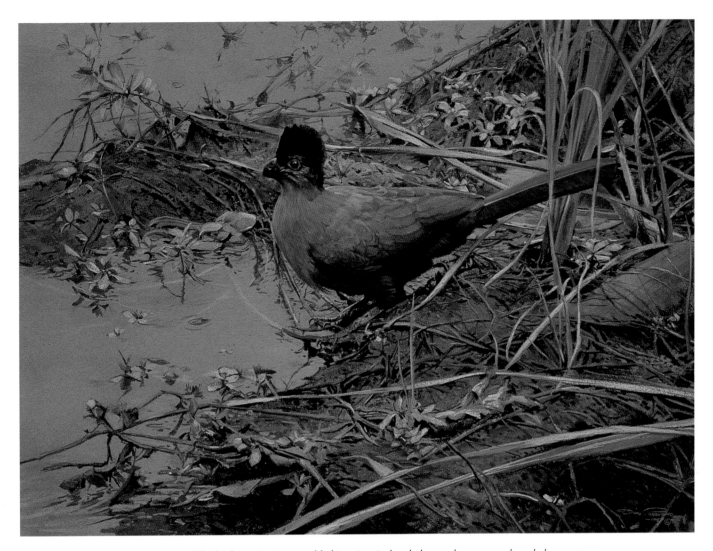

DINO PARAVANO
PURPLE-CRESTED LORY
Pastel paper, 21 x 29" (53 x 74 cm), 1995.

The bird, seen in its natural habitat, is poised and alert, and appears ready to dash away at any moment, lending a sense of reality to the piece. Paravano had actually observed this scene, so it's an authentic setting. Artistically, the painting is well designed, with the grasses echoing the tail and legs of the bird. The colors are also harmonious—the colors on the bird work well with the blues in the water and with the yellowy rust colors in the grasses. Repetition of color helps balance a painting and gets it to work as a whole.

RE-CREATING ENVIRONMENTS IN THE STUDIO

I love to paint intimate animal scenes and create settings that offer a glimpse into an animal's immediate surroundings and its normally secretive daily life. The best way to gain experience in depicting such scenes is by observing nature firsthand. Having said that, I must now confess that I often re-create these scenes in my studio because there I can design the composition and lighting, and control the overall effect. I've been known to drag logs and leaves, or haul backpacks filled with rocks and other assorted materials, back to the studio to create a natural-looking "still life." There's nothing better than painting with the real colors of nature right in front of you, with all their textures and subtle nuances, and, most important, their three-dimensionality to add solidity to your art. The result is far richer and more convincing than you could ever get from a photo.

I arrange my setups on a long tabletop in my studio. I use either natural light from a window or arrange the lighting to create my own effects. That way I can spotlight only areas where I want the light, pushing other areas into shade, or create interesting effects with dappled light.

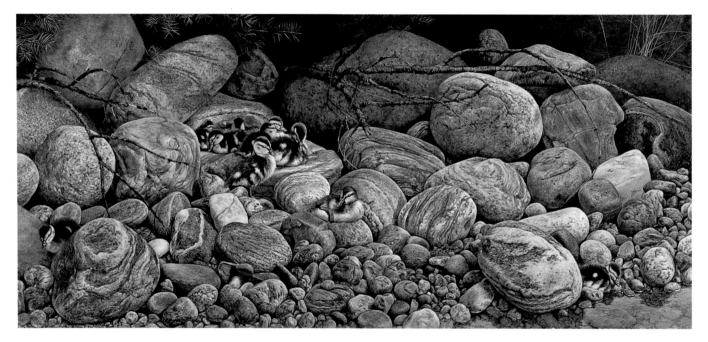

STREAMSIDE *(Mallard Chicks)*
Oil on Masonite, 22 x 48" (56 x 122 cm), 1994.

This is one of the most elaborate setups I have ever portrayed. I literally created a stream bed on a table. I wanted to paint a riot of rocks where mallard chicks could get lost and hide. So with the help of a friend, I lugged hundreds of rocks into the studio and arranged the rocks and sticks on the table until I was satisfied with the placement. The painting took the better part of a month to finish. Toward the end I added the juniper, then painted the mallard chicks from various photos I had taken. The resulting painting is a good example of this manner of working.

WET ROCKS
(Mallard Chick)
Oil on Masonite, 12 x 24"
(30.5 x 61 cm), 1993.

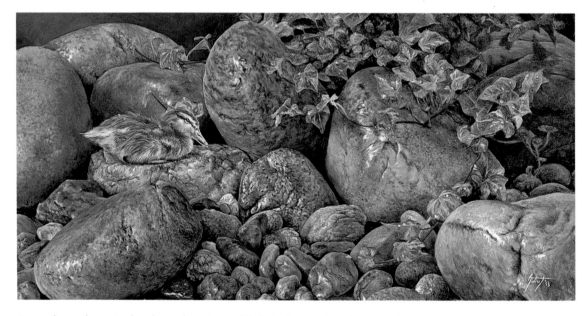

I wanted more than a simple rock setup here; I wanted the look of an area just after a rain. So I arranged the rocks and plants and wet them down with a spray bottle. Since the rocks only stayed wet for a little while, I had to spray the rocks I was working on continuously. I painted the plant first, and, by the time I finished the painting a couple of weeks later, it had grown several inches and looked very different. To get a wet effect, I paid particular attention to the look of the rocks with and without water. Water makes rocks much richer in color, so I used more burnt sienna and raw umber than I would have if they were dry. I also suggested water by showing reflections of the surroundings in the glassy liquid sheen. To create the effect of the sky and light source reflecting onto the wet surfaces, I painted cobalt blue and alizarin crimson around a pure white highlight.

CREATING THE ILLUSION OF DISTANCE

There are a few basic things to know in order to depict distance in a landscape. As distance increases, the amount of atmosphere (sky color) increases. And, so, the more atmosphere there is between the viewer and the subject, the more layers of atmosphere, and bluer, objects in the distance become. Thus distant mountains take on a pale blue cast as they recede. Distance also decreases the amount of contrast in a subject. Bright whites and dark darks are strongest on the closest subject and gradually become weaker (in contrast) in the distance. The darks get slightly lighter and the lights get slightly darker. Details also become less observable as they move into the distance. If you omit these principles when executing your painting, your work will suffer. Of course these are only general rules. There are always successful exceptions in different artists' interpretations.

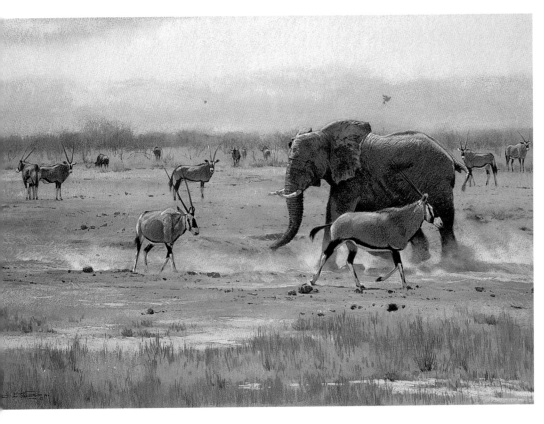

DINO PARAVANO
THE BULLY
(Elephant and Gemsbok)
Pastel on paper, 28 x 42" (71 x 107 cm), 1994.

This painting effectively shows the vastness of the African savannah by using all the elements necessary to create the illusion of depth and distance. The horizon is blued, softened, and blurred by the heat of the day, and Paravano has reserved the contrast and detail for the closest animals, which separates them from the distant, hazier ones. He also captures the dry, dusty feel of the African savannah through his choice of colors and use of intense direct lighting. In addition to this being a fascinating painting, it's also an effective display of well-handled distance and perspective.

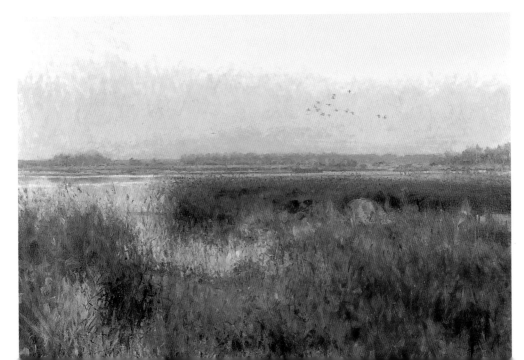

ROLAND JONSSON
AUTUMN *(Wigeon)*
Oil on canvas, 38 x 53" (96.5 x 135 cm).

This is another great example of the depiction of the vastness and depth of a landscape. Jonsson has reserved the rich colors for the foreground and the soft blues and purples for the background. In an interesting twist, he has softened the foreground and made it more abstract while adding a bit more detail and clarity to the horizon and the birds. This brings the viewer's eye into the painting, seeing the scene as if he or she is actually present.

WORKING WITH NEGATIVE SPACE

The effective use of negative space is a very important consideration in a painting. Negative space is the area surrounding the positive (or specific) shapes and forms—the space between leaves on a tree, or between the animal and a branch, or between one animal and another, or even between an animal's legs. Negative space is also important as a resting place from more active areas, a place to "breathe." By being of less interest to the eye, it supports the subject. Like yin and yang, the active and passive areas of the painting complement each other.

Tom Quinn's work is an excellent example of design, elegance, and the effective use of negative space in relation to his subjects and to the painting itself.

This is a brilliant example of the use of negative space in a painting. Notice the way the branch slices through the background and the almost abstract shapes of the ducks. The space around these elements is the negative space, and Quinn has effectively used this space to create interest. What he has left unsaid (unpainted) allows what is said (the birds and branch) to be the primary focus and gives a soothing platform for the birds and branch. It also creates a soothing atmosphere of mood and color. The shapes of the negative spaces vary in size and shape, providing an interesting experience for the eyes.

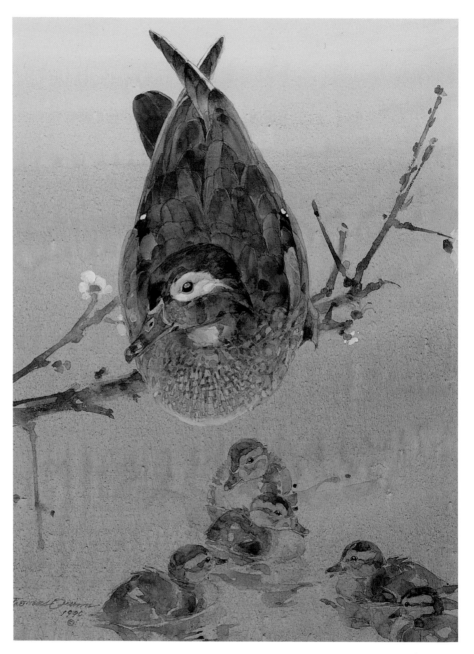

Tom Quinn
Wood Sprites
Acrylic, 13 x 9⅝" (33 x 24 cm), 1996.

SOMETHING TO THINK ABOUT

Is there magic in your work? Or do you say too much and diffuse the mystery in the process? Do you tell all? Or have you left room for interpretation, a space in which to dream?

Color Temperature

Temperature is the visual experience of a particular color in terms of coolness and warmth, and all colors have it. You can tell if a color is warm by the way it "feels"—blues are cool and reds and yellows are warm. But each color also has a cool and warm version. Some yellows are cooler and greener and others warmer and more orangy. Alizarin crimson is a cool red, and cadmium red light is a warm red. White cools the colors it's added to, while cadmium yellow warms them. If you're not sure which version of a color is cooler or warmer, place them side by side. You can always see the nature of a color best in relation to the colors around it.

Working with cool and warm colors creates interest in a painting. It's also a technique you'll find in the art of the great masters. Notice the interplay of cools and warms in the shadows and in the light parts of paintings. That's what makes a painting seem strong and solid. Cools and warms can be used boldly or they can be very subtle.

The interplay of warms and cools can also add a sense of solidity to objects that can't be achieved any other way. For example, you can change the planes of a cube simply through color temperature, by putting a slightly different hue on each side. You can also use color to describe changes on a rounded form. For example, a form lit from the side gradually changes in value as it moves out of the light, going from highlight to light to halftone to shadow to a sliver of reflected light and back to shadow. Instead of showing these shifts as changes of light and dark, you can add subtle temperature changes by deciding if the light on it is warm or cool, and by adding the colors of nearby reflected lights.

Notice the effective use of cools (blues, purples, and some greens) and warms (reds, oranges, and yellows) in some portraits, for example. Colors that may not at first seem to be in a face—rich reds, blues, and purples, for example—upon closer examination can actually appear to be there. Adding these colors gives the effect of solidity to the face.

So, next time you see an area in your painting that's not as strong or solid as you'd like it, instead of just making it a darker or lighter version of your initial color, try using color temperature. It's far more effective to play cools and warms against each other to achieve realistic color than add black to a color to create a shadow. Use black selectively to add contrast and depth to your work. Reserve it for the final "punch" of a painting, not a consistent overall tone.

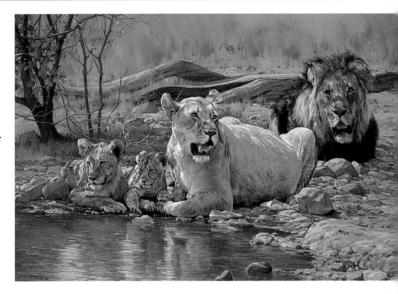

DINO PARAVANO
LION FAMILY AT WATERHOLE
Pastel on paper, 28 x 42" (71 x 107 cm), 1993.

This is a good example of the use of warms and cools within areas of a painting to add punch and interest. Notice the shaded areas on the female lion. There are intermittent warms and cools in very subtle tones all through the body, accented by distinct warms under the chin, contrasting with cools on the side of the face and in the shadows on the head. His intentional and conscious use of these color temperature variations create the tremendous solidity of the lion. Notice the use of cools and warms in all of Paravano's work.

GAIN INSIGHT FROM GREAT PAINTINGS

Look at paintings that use color instead of value to create form. Go to a local gallery where you can study the actual paintings themselves. Ask yourself: Do they add a hint of cool color to the highlight? Are there subtle cools in warm areas? Compare the colors of the different parts of an object. How does the color of an object in shadow differ from the lighted area? Do you see a noticeable difference? Perhaps it's redder or bluer, or more orange or purple. It's this dance of color that makes a painting great, no matter what its subject.

Lighting

One of the most compelling aspects of a painting is the lighting. Effective lighting can be anything from a direct light, boldly illuminating a subject and creating harsh shadows, to a thin wispy light among deep, dark tones, giving a great sense of atmosphere and focus. Lighting is fundamental to a work of art, setting its mood and character. Pay close attention to the various lighting effects in the natural environment so you can re-create it in your own art.

You need to be aware of how changes in lighting affect the overall feel and look of your painting so you can choose the situation that's best suited to your subject and what you want to convey. This is especially true when you're painting outdoors, where nature changes frequently and you can choose the time of day or weather conditions you want to paint in. As discussed earlier, working from a mounted specimen does give you more control, allowing you to change the direction of the light by turning it around and making the light come from practically anywhere you wish. You can also work from a photo reference with a lighting effect that is interesting and enhances the quality of your image. With enough experience painting lighting, you'll even be able to make up your own lighting effects. But for now, paint only what's in front of you.

LIGHT DIRECTION

When light is actually hitting the subject either in a direct or somewhat diffuse form, it can be broken down into three general groups, depending on the direction the light is coming from. These directions are back, front, and side. Each lighting direction has its own characteristics and produces different effects on the subjects.

Side Lighting

Any light hitting a subject that's not coming from directly behind or in front of it is side lighting. Side light creates shadows and thus effectively shows the form of the subject.

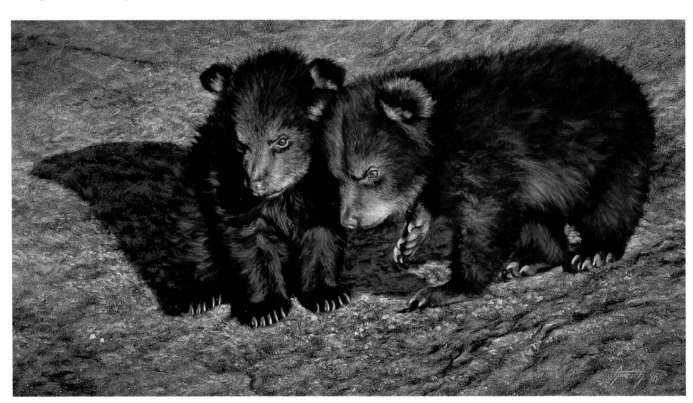

SIBLINGS (*Black Bear Cubs*)
Oil on Masonite, 10 x 18" (25 x 46 cm), 1996.

I was fortunate to get the opportunity to photograph some tame bear cubs that had been brought into a natural mountain setting. These photographic opportunities are invaluable, and the photos I took led to some wonderful paintings. Notice the side lighting—the cast shadows and play of light it creates on the fur, as is usually the case in this type of lighting. Direct sunlight can create a light, almost shiny, reflection on dark fur that's evident here on the cub faces and legs.

The play of light and shadow on a form also allows us to see the different planes and angles on the subject. Since a scene can look totally different when lighted from different angles, I move the light around and check it from every direction before I paint a mounted specimen or setup, to see which direction is the most interesting.

Backlighting

Backlighting can create some wonderful effects. The characteristic halo or crisp of light that appears on the outside rim of the subject can be very interesting. Back lighting can also create a silhouette effect—throwing the subject into blackness and leaving the surrounding background brighter. This can be interesting if it is used correctly but frustrating if you want the subject to be seen as well.

Front Lighting

When you paint from a photo taken with the aid of a flash that's on the camera, or if the sun was directly behind you when taking a picture, you'll notice that the light is very bright and the shadows are almost nonexistent. This overall lighting can be interesting, if that's what you want, but it also can be too consistent, leaving nothing more important than anything else in your painting. Where that's the case, you may want to invent some shading or shadows on certain areas of the animal to push it back a bit.

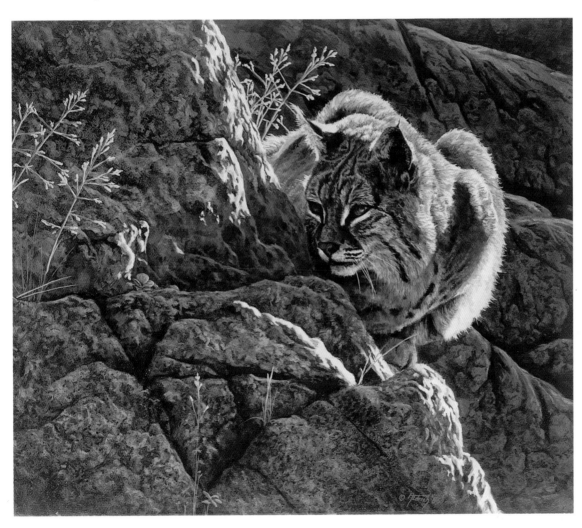

WAITING *(Bobcat)*
Oil on Masonite, 20 x 24"
(51 x 61 cm), 1986.

I started with a wonderful photo of a bobcat. But I also needed a photograph of an appropriate rock formation for the bobcat to perch upon—one, of course, with the right lighting on the rock. I searched the forest for an entire afternoon, going through the better part of a roll of film. Ultimately I used two different photos and grafted them together. I conjured up the background entirely from imagination—I wanted it dark and set back so the lighted foreground would stand out more. The backlighting, which was one of the elements that drew me to this image, was strong and came from behind and to the right. In this case, the high contrast between the darks and the lights gives a sense of dramatic power to the piece.

PAINTING THE TIME OF DAY

Morning, late afternoon, high noon, evening, and all the times in between have distinct lighting effects. Perhaps the most beautiful times of the day are early morning (just after dawn) and early evening (just before sunset). It is the dramatic color that makes these times so lovely. Nature is rich with color at all times, and no one set of colors makes up any particular time of day. To depict these colors accurately, it's best to experience them firsthand by going into nature and making quick color notations or a quick plein air painting.

Learn to use lighting and the shadows it casts to create intrigue in your paintings, or to create wonderful compositional effects. The shadows themselves even can be the subject of a painting (see *Ocelot*, pages 126 and 127).

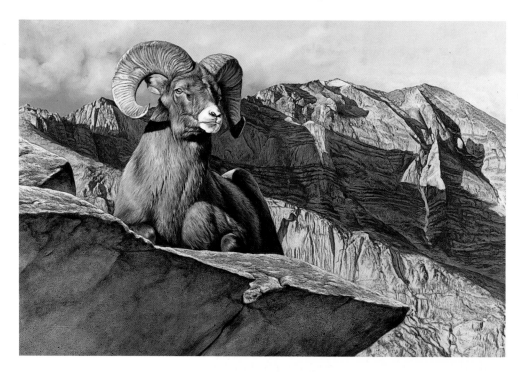

BIGHORN
Oil on Masonite, 20 x 40"
(51 x 102 cm), 1994.

The reference for this painting came from a photograph I took on an early morning hike. As I climbed the mountain, the sun was coming up and I was captivated by the color of the light and the wonderful, deep, long shadows it was creating. In the raking light, the textures of the mountain became apparent. I deliberately silhouetted the bighorn's head in front of this dark streak so that it would stand out.

RECLINING COUGAR
Oil on Masonite, 16 x 7" (41 x 18 cm), 1992.

Direct lighting that creates a strong contrast between light and shadow areas can be a powerful and effective compositional tool. The position of the sun in this scene is familiar to anyone who owns a cat; you can tell a midday catnap is in progress. It is the lighting—the light and shadows and the shapes they create—that makes this image graphically interesting.

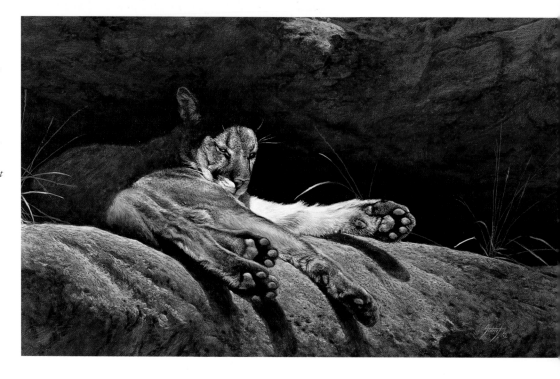

Seeing the Color in Shadows

One of the most obvious aspects of working from life is noticing the tremendous amount of color in the shadows—both cast shadows and areas of objects in shade. These rich colors are rarely seen in photos, which tend to throw shadows into blackness.

By putting a color into the shaded area of an object you can add life to an otherwise dead area. It could be the bright color of leaves reflecting off a nearby tree lit by bright sunlight, or the warm tones from a nearby sunlit rock. Or the shaded side of a rock may be reflecting the sky, adding a bluish to purplish tone that's far more interesting than the usual gray or black an amateur might paint it. The under-side of a bison standing on a sunlit patch of earth reflects an orange glow. A bird sitting near colorful flowers or rich green leaves reflects these colors on its body. Furthermore, if you don't put these colors in, the animal won't appear to be part of its environment. So get used to looking for subtle colors on objects. You may not see them at first, but if you look long enough, you'll see them there.

The contrast between the colors of morning and evening light are wonderfully portrayed in this pair of paintings by Dino Paravano. Each has a completely different palette, yet both convey a sense of the low angle of the sun. Compare the oranges and yellows of *Elephant Sundowners* with the blues and purples in *Happy Hour*.

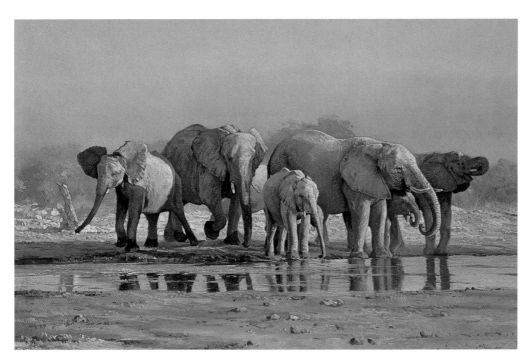

DINO PARAVANO
ELEPHANT SUNDOWNERS
Pastel paper, 28 x 42" (71 x 107 cm), 1996.

Notice how the warm colors of the dirt are carried into the background bushes and even into the sky, giving this painting a feeling of harmony and warmth. These colors are accentuated by the presence of bits of pure blue and purple. Had Paravano used blacks and grays or browns in the shadows, it would have had a far less convincing and stunning effect. The few greens in the water bring yet another area of the spectrum into play, adding further interest without being too bold.

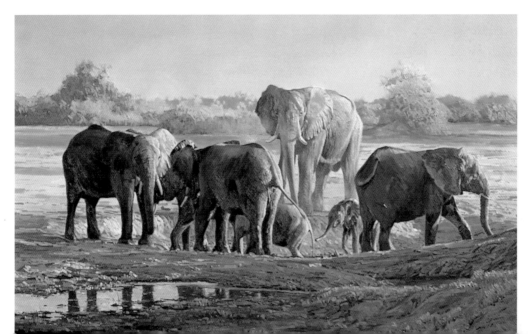

DINO PARAVANO
HAPPY HOUR *(Elephants)*
Oil on canvas, 24 x 36" (61 x 91 cm), 1997.

Notice how the light, which is hitting the elephants and the dirt, really glows with intensity when surrounded by cooler, darker colors. The contrast creates a convincing glow and enhances the intensity of the bright colors. Because of the choice of colors, this painting feels cooler than Elephant Sundowners. *Here again, Paravano is able to avoid using a lot of intense blacks in the shadows, substituting instead a range of cool and warm colors.*

USING LIGHT EFFECTIVELY

The lighting in your painting doesn't always have to be strong and dramatic. Subtle lighting can also add wonderful effects. In the soft, hidden areas of nature, away from the intense light of the sun, you can find some intriguing lighting conditions. Subtle lighting lets colors come alive without bleaching them out like bright lighting. Under a delicate light, tones blend into one another then fade into darkness, providing a totally different mood. No wonder so many portrait painters work in closed studios with nothing but the light from a single small north window. So when I want to control the lighting, as I said earlier, I set up the background environments in my studio. If I want a dappled light, I create a light source and put up a screen to selectively block areas I want in shadow. To create subtlety, I use a diffuse, distant lighting source.

You can also direct the eye and move it around the painting through selective lighting, which acts somewhat like a spotlight. Take, for example, a single white mark on a totally dark panel—an extreme example of selective lighting. Where does the eye go? To the white mark, of course. Even if it wanders off, it inevitably returns to that white spot. Rembrandt used selective lighting brilliantly in his portraits. There he focused on a face by bathing it in light, letting the

FLAMINGO
Oil on Masonite, 12 x 16"
(30.5 x 41 cm), 1995.

You don't normally see subtle colors on a flamingo in bright sunlight, but under the soft lighting I used, and by enhancing the colors of my reference photo slightly, I made this flamingo appear colorful. I also intensified its colors by casting much of the body into a shadow that contained the complementary colors of blue and purple. This also focused attention on the head.

DRY BED *(Scaled Quail)*
Oil on Masonite, 14 x 20" (35.5 x 51 cm), 1991.

In this painting, I wanted to create the effect of a dry, lonely place. The lighting I chose gave a wonderful, dark, overcast feeling while leaving enough light on the quail, sticks, and foreground to tell the story.

background and body fade into darkness. This kind of selective lighting is far more interesting and emotional than dull, overall, consistent lighting.

Study the lighting in effective landscape paintings. Rarely will you see consistent overall lighting—it's usually dull and boring. Instead, within the painting, you'll find different lighting effects in the foreground, background, and middle ground. You can layer lights and darks through the use of shadows, shafts of sunlight, and subtle nuances. Selective lighting provides interest, focus, and release of tension (a term I use for juxtaposing subtle passive areas against complementary areas of intense interest or focus).

Gradations of Value

It's important to vary the values in your painting from top to bottom and from side to side for an interesting and more natural effect. After all, that's the way light falls—lighter near the sun, darker as it moves away; lighter closer to the sky, darker nearer the ground. Applying this the opposite way (dark top to light bottom) can create an effect of an ominous sky or more foreboding feel, or possibly the dawn of a day. Gradation can be particularly effective where the actual background is just one tone or a single mottled color. Even vague-colored sky or water could be spruced up with gradations of lighter and darker versions of the same or similar colors. Gradation not only adds interest; it also adds the illusion of depth.

SEEING DIFFERENCES IN COLORS AND TONES FIRSTHAND

Study the way light falls on different kinds of materials such as rocks, fur, steel, and skin and take note of these differences. Set up a still life indoors with such items as rocks, feathers, plants, wood, fruit, and other objects and observe how indirect light from a window plays upon these surfaces. What kind of shadows does it create? How bright are the colors? Then take the items outdoors in sunlight and ask the same questions. You'll notice great differences in color and texture under different types of lighting. Now take a picture of the setup and see how the photo or slide differs from the real thing. You'll find that in photographs, shadows look black, highlights bleach out, and the subtle colors disappear.

INTO THE FOG *(Black Swan)*
Oil on Masonite, 12 x 15" (30.5 x 38 cm),
1995.

*Thanks to the tonal variation, this
painting draws your eye from top to
bottom. A dark foreground and
light background make for a more
pleasing composition than one in
which both areas are the same basic
value (thus inferring the same
amount of light on both areas).*

PAYING ATTENTION TO LIGHTING

Train yourself to notice the lighting. You can do this by making thumbnail
sketches in which you arrange the composition into simple lights and
darks with no details. Make sure your sketches are graphically interesting
and that the eye moves around the image. After you've done several ver-
sions, decide which of your sketches is the most effective. Of course, that's
the one you'll paint. This exercise will get you accustomed to using light-
ing more effectively in your paintings.

Painting Animal Portraits

Sometimes when there aren't many external distractions to take away from its focus, a subject can have tremendous impact on its own. The saying "less is more" has often been used to describe this way of painting, which can be anything from a nonintrusive habitat background to a head-and-shoulders portrait where the background is foggy and nondescript. I often use the portrait because it allows the viewer to make a connection with the animal without being distracted by anything else in the painting. The background becomes a silent complement to the character and the colors of the animal.

In a portrait the artist is forced to focus on the quality of the brushstrokes and color choices because there are no distracting background details to worry about. On the other hand, the extreme focus in a portrait is extremely unforgiving, revealing flaws in the painting more readily than a painting filled with details from corner to corner.

In creating a backdrop for a portrait, the color and value should either complement the subject artistically or contrast with it, depending on the effect you want to achieve. For a dramatic backdrop, you may want a strong contrast—a light subject against a dark foreground and background will "pop." So will the reverse, a dark subject against a light background and foreground. For a subtler effect, choosing a similar color and value for background and subject will make the animal appear to melt into the scene. Using similar colors and values can also be a way to downplay certain areas of your painting.

SHOEBILL STORK
Oil on Masonite, 10 x 12" (25 x 30.5 cm), 1996.

I designed the background to complement the stork—dark on top to make the head stand out and light below to make the body seem to fade into the background. The variation of values in the background add an interest that an overall similar toned background just wouldn't achieve.

Simplicity

The pleasure of painting detail is what entices many people to paint wildlife, but it's easily overdone. Detail without knowing how to paint solid forms convincingly or use brushwork effectively can make a painting look shallow and lifeless. Detail doesn't necessarily make a painting good or even realistic. When you're overly absorbed in rendering every hair on the animal, it's easy to overlook the more important elements that make a painting successful. Simplicity is one of them.

Simplicity can make a painting seem relaxed and soothing. It's also more graphically pleasing than a complex, detailed painting. A strong, two-dimensional design is often sufficient to carry the painting.

In effective paintings, much of what you take to be detail is really an illusion, achieved through loose brushwork. Ultimately, detail is a final textural or focusing ingredient. So, let go of the detail, especially in the beginning of your painting, and focus on the broader view. Learn to play mysterious and vague areas in the painting against detailed focal points such as the animal's face or head.

Unfortunately, my habit of working close to the art, sometimes even painting on my lap, creates an undesirable visual condition I call "not being able to see the forest for the trees." It's easy to get so caught up in the details of your painting that you miss its overall effect, the way it is coming together as a whole—and that's an artistic tragedy. So get into the habit of stepping back from your paintings every few minutes to get its total impact. I do it all the time. However, since my studio is small, I keep a mirror behind me as I paint and periodically check the painting in it. The mirror not only adds visual distance, but it allows me to see weaknesses and strengths I normally wouldn't notice. I can tell immediately if the composition is strong, where weak areas shout for correction, and spot obvious anatomical errors.

HOUSE WREN
Oil on Masonite, 5 x 7"
(13 x 18 cm), 1995.

This is about as simple a painting as you can get. There's nothing to distract your eye from the bird, and the soft background complements the bird in both color and texture. This painting was completed in two sittings in the Denver Museum of Natural History from a very old specimen. As an artist, you must breathe life into your subjects, even an old mounted animal (see page 38). Here I focused on the delicate texture of the bird's feathers, leaving the viewer feeling that it can fly away any second. The warm, soft background tone complements the colors of the bird, yet it's light enough for the darker bird to stand out clearly against it.

Serval Portrait

Oil on Masonite, 10 x 12" (25 x 30.5 cm), 1991.

I designed this classic head-and-shoulders portrait to show the graceful lines and wonderful shape of the animal's head. In fact, it was the black line—which runs from the tip of the ear around his neck and down his shoulder, tracing the movement of his turned head—that originally got me excited about this image. The great advantage of painting a portrait is that it allows you to see the animal as you would a landscape. You can explore the many textures and tones of its fur the same way you would explore the elements of a forest. Furthermore, the focus of the painting is generally the wonderful expression in its eyes, especially the intensity of its feline stare.

Composing with Photographs

If you plan to work from photographs (or slides), it's better to use several rather than to simply copy the entire scene from a single photo. This forces you to use your own personal creative process to design the painting instead of leaving it up to a camera to do it for you. Besides, designing a painting can be one of the most exciting elements of the painting process, a time of pure creation, where you make up something that never existed before. This is where your expression starts to take form.

Fusing elements from several references—multiple photos, three-dimensional objects or setups, or a combination of the two, can be complicated. You may have a series of photos of birds and want to portray a grouping of birds standing on a beach. Or perhaps you've just returned from a trip to Africa with some great photos of lions and want to combine the lions from several photos and superimpose them onto the background of yet another photo, with a tree from still one more photo. Before you attempt this, there are a few critical things to consider.

LIGHT DIRECTION AND QUALITY

Whenever you combine a series of photos, one of the first things to consider is the light direction and its strength and type. If the light in one photo comes from the side and you plan to paint a front-lit animal from another photo, you have a problem (although slides can be reversed and prints can be "flopped" or printed backwards to correct this). And if it's dim twilight in one photo, while the other is a cloudy day, you also have a problem. So in using multiple references, only combine photos with the same lighting conditions or you'll run into trouble.

RELATIVE SIZE

Another thing you need to consider when using several different references is the relative size of the various elements you'll be combining. You don't want the animals too big or too small for their environment, or the wrong size for the species (for example, an elephant as small as a cat). Pay attention to the relative size of objects in your painting.

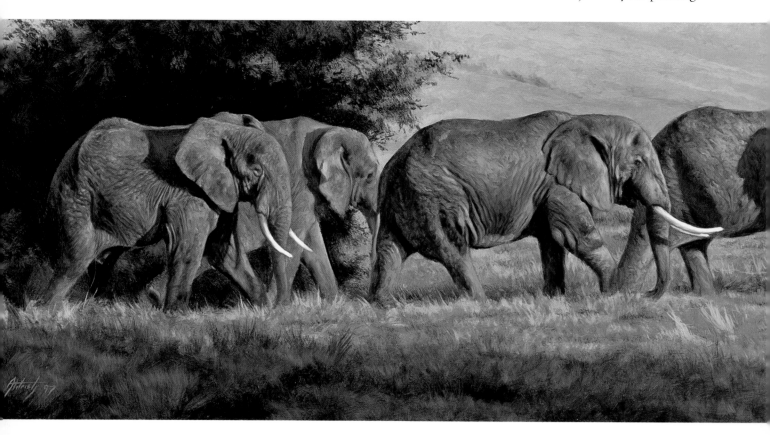

PROCESSION *(Elephants)*
Oil on Masonite, 7 x 28" (18 x 71 cm), 1996.

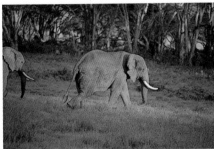

Reference Photographs for *Procession*

I used this combination of photographs that I took in Africa as a reference for my elephant painting, Procession. *I was careful to use photos taken at the same time of day so that the lighting would be similar.*

PENCIL SKETCH OF ELEPHANTS FOR *PROCESSION*
Graphite on Bristol board, 11 x 14"
(28 x 35.5 cm).

This is the sketch I came up with, using the above photos as a reference. I placed the elephants several different ways before I felt that the composition was just right. In overlapping their bodies, I was also conscious of the amount of space between them.

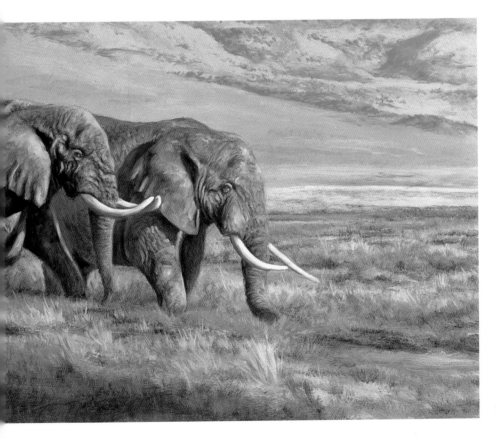

The final painting.

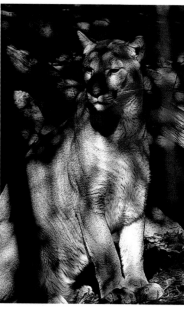

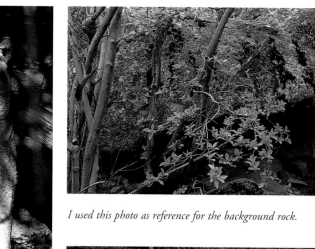

I used this photo as reference for the background rock.

I used this photograph as reference for the basic body shape.

This was the photo I used as reference for the head and front of the cat.

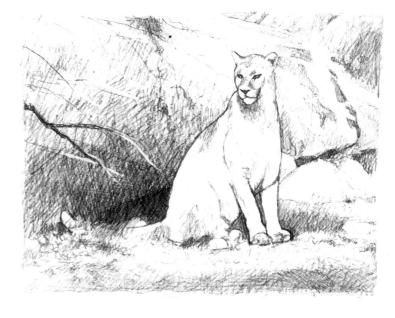

These photos were used as reference for the bed of pine needles.

INITIAL DRAWING OF COUGAR FOR *GUARDIAN*
Pencil on drawing paper, 18 x 24" (46 x 61 cm).

I compiled this drawing from the above five photos and then used it as reference for the painting.

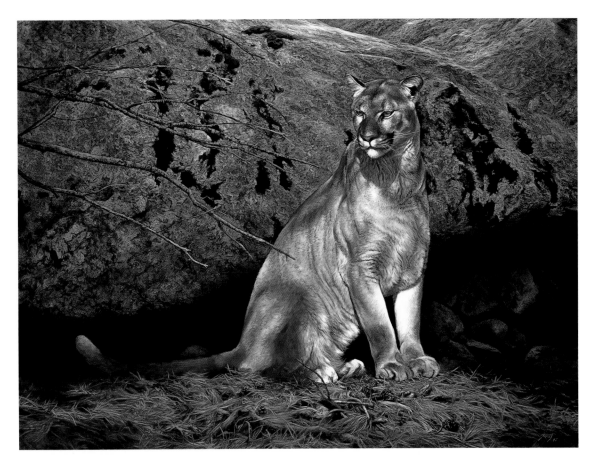

This painting was inspired by a visit to the zoo and by the beautiful look of dappled sunlight. For a backdrop, I chose a rock I liked, then went into the forest in search of an object for the cat to sit upon. I finally chose some old pine needles that reflected the color of the cougar and had great lines running throughout them. I created this painting from multiple photos. To get photos to work together effectively, it's best to draw them first so you can see inaccuracies and correct them relatively easily before you start painting. Also, when grafting different parts of the animal together from multiple photos, be sure the results look natural. Pay attention to size relations and placement of elements. Finally, check the drawing in a mirror to see it with a fresh eye.

CREATING A REFERENCE FILE

In order to locate a reference slide for a particular subject or background with ease, I created a practical system to store and classify my references. I keep the reference slides in plastic sheets, twenty to a page, and hang them vertically in a large filing cabinet. I classify them alphabetically by species or type of environment (for example, under rocks, mountains, grasses, water). With the thousands of slides I own, I find this to be the best way to keep track of my reference collection. Of course, other artists have their own systems. Some keep their slides in small labeled slide boxes, others put them in giant flat drawers, sectioned off to hold rows of slides standing vertically. Choose the method that's best for you.

Keep print film in the individual folders they come back in after they're developed. Then label and classify them according to general subject. Keep the photos together with their negatives in case you want to reproduce or blow up specific photos.

References cut from magazines can be easily kept in an accordion folder labeled as to the particular species or environment. Do note—and this is very important—that working directly from pictures that are another photographer's work and attempting to sell the resulting painting without the photographer's permission is plagiarism. Many artists have been sued for this violation of copyright. So unless you have made significant changes to the original image, you run the risk of being taken to court. Instead of using other people's photos as references, I suggest that you either take your own reference photos or find a photographer from whom you can get images personally, so there is no chance of plagiarism.

In Conclusion

AS YOU NOW KNOW, the creation of wildlife art is a multifaceted and in-depth process that combines patience, practice, technique, design elements, as well as mood, emotion, and the personal touch of the artist. Certainly, creating art assumes a knowledge of technique, but as you can see from Chapter Six, it goes way beyond that.

The need and desire to create art can be anything from a lifelong pursuit to a hidden passion. Whatever role art plays in your life, it can provide a wealth of satisfaction, excitement, and reward to you if you stick with it and weather the artistic slumps and other difficulties. My advice is to get out there and create. Express yourself. Listen to that voice inside you that wants to bring forth something not yet created, something unique.

I certainly hope this book helps you and inspires you. Use what you find here as a springboard for your own vision, not as a book of rules to be lived by. Use the parts that help you, then modify them and make them part of your own creative voice. The point is—get out there and do it!

"Whatever you can do or dream you can, begin it. Boldness has genius, power, and magic in it."

GOETHE

RAYMOND HARRIS-CHING
NEW ARK
Oil on panel, 27½ x 36"
(70 x 91 cm), 1991.

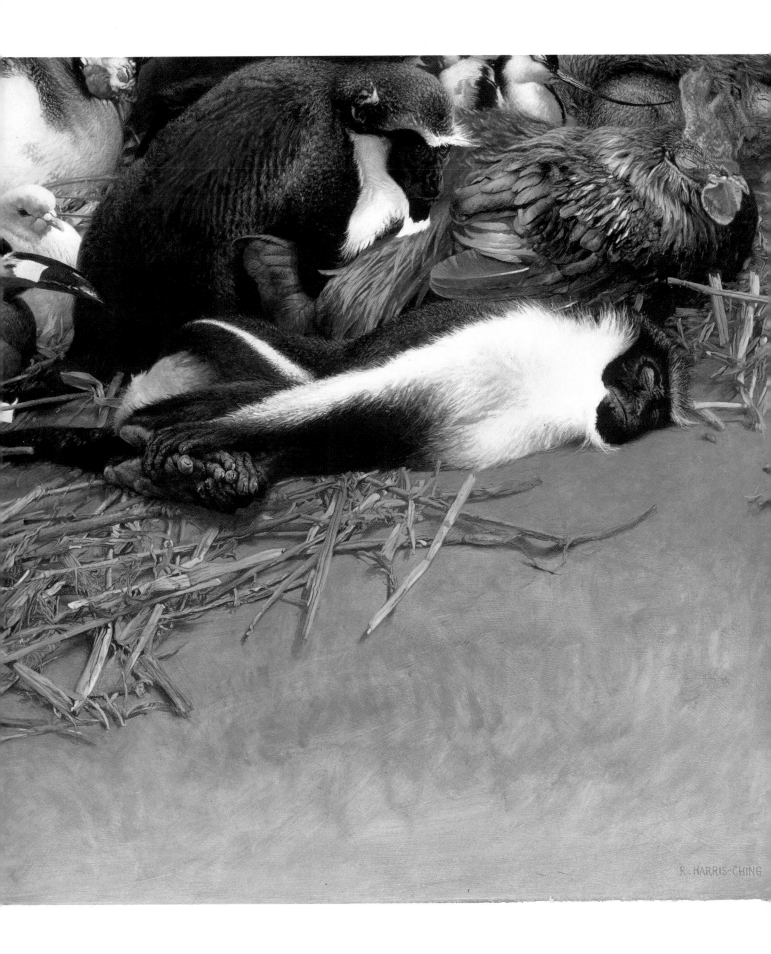

R. HARRIS-CHING

Selected Bibliography

Adams, Norman, and Joe Singer. *Drawing Animals*. New York: Watson-Guptill, 1979.

Bridgman, George. *Bridgman's Life Drawing*. New York: Dover, 1961.

_____. *Constructive Anatomy*. New York: Dover, 1960.

Calderon, W. Frank. *Animal Painting and Anatomy*. New York: Dover, 1975.

Ellenberger, W., H. Dittrich, and H. Baum. *An Atlas of Animal Anatomy for Artists*. New York: Dover, 1956.

Gallwey, Kay. *An Introduction to Drawing Animals*. Edison, N.J.: Chartwell Books, 1996.

Knight, Charles R. *Animal Drawing*. New York: Dover, 1947.

Mayer, Ralph. *The Artist's Handbook of Materials and Techniques*, 5th rev. and updated ed. New York: Viking-Penguin, 1991.

Rayfield, Susan. *More Wildlife Painting Techniques of Modern Masters*. New York: Watson-Guptill, 1996.

_____. *Painting Birds*. New York: Watson-Guptill, 1988.

_____. *Wildlife Painting Techniques of the Modern Masters*. New York: Watson-Guptill, 1985.

Rulon, Bart. *Painting Birds Step by Step*. Cincinnati: North Light, 1996.

Seslar, Patrick. *Wildlife Painting Step by Step*. Cincinnati: North Light, 1995.

Smith, Ray. *The Artist's Handbook*. New York: Alfred A. Knopf, 1996.

Van Gelder, Patricia. *Wildlife Artists at Work*. New York: Watson-Guptill, 1982.

Artists' Biographies

EDWARD ALDRICH

Edward Aldrich, born in 1965, is an artist dedicated to reaching beyond the realistic rendering of wildlife and the natural world.

Aldrich graduated in 1987 from the Rhode Island School of Design. In 1991, at the age of twenty-six, he was juried into the Society of Animal Artists and has had work in their annual Art and the Animal shows. Aldrich was accepted into the prestigious Birds in Art show at the Leigh Yawkey Woodson Art Museum, Wausau, Wisconsin, the last four years and the painting in 1997's show was purchased for the museum's permanent collection. To date, he has had ten one-man shows and many two-man shows in various galleries, as well as annual appearances in shows throughout the United States and Canada. He was one of six artists featured in *American Artist* magazine's Emerging Artists issue of August 1988 and was honored, as well, to be the cover artist. Articles featuring him and his work have also appeared in *Wildlife Art*, *Inform Art*, and *Hunter's Quest* magazines.

Aldrich depicts wildlife from around the world, his preferences being the cat family, primates, and exotic birds. He paints in both watercolor and oil. Aldrich's art is carried by a number of galleries in both Canada and the United States. He currently resides in Broomfield, Colorado.

RAYMOND HARRIS-CHING

Born in Wellington, New Zealand, in 1939, Ray Harris-Ching is known as one of the world's finest wildlife artists. Encouraged by the late Sir Peter Scott, England's renowned artist and conservationist, Ching traveled to England in the 1960s. Harris-Ching's technique for painting feathers was so exquisite, said Scott, that he predicted a great future for the dedicated young artist.

Harris-Ching's watercolors and oils depict all varieties of animals, although he specializes in birds. His work is known for its great power and elegance. His ability to depict texture, from the softness of feathers to the luminosity of water, is remarkable. His drawing skills are unmatched. In 1997, he was featured as the Master Artist at the Birds in Art show at the Leigh Yawkey Woodson Art Museum. With over sixty prints, seven books, and many one-man shows to his credit, his work is renowned the world over. He currently resides in England.

ROLAND JONSSON

Roland Jonsson was born in 1958 in Uppsala, Sweden. He paints in oil, watercolor, and with lithography, and is known for his thoughtful, impressionistic style and his wonderful sense of color. Many of the scenes he paints are done on fishing trips, which he takes frequently.

Jonsson has had exhibitions in Sweden, Norway, Germany, Japan, England, and the United States. He has been in the Leigh Yawkey Woodson Art Museum's Birds in Art show five times. His appearances in publications include *Birds in Springtime* (Sweden), and *Paintores de la Naturaleza (Spain)*.

His work is currently represented by Holland and Holland Fine Arts and the Tryon galleries, both in London.

BOB KUHN

Born in 1920 in Buffalo, New York, Bob Kuhn received his formal education at Brooklyn's Pratt Institute. He was only six when his father took him to the zoo for the first time, a trip he credits with beginning his passion for wildlife. He has never wanted to paint anything but wildlife, preferably large, big game animals in Africa. His favorite places are the Serengeti Plain and the Mara in Africa.

Kuhn's work has received acclaim from critics and collectors. Starting his career as an extremely successful illustrator, and contributing to many major magazines, he eventually turned to the fine art side of painting. In 1965, his first one-man show was at Abercrombie and Fitch in New York. His paintings appear in the collections of many major museums and collections, and there are many books on his work. Kuhn currently lives in Tucson, Arizona.

DINO PARAVANO

Dino Paravano, born in Italy, moved to South Africa with his family in 1947 at age twelve. He started painting at an early age, initially encouraged and educated in art by his father. Paravano is famous for his masterly portrayals of South Africa's sun-drenched landscapes, ocean scenes, and wildlife.

Since 1966, Paravano has held fourteen one-man exhibitions in South Africa's major cities, New York, and London. Paravano has participated in more than two hundred two-man, three-man, and group exhibitions throughout the world. A member of the prestigious Society of Animal Artists he has exhibited with its annual shows and won Best of Show, Honorable Mention, and the Award of Excellence. He is also a member of the Pastel Society of America and is a frequent exhibitor at its juried annual show. The year 1997 was the eleventh consecutive year that Paravano's work was included in the Birds in Art show at the Leigh Yawkey Woodson Art Museum. In 1993, Paravano had the great honor of being chosen Master Wildlife Artist. His works are included in the museum's permanent collection and appear in many corporate collections and museums in southern Africa, the United States, Canada, Europe, the United Kingdom,

Australia, New Zealand, and Asia. His paintings appear in many books including two books by best-selling author Peter Hathaway Capstick. He is currently represented by Trailside Galleries, Carmel, California, Everard Gallery, in South Africa, and the Tryon Gallery, London. Paravano and his wife Kiki live in Tucson, Arizona.

CHARLES TIMOTHY PRUTZER

Tim Prutzer is an internationally recognized natural history artist with over twenty-five years of experience. He works most extensively as a plein air painter and has become known for the diversity of materials and techniques he brings to his art.

He was a protégé of the late Donald Malick, apprenticed under William H. Traher, and studied plein air painting with George Carlson. Prutzer began his career as a diorama artist at the Denver Museum of Natural History in 1972 and has worked on dioramas in museums in both the U. S. and South Africa. He has taught illustration at the Rocky Mountain College of Art and Design and zoo life drawing at zoos in Colorado.

Prutzer's illustrations have appeared in *Reader's Digest*, the National Wildlife Federation stamp program, and for the Artists for Nature Foundation in Extremadura, Spain. His paintings have been exhibited at the Beijing Natural History Museum in China, in Japan's Sotetsu Gallery in Yokahama, and in the prestigious Denver Rotary Club's Artists of America show. His paintings have been juried into the prestigious Birds in Art show eleven times. Articles on his work have been featured in *Southwest Art* and *Wildlife Art* magazines, as well as in many other periodicals. He currently lives in Colorado.

TOM QUINN

Born in Hawaii in 1938, Quinn graduated from the Art Center College of Design, Los Angeles, then went to New York to become a graphic designer. He was soon receiving illustration commissions from major magazines, such as *Field and Stream* and *The Saturday Evening Post*. Eventually, he returned to California, settling in the tiny town of Port Reyes, and quickly established himself in the wildlife art field. Strongly influenced by the work of Chinese and Japanese masters, such as Li An-Chung and Maruyama Okyo, Quinn works with a limited palette and a minimum of detail. Painting only birds and animals he knows intimately, he is a master of maximizing expression within assured and spontaneous simplicity. In addition to painting, Quinn trains Labrador retrievers. These dogs were the subject of a book he wrote called *Working Retrievers*. His work has also appeared in many books on wildlife art. Tom Quinn's work is in the collections of many museums, including the Leigh Yawkey Woodson Art Museum and the National Wildlife Art Museum.

Index